CW00588692

PALGRAVE STUDIES IN THEATRE AND PERI
the best of theatre/performance scholarship
jargon. It strives to include a wide range of
performance forms that in recent years have helped broaden the understanding of what
theatre as a category might include (from variety forms as diverse as the circus and
burlesque to street buskers, stage magic, and musical theatre, among many others).
Although historical, critical, or analytical studies are of special interest, more theoreti-
cal projects, if not the dominant thrust of a study, but utilized as important underpin-
ning or as a historiographical or analytical method of exploration, are also of interest.
Textual studies of drama or other types of less traditional performance texts are also
germane to the series if placed in their cultural, historical, social, or political and eco-
nomic context. There is no geographical focus for this series and works of excellence of
a diverse and international nature, including comparative studies, are sought.

The editor of the series is Don B. Wilmeth (EMERITUS, Brown University), PhD,
University of Illinois, who brings to the series over a dozen years as editor of a book
series on American theatre and drama, in addition to his own extensive experience as
an editor of books and journals. He is the author of several award-winning books and
has received numerous career achievement awards, including one for sustained excel-
lence in editing from the Association for Theatre in Higher Education.

Also in the series:

The Education of a Circus Clown

Mentors, Audiences, Mistakes

David Carlyon

THE EDUCATION OF A CIRCUS CLOWN
Copyright © David Carlyon 2016
Softcover reprint of the hardcover 1st edition 2016 978-1-137-55481-9

All rights reserved. No reproduction, copy or transmission of this
publication may be made without written permission. No portion of this
publication may be reproduced, copied or transmitted save with written
permission. In accordance with the provisions of the Copyright, Designs and
Patents Act 1988, or under the terms of any licence permitting limited
copying issued by the Copyright Licensing Agency, Saffron House, 6-10
Kirby Street, London EC1N 8TS.

Any person who does any unauthorized act in relation to this publication
may be liable to criminal prosecution and civil claims for damages.

First published 2016 by
PALGRAVE MACMILLAN

The author has asserted their right to be identified as the author of this
work in accordance with the Copyright, Designs and Patents Act 1988.

Palgrave Macmillan in the UK is an imprint of Macmillan Publishers Limited,
registered in England, company number 785998, of Houndmills,
Basingstoke, Hampshire, RG21 6XS.

Palgrave Macmillan in the US is a division of Nature America, Inc., One
New York Plaza, Suite 4500, New York, NY 10004-1562.

Palgrave Macmillan is the global academic imprint of the above companies
and has companies and representatives throughout the world.

ISBN 978-1-349-57507-7
E-PDF ISBN: 978–1–137–54743–9
DOI: 10.1057/9781137547439

Distribution in the UK, Europe and the rest of the world is by Palgrave
Macmillan®, a division of Macmillan Publishers Limited, registered in
England, company number 785998, of Houndmills, Basingstoke,
Hampshire RG21 6XS.

Library of Congress Cataloging-in-Publication Data.

Carlyon, David.
 The education of a circus clown : mentors, audiences,
 mistakes / by David Carlyon.
 pages cm.—(Palgrave Studies in Theatre and Performance History)
 Includes bibliographical references and index.

 1. Clowns—Training of—United States. 2. Circus performers—
United States. 3. Carlyon, David. I. Title.

GV1828.C36 2015
791.3092—dc23 2015020687

A catalogue record for the book is available from the British Library.

To Mom & Dad,
gentle but playful & dignified but corny,
good role models for a clown

It takes all sorts of in- and outdoor schooling
To get adapted to my kind of fooling.

Robert Frost

Contents ✑

Figures ❧

Acknowledgments ✧

Immense have been the preparations for me,
Faithful and friendly the arms that have helped me.

Walt Whitman, *The Song of Myself*

It is an immense pleasure to thank those who have helped me. Though this accounting will be long, it should be longer to include all the faithful and friendly who encouraged me, gave me insight, prodded me, and challenged me. It also should be longer to include those I neglect to name.

What I've written in this book reflects my gratitude to those who helped me along the circus path, starting with Clown College: Lou Jacobs, Bill Ballantine, Bob Momyer, Chris Barnes, Phyllis Rogers, Peggy Williams, Barry Lubin, George Khoury, Dale Scott, and my roommate and pal, Bruce Warner. The clowns on tour helped immeasurably: Mark "Mark Anthony" Galkowski, "Prince Paul" Alpert, Billy Baker, Kevin "Cuz" Bickford, Bob "Buzzy" Boasi, Lenny Ciaccio, Bernice Collins, Kenny "Gumby" Colombo, Richard Fick, Rick Davis, Peggy "Nosmo" King, Steve LaPorte, Terry LaPorte, Jeff Loseff, Joe Meyer (Wood), Scott Parker, Peter Pitofsky, Danny Rogers, Victor Ruiz, Dolly Span, Wayne "Hated His Nickname" Sidley, Ed Smith, Allan Tuttle, Bill Witter, Dana Worthington, and especially my clown (and sparring) partner, Dean "Elmo Gibb" Chambers, plus clown wardrobe guy and circus fan extraordinaire Ross Wandrey. I am also grateful to many beyond the Alley, especially Bisi, Doncho, Charly Baumann, Biscuits and Jim, "Camel John" Rouchet, Buckles Woodcock, Dawnita Bale, Tim Holst, and my neighbors in the King Charles Troupe. Connection since then to the non-traditional world of clowning and physical comedy has enriched my life and my work, especially thanks to Michael Bongar, Hovey Burgess, Hillary Chaplin, Tom Dougherty, Jeff Gordon, Ron Jenkins, Barry Lubin, Dick Monday, Michael Preston, Tiffany Riley, and John Towsen.

Beyond circus, and beyond any particular show, a few theater directors taught me how performance *works*: Bob Chapel, Guil Fisher, John Reid Klein, and B. H. Barry. And for teaching me that performance not only doesn't have to be the way it's "supposed to be," but can improve with sudden twists and surprising inevitabilities, I am indebted to George Balanchine, Walter Kerr, Lily Tomlin, and the jazz pianist, Father Tommy Vaughn.

Just as performance informs the scholarship, scholars inform the insights into performance, starting with mentors and friends at Northwestern University who propelled my doctoral explorations of the cultural history that performance reflects and inspires: Joseph Roach, William B. Worthen, Karen Halttunen, Les Hinderyckx, Charles Kleinhans, Tracey Davis, David Downs, Mary Poole, Susan Manning, Bruce McConachie, and David Joravsky.

Because I can't name all the scholars who prodded and inspired me, instead of the scholarly trope of standing on the shoulders of giants, imagine a circus troupe trope, each one I name here as part of an act many persons high: Rosemarie Bank, Mark Cosdon, Janet Davis, John Frick, Stuart Hecht, LaVahn Hoh, David Mayer, Brooks McNamara, Robert Sugarman, and Matt Wittman.

For welcoming me to their fascinating world, I owe a special debt to the new breed of circus historians, who dug into primary research to augment and deepen the usual circus anecdotes and literary treatises. Though most circus and clown histories *continue* to rely on secondary sources, these historians prepared a solid foundation for later scholars: Stuart Thayer, Fred D. Pfening, Jr., Fred D. Pfening, III, Fred Dahlinger, Richard Flint, William L. Slout, Richard J. Reynolds, John Polacsek, and George Spaeight. I'd also like to thank the anonymous readers of my manuscript, and the un-anonymous (onymous?) Lisa Simmons, for her careful reading, bountiful humor, and savvy comments.

I thank the curators at the Circus Collection of the Ringling Museum: Debbie Walk and Jennifer Lemmer-Posey, and the Head of Special Collections at the Milner Library at Illinois State University, Maureen Brunsdale.

I thank the artists who generously gave me their gorgeous paintings and drawings, which in a world oblivious to page limits would have been illustrations in this book: Ray Dirgo, Vivienne Johnson, Jean Wall Penland, Terry Townsend, and Sue Wiggins. I'd also like to thank those who helped me with permissions: Pat Cashin, Greg DeSanto, Liz Dirgo, Thomas Dirgo, Linda Granada, Paul Gutheil, John Kerr, Maranda May-Miller, Fred D. Pfening, Nicole L. Pope, Terry Townsend, Warren Townsend, and Peggy Williams.

For my book's epigraph, I would like to express my thanks for permission to reprint the excerpt from "It Takes All Sorts" by Robert Frost from the book *THE POETRY OF ROBERT FROST* edited by Edward Connery Lathem. Copyright © 1969 by Henry Holt and Company. Copyright © 1962 by Robert Frost. Reprinted by arrangement with Henry Holt and Company, LLC. Similarly, I thank the literary agents for Walter Kerr and to the Kerr family for permission to reprint, for the chapter 9 epigraph, a quotation from *The Theater in Spite of Itself* by Walter Kerr, copyright © 1963 by Walter Kerr. Used by permission of Brandt & Hochman Literary Agents, Inc. All rights reserved. I also want to thank Pat Cashin for permission to use a variation on the "Brief History" in appendix B, which first appeared on his blog. Credits for all illustrations appear with their respective captions, but I would like to make my thanks explicit to Maranda May-Miller for the cover image; Jean Wall Penland for her etching in chapter 3; to Elmo Gibb for his

photograph of Prince Paul in chapter 6; to Don Wilmeth for the image of Otto Griebling; and for permission to reprint three illustrations, and even more for the life-changing opportunity to clown, I thank Ringling Brothers and Barnum & Bailey, Inc., Irvin Feld, Kenneth Feld, and the Feld family. (*RINGLING BROS. AND BARNUM & BAILEY and THE GREATEST SHOW ON EARTH are registered trademarks of and are owned by and used with permission of Ringling Bros.-Barnum & Bailey Combined Shows, Inc. All rights reserved.*)

I give many thanks to my students in acting, movement, intro to theater, and history classes over the years, from whom I learned immeasurably.

Thank you too to two, my sons Daniel and Will, who make me laugh.

Finally, I'm happy to express my gratitude to the inimitable Don Wilmeth, who fits many of the categories and much of the praise above.

Come-in ∾

The young man himself, the subject of education, is a certain form of energy; the object to be gained is economy of his force; the training is partly the clearing away of obstacles, partly the direct application of effort.

Henry Adams, *The Education of Henry Adams*

They laughed.

That might seem predictable, them being an audience and us being clowns. But they didn't laugh because we'd done something funny, they laughed on the assumption that, watching clowns, it's what they were supposed to do. They also laughed because people enjoy unscripted performance moments, and it obviously wasn't part of the plan when I reached for the whip and Dean jerked away. I'd grabbed for the whip because our gag had been feeling stale, and I aimed to spark it back to life by suddenly switching places. Congratulating myself for following impulse, going with the flow, I saw us as Sir Laurence Olivier and Sir John Gielgud alternating roles in their legendary *Hamlet*, only we weren't Sirs and this wasn't Shakespeare. We were First-of-Mays with Ringling Brothers and Barnum & Bailey Circus. "First-of-May" means rookie, and this rookie was being creative.

Dean thought not. Our gag in Come-in, the clown preshow, was called Whipcracker, and he was determined to hold the whip hand.

I grabbed again. He dodged and stomped over to the audience, directing a youngster to stand. Dean didn't talk as a clown so he gestured how the kid should do my stooge role but it didn't work. Playing simple isn't so simple, and Dean knew that. He just wanted to make clear he was mad. Giving up on the boy, he shot me a glare through the bangs of his yellow wig sewn into a blue-&-white striped cap—he looked like a red-nosed version of the Dutch Boy—and stormed down the track.

The crowd watched, as anger intensified the waddle in his Elmer-Fudd walk. Was that steam shooting out of his ears? When he smacked out the

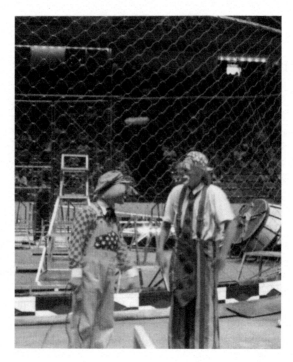

Figure I.1 Whipcracker: a clown gag, a battle of wills. Author's collection.

back curtain, they turned back to me. Here was my chance to salvage the situation with some dazzling comic move. A shrug can be a dazzling comic move. Mine wasn't, and I slunk away.

Maybe I shouldn't have jumped from Berkeley Law to Barnum & Bailey.

∞

Clowning was no lifelong dream. I'd only seen one circus as a kid, and I didn't remember where. All I recalled was the hot tent, sitting in one end on bleachers with splinters, and getting a chameleon that died. Nor had I been the class clown. I'd never even thought about this strange path until my sophomore year at the University of Michigan when I read in the Sunday paper that a "college" for clowns had opened.

Immediately, it felt right.

It was the 1960s after all. This flower child had blossomed in Ann Arbor, marching in sandals, beads, and bell-bottoms with thousands against war

and, thanks to the place's refreshingly split personality, with many of the same thousands going to football games. To put myself through school, I worked at a meat packing plant, lugged trays as a bus boy, sorted mail over December holidays, and fought forest fires in the West, my long hair waving under a hardhat decorated with a painted orange daisy. Groovy. Telling a gal at a party that I might be a clown, I discovered that this hint of a free spirit tickled her fancy. I hoped to tickle more but did get a Winnie-the-Pooh poster—"perfect for a clown"—as a parting gift.

It was more than hippie whim though. In college, I performed in musicals, specializing in baggy-pants comedy, and I volunteered with preschool children. Both activities seemed suited to clowning. I was also a natural-born contrarian. More than adopting the era's default anti-establishment position, I also questioned the mantra "Question Authority" as authoritarian.

When Ringling came to Detroit, I saw my second circus. From the cheap seats, I laughed loudly at the clowns, as if my eagerness made us kin. The gags looked sluggish from my high perch, so I laughed louder, hoping circus didn't die before I could try it. But if this impulse felt right, it also seemed ambiguous. Did I have the nerve to veer from the straight-and-narrow?

Uncle Sam spared me the decision, inviting me to join his little marching society. My conscientious-objector application deposited in the circular file, I found myself on a night bus to Basic Training at Fort Knox, Kentucky, rain smacking the window. They shaved my head, hair falling to the floor like delusions of Samson-like strength. I did qualify with the M-16 as an Expert, Sharpshooter, or Marksman—Expert, maybe, I forget which—but that was only because *everyone* qualified as one of those. Meanwhile, I was ashamed how easily the drill sergeants rattled me. In college I'd seen myself as a rebel, free and proud. Marching for civil rights back home, I'd change the world. In the West, fighting fires, I'd been a mountain man of infinite horizons. But Basic shriveled me to a cringe. For AIT, Advanced Individual Training, they shipped me to MP School at Fort Gordon, Georgia. They intended to turn this hippie freak into a military policeman. Firing a .45. Searching a suspect, declared "dead" because I didn't recognize a pen was a lethal weapon. Being taught to write name and date on arrest forms where it says "Name" and "Date." One day I raked sand. No reason: it's the Army.

Late one Friday, on a weekend pass and a vague impulse, I headed to Atlanta, and caught a bus south: I was going to see "Clown College." I dozed through the night, downed a breakfast of fried grease in Jacksonville, Florida, dozed again, stirred passing through Ringling's old home of

Sarasota, and hopped off at the cinder-block bus station in Venice. The clerk said to get back on and ask for "winter quarters."

I'd barely returned to my seat when the driver pulled off the road. "Where's the kid who wants to be a clown?"

Heads swiveled my way as I casually slung my luggage, an Army laundry bag, on my shoulder. Then it slid to my legs and I stumbled up the aisle, an inadvertent comedy routine. Off the bus, seeing an empty field, I turned to the driver, who pointed, jammed into gear, and rumbled back onto the highway. *There* it was in the distance, shimmering like a blue-and-white Oz. Omigod, I'm Dorothy.

Cold ever since the Army got me, I paused to soak in the warm sun. Then I waded through tall weeds, transformed into the soft focus of a movie, with grasshoppers buzzing a soundtrack, till I got to a chain-link fence stretched around a compound, with wagons and a long pole next to an elephant tub. But where were acrobats flipping? Showgirls in ornate makeup? Clowns? There ought to be clowns.

I knocked on a red door. No answer. Knocked again. Nothing. When I leaned in a third time, the door jerked open to a security guard whose belly looked as if he'd swallowed a watermelon whole. He clearly wanted to yell but the combination of my shaved head, rare for the time, and hippie bellbottoms confused him.

"Wha' ya want?!"

Uh, the dean of Clown College?

"Ain't here."

Could I look—?

"Nothin' to see."

Anyone from the circus—?

"Both units on the road." He slammed the door, an echo confirming the place was empty.

I was an idiot. With no preparation or research, I'd simply headed out, not considering that a two-month "college" in the fall wouldn't be operating in January. Still, I wasn't upset. After years of possibly-maybe-might, I'd finally done *something* about this…dream? Notion? Curiosity? Settling under a palm tree, I pulled a book of Russian stories out of my bag, to pass the time till the next Greyhound north. I don't know how long I read— MPs had to wear a watch so, in petty rebellion, I never wore mine off-duty—but I'll always be grateful for long-winded Russians. Finally reaching the end of a story, I stood and stretched, dusting sand off my pants.

As if on cue, a convertible pulled off the highway. Maybe a white Cadillac but pink in my memory, it got closer. The movie in my mind

continued. I didn't breathe as the car pulled to a stop in a swirl of dust, like glitter in the sun. The driver got out. Smiling in a pink button-down shirt and white jeans, with white hair swept back from a shaved pink face, he could have been a pastel Santa Claus.

"Hi, I'm Bill Ballantine, the Dean of Clown College. Looking for me?"

He took me past the guard—quests have dragons—and up to his office. He said it was helpful that I'd performed, and had experience with kids. He also said the Army was good preparation. I wouldn't tell the drill sergeants that. He asked if the acne blotch on my temple bothered me. It barely showed so I knew he was asking an awkward question to see if it threw me. When Bill warned that circus was hard, I nodded earnestly, but I'd supported myself since high school, hitchhiked the country, slept on the side of the road, flown a plane solo, paid my own way around Europe. I'd known danger, on a New Mexico wildfire that nearly cooked me to a crispy critter, and as a substitute teacher facing 7th graders. How hard could circus be?

My Florida idyll over, uncertain if I'd ever return, it was back to khaki and compulsion. Once we'd learned enough to be dangerous to ourselves—parting words from the hand-to-hand combat instructor—the Army sent me to be a military policeman at Valley Forge Hospital, west of Philadelphia. The doctor-officers were irreverent, like the ones on *M*A*S*H*, just not as funny, and enlisted men were tranquil, thanks to self-medication. The MPs did have flare-ups, like high noon facing armed Philly drug dealers in the PX parking lot, but mostly things were so low-key that a salute could be sarcasm. Because the MPs were short-handed, we ran 12-hour shifts—three days, three nights, three off. Resetting my internal clock every 72 hours staggered me till, noting the many free evenings this strange schedule allowed, I auditioned for local dinner theater. Cast in *A Funny Thing Happened on the Way to the Forum*, off-duty I'd be a professional performer—if sub-minimum wage qualifies as professional pay. Because I'd choreographed shows, they hired me to stage the dances in their next one, *Guys & Dolls*. I worked out the steps after midnight on duty in the gate shack, so the occasional passing driver saw, framed in the shack's big window, an MP spinning, nightstick and .45 holster flopping.

When I was short—Army slang for nearly done—I applied to law school. I joked that I only applied for an early-out, but clowning still felt implausible.

Berkeley Law surprised me. Expecting picky words and sneaky clauses, I loved the joust of ideas. Meanwhile, old habits returned: I acted in San Francisco with an avant-garde troupe blending Japanese Noh plays with our personal journeys, and I worked with physically challenged kids my sister Jan taught in Fremont. To see shows, I volunteered as an usher at Zellerbach Hall, making sure I worked every performance of the Alvin Ailey dance troupe and the mime Marcel Marceau. Returning to Philadelphia to intern in the US Attorney's Office, I acted again, playing the blind guy in *Butterflies Are Free*, plus I sold beer at Vet Stadium. Back in Berkeley, I got job offers: a big Chicago firm; an Alaskan outfit that'd pay me to finish the flying lessons I'd started; and a Salt Lake City lawyer who called himself the only Jew in Utah.

But it was time to put up or shut up. Without exactly deciding to veer from the law, I pulled out the Clown College application. I don't know if I'd have literally run away with the circus but filling out applications was familiar territory. The questions fascinated me. When was the last time you cried? (Watching Louise Fletcher use sign language to thank her deaf parents as she accepted an Oscar for *Cuckoo's Nest*.) How'd you handle an adverse situation? (After 18 hours on a Yellowstone fire and little sleep, waiting for a helicopter to return our bone-weary crew to the fire line, I made them laugh by blustering like a British officer inspecting the troops. Pip pip, cheerio.) Drugs? In the Sixties, in Ann Arbor, in the Army? Heaven forfend. Favorite circus acts? I put down the only one I knew, Emmett Kelly, and looked up others. Hiding law school, I wrote that I'd "taken classes, worked with kids, and performed." Did that incomplete answer reflect legal training or innate deviousness?

After graduation I crammed for the California Bar exam, when not playing basketball—always enthusiastic, seldom stellar—on the court across Alcatraz Avenue. Taking the exam, I dredged up every legal phrase that came to mind. Attractive nuisance. Rule against perpetuities. Unconscionable. For example, a three-day exam is unconscionable.

Then I waited. Had I passed the Bar? Would Ringling take me?

September, with Clown College starting in three weeks and no word, I wondered what to do with my life next. Then Bill Ballantine called, and as he talked, I literally jumped around, not easy to do when phones had cords.

∞

This book is about the education of a working circus clown. It requires clearing obstacles.

First, clowning is hard because clowning is easy. Throw on makeup, and some laughs are automatic. I-get-it laughs. I'm-a-free-spirit laughs.

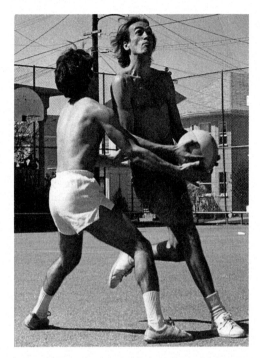

Figure I.2 Studying for the California Bar exam. Author's collection.

Ironic it's-not-funny-which-makes-it-funny laughs. Encouraging-laughs, like mine in Detroit. Polite laughs when one clown bolts a two-man gag. The various laughs convince rookies they're comic geniuses. But my performance experience whispered I had to figure out the hollow ones, then maneuver past them. (Some clowns I admire say that if people laugh, it's funny. But that seems less comic philosophy than a way to brush off clueless questions. The same clowns know that laughs can be misleading, and know too that people can appreciate comedy without laughing. As those clowns often do.) That's not to say I was analyzing all this then. Though I am fond of analyzing, clowning overwhelmed that tendency, with instinct and movement taking over in performance.

Second, this isn't a how-to tome. You can't learn to clown from a book. Nor do I believe you can learn professional clowning from a class. Clown College provided a strong foundation, and the clown schools and classes now thriving can unleash lovely silliness, while offering their own foundation—maybe a better one: decades must have improved clown pedagogy.

And as a teacher myself, from grade school to college, and movement classes to history seminars, I try to create a safe space to help my students learn. But none of that's professional clowning. Ain't no safe space when you flop. So comparing a clown class to performing three-hour shows, twelve times a week for eleven months, is like comparing batting practice to a season of professional baseball. Helpful, but not the same thing. Vaudeville's baggy-pants comedians knew that, learning through the *job* of performance. That's how I learned, from mentors, audiences, and mistakes in performance. Mentors taught, though distinguishing teaching from scorn was tricky. Audiences taught, a hard lesson for me because my theater background insisted that heeding audiences is pandering. Mistakes taught most, and were hardest to accept. George Burns said that the circus is the last place left to fail, but it's tough admitting that you flopped—and tougher still, trying again. Easier to blame an awkward moment on a bad audience. Or a stubborn partner.

Weaving through those two obstacles is a third one, the clattering concatenation of clown clichés. The happy clown. Its flip side, the sad clown. Clown with sick child. Tears of a clown. The Sixties had spawned new variations: trickster-posing-challenge, refined-artistic-clown, find-your-inner-clown. Though clichés drew me to clowning, I had to work past them, in audiences and in me, if I was going to learn. The struggle continues in this book: wrestling with stereotypes, I sometimes embodied them. Trickster-like, I got satirical. A dying girl giggled. A literal clown mask hid my tears. Heck, I may have even gotten artistic when I wasn't looking.

The clichés are especially difficult to avoid because they're embedded in our culture. Though skewed and often false, they seem natural, what "everyone knows" about clowning. An appendix covers the history, but briefly here: The first century of circus, from the late 1700s, clowns provided rowdy adult fare. Around 1880, though adults still filled most of the tent, children increasingly attended and became symbolically identified with clowns. The hippie 1960s propelled another shift into the twenty-first century. Free-spirit antics seemed more authentic than traditional clowning, irony ruled, and people did their own thing. Meanwhile commercial exploitation bloated the image of clown so much that backlash was inevitable, generating the new images of creepy clown and scary clown. Though the 1960s opened new opportunities, the old mixed crowds splintered, as did the lessons they might teach. Now clowning swings between niche audiences and the new giant, the pricey Cirque du Soleil. Yet, as always through history, good clowns improve, bad clowns persist—sometimes "experience" means doing the same thing over and over—and somewhere between, clowns write books.

I write to explore what a working clown does. I wasn't the best clown, or the worst, but I know that day-to-day labor. To convey the work in words conjures Bob Dylan's lyrics in "Mr. Tambourine Man": a ragged clown behind, chasing a shadow. Still, down the foggy ruins of time, I try to capture the learning process in action. At the same time, years have added perspective. A second year with Ringling, and a third as "Advance Clown Ambassador," promoted to do publicity a week ahead of the show, reinforced lessons of the first year. I then relearned the lessons of clowning as an actor, director, and acting teacher, as a parent, and as a historian of performance of all kinds, including political performance. Performing, staging, and writing about Shakespeare, and penning my own plays in iambic pentameter, showed me deeper than deep thoughts about his poetry and characters and thought, a practical man of the theater, with more of the same comic lessons, the same *clown* lessons. Meanwhile, though Broadway and funky performers in tiny venues mistrust each other, the former scorned as slick, the latter as amateurish, I love both, appreciating Broadway's craft and inspiring quality, and funky-town's adventurousness and inspiring rawness.

I write to sort out the difference between arena clowning and clowning up in the stands. I originally thought that my routines around the three rings were the foundation, while what I did in the seats directly with the audience was peripheral. Gradually, the road taught a different lesson, that connecting with people in the stands fed what I did on the arena floor. The combination of perfecting set routines and of improvising with an audience is similar to what the comics of vaudeville did, and what stand-up comedians do now, as Steve Martin recounts in his book, *Born Standing Up*. One of my favorite toys as a kid was Bill Ding Jr., a set of stacking clowns, and what appealed to me most was the varied ways the figures connected. So whether or not this book is a *Bildungsroman*, it's at least a Bill-Ding-Jr.-roman, looking at how individuals connect.

I write to honor the veterans who guided my apprenticeship. The old guys, Lou Jacobs, Prince Paul, Mark Anthony. The younger ones, Cuz and Billy. The baggy-pants comics out of vaudeville, Buster Keaton, Bert Lahr, the Marx Brothers, W.C. Fields, whose movies—and moves—I absorbed. They all had wisdom in their bones.

I write to pay tribute to Clown College, now closed.

I write to celebrate trouping. Riding the rails I found the land of Saul Bellow and Willa Cather and F. Scott Fitzgerald. Walking each town, I learned my anxious, changing country from the ground up. As I engaged audiences in different places, those places became part of me.

I write to emphasize the commonly asserted—and commonly ignored—lesson that comedy is serious. Defenders of the comic faith trot out practical reasons: laughs cure illness, improve life, threaten the powerful. But medicine, friends, and political action do those things better. Comedy reaches deeper. The ancient Greeks saw levity and gravity as counteracting forces of nature. While gravity survives in science, and as a mark of character, levity has floated up, up and away, as diversion. But level with the human soul, levity still pulls as strong as gravity, helping us share our humanity, and shape it.

I write to figure how a lawyer became a clown. ("Aren't lawyers already clowns?" If I'd known how often I'd hear that witticism, I might've picked another path.) Though I enjoyed law school, did I shy from the rigors of a legal career? Was it hippie determination to be different, a dutiful guy dropping out? Or, ironically, was I being dutiful to 1960s' dogma that I *should* drop out? Hadn't I been hugged enough as a kid? Do guys just want to have fun?

For years, repeating my own romantic cliché, that being a clown simply felt right, I didn't see the push and pull that got me there. The push, time's arrow, kept shooting me off the straight and narrow till I tumbled into clowning. The pull of unconscious motivations would take the writing of this book to recognize—or admit.

Chapter 1 Romance of the Red Nose ✧

Fall 1976: Clown College, Ringling Arena, Venice, FL

We lawyers are always curious, always inquisitive, always picking up odds and ends for our patchwork minds.

<div align="right">

Charles Dickens, *Little Dorrit*

</div>

It was a perfect picture of a school for clowns. Jugglers passed clubs, the glossy colors catching the Florida sun, while acrobats took turns doing flips on the grass. A gal in a purple leotard slid one foot, then the other, along a rope she'd strung between two palm trees. A kid in a Hawaiian shirt rolled on a unicycle, his legs churning down the sidewalk past the Venice Villas, our home for two months. In and out of courtyards stretched between a swimming pool and the Gulf of Mexico, 60 of us formed and reformed groups like mercury on a plate. Everybody was everybody's buddy. A guy emerged from his room in clown makeup, and talked about circus with the kind of detailed knowledge that I'd seen in theater fanatics. Should I know this stuff? Did clowns have a secret handshake? With a joy buzzer? My roommate Bruce, with frizzy hair and glasses, sat on top of his brown van, strapping on home-made stilts and grinning. When he grinned, which he did a lot, his cheeks puffed out and his teeth pushed forward, making him look like a cheery chipmunk. Grinning, he said "Isn't this great!" It was.

Bruce had been in the service too, a Navy nurse—probably why they'd made us roommates—and added his own tale of long desire, saying he'd wanted to be a clown since he was a kid. When he wasn't accepted last year, he'd driven from Connecticut to stand outside the gate, hoping his zeal would persuade them. It didn't then but here he was now.

So how did I fit? I was one of the oldest, 26, and this hadn't been my lifelong dream. I could have talked about my swerve from law school but I

told no one. I doubted I'd have gotten in if I did, and I kept my secret now
because, certain they wouldn't offer me a contract if they assumed I'd prac-
tice law, I still wanted to see if I was good enough to get one. I was about
to show off the three-ball juggle I'd taught myself when Mike, in rainbow
suspenders, launched a juggling routine with patter about ecology, one ball
representing Mother Earth. I was about to judge it simplistic when Terry,
pixie-cute, said she liked comedy with a message. Smiling, I agreed.

As sunset streaked orange on the sky, I invited Terry out to eat with
Bruce and me. One of a dozen girls, she had to be extricated from about
half of the 50 boys. Over dinner, when Terry mentioned her college mime
class, Bruce mimed eating and we all laughed. I saw us becoming the Three
Clown Musketeers. Or two: at the Villas, Terry and I wandered off alone.
Groucho Marx said the best party is a boy and a girl and a whole cheesecake.
I figured the cheesecake was optional.

* * * * * * * * * * *

The first morning of classes, we arrived at Ringling Arena in cars, Bruce's
van, and a school bus. Tumbling into the bleacher seats at the near end,
we buzzed like kindergarteners expecting a treat as we waited for Bill
to descend from his second-floor office, in the corner above our right
shoulders. Sitting between Terry and Bruce, I looked down the expanse
of the arena's concrete floor, with aqua-blue rolling globes, like 3D polka
dots, around a trampoline, and pipe railings framing the blue seats rising
on the sides. At the other end a red carpeted bandstand was flanked by
openings that led to an empty area, then a barn-sized door outside.

Leaning across me to tell Bruce something, Terry put a hand on my
knee. I lost my train of thought. Or rather I started a new one, interrupted
as Bill emerged from his office and strode down the steps, two at a time,
again in pink shirt and white jeans.

He welcomed us "extraordinary few," chosen from thousands of appli-
cants. It was harder to get into than law school, though I didn't volunteer
that comparison. Bill quoted James Whitcomb Riley, "O, we all wanted to
be circus clowns," and said that a guy named Dan Rice from the 1800s was
America's first major clown. He told us the Ringling family had sold the show
in 1967 to Israel and Irvin Feld. Or Mister Israel Feld and Mister Irvin Feld,
as Bill called them. The brothers had split Ringling into two units, Blue and
Red, and started Clown College to replace old clowns. After Israel died, Irvin
ran Ringling, now with his son Kenneth. Bill stressed that Clown College
was Mister Irvin Feld's special project, and that he paid for everything except
our room and board. Someone whispered it cost a million bucks.

Though we were eager to do more than watch, excitement carried us through a day of announcements and demonstrations. That included Lou Jacobs. A tall, old man with glasses who could have wandered in from shuffleboard, he seemed too unassuming to be what Bill called him, "the world's greatest clown," but when he applied his makeup, I knew that face: A wide "U" of a black-painted mouth framed by a swoop of white around the mouth, a giant red nose, and white makeup arching high over each eye on a tall domed head, topped by a tiny hat. He'd come off the circus to stay the two months to teach. Makeup compete, he put fake rabbit ears on his Chihuahua as Bill announced that the great Lou Jacobs was going to perform his famous Hunting gag with Knucklehead. Bill said to carefully study what Lou did. Unsure what to study, I stared intently.

We watched more, this time, makeup demonstrations of the three types of clowns, with Bill's commentary. The whiteface is the authority figure,

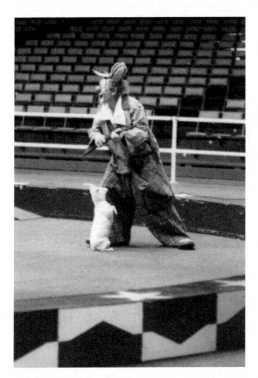

Figure 1.1 Lou Jacobs and Knucklehead, American classics at Clown College. Author's collection.

like the straight man in a comedy duo. White greasepaint covers the face, accented by other colors. The second type is the "Auguste," the baggy-pants buffoon. Pronounced aw-*goost*, the label apparently comes from a slang flip of "august," pronounced aw-*gust* and meaning dignified. Though the quintessential aw-goost, Lou Jacobs was undeniably aw-gust. The third type, the character clown, is actually a category. The best known character clown is the tramp. Another is the rube clown, which Billy was applying. Young, skinny Billy was so different than round-faced, grandfatherly Bill that it didn't register they had the same name. Billy had left Ringling to be a songwriter in Nashville and was back to teach. Our first night, he'd pulled out his guitar on the beach to warble "Contrary to Ordinary," his song being recorded by the country star Jerry Jeff Walker. Self-described country boy Billy made circus seem both down-to-earth and romantic. When he said "The clown is magic: respect that," that felt magic itself.

Near the end of the day, we *finally* got to do something. Makeup! We swarmed the tables under the side bleachers, with afternoon light through glass doors. Between Bruce and Terry again, I laid out the red and black makeup, cigar-shaped sticks of color, and opened the tin of white greasepaint, the size of a cupcake. Bill had said to study our features in the mirror and find a makeup that fit our face, but what did that mean? The longer I stared at my nose, the stranger it seemed, as if it were independent of my face, like the runaway nose in Gogol. Everyone else had started, and Terry was nearly done. My hesitation seemed like the moment before jumping in a lake, eager but shrinking from the splash. With clown makeup, would I feel like a clown?

The white makeup smelled like wax crayons, and the surface looked like vanilla frosting, with a tiny peak on its glossy surface. I tapped it, leaving a fingerprint, then again to get more. I'd try whiteface. The greasepaint felt smooth as I spread it on my cheek but it streaked. Bill said patting would fix streaks but my patting only shifted them. Maybe I should have tried Auguste, which had less white. Progressing from light colors to dark as instructed, I applied red but too thick. After brushing wobbly lines of black greasepaint, I tried to smooth them with a black pencil. Stepping outside, I whacked my face with a sock full of baby powder, coughing through the cloud of powder as I brushed off the excess. If done right, powder dries the makeup so it doesn't smear. If done wrong, the sock picks up greasepaint on the first smack and transfers it back to the face on the next one. I done wrong. Traces of black and red splotched my face like a Jackson Pollack painting.

Bill recommended baby oil to take the makeup off but said any oil would do, so after I ran back to the Villas with Glenn, a square-jawed kid from Wisconsin, I used cooking oil. I smelled like a French fry.

* * * * * * * * * * *

"Mime chocolate."

Another clown off the road to teach for a week, George wasn't promising a treat for pulling a pretend rope, he was giving an assignment.

"Use your body to express the essence of chocolate."

It was an impossible task, but the point was the effort. With dark curly hair, and a dark intensity that seemed nothing like circus, he wanted us wrestling with ideas beyond red noses and shaggy wigs. The first week had lots of that. Our acting teacher, a skinny Brit who looked like Marty Feldman, asked us to show emotion with our feet. The mime teacher from San Francisco combined our voices in a "universal sound," and talked about creativity, inner clown, and speaking truth to power. When she directed us to "do anything you want," Buzzy got up first. An ex-Marine in combat boots, he was the third veteran in the class. Buzz looked Marine severe but moving his Jimmy Durante face and angular body, he turned out to be a natural. Like the rest of us, he interpreted "do anything" to mean "something funny." Pretending to trip, he reacted with quizzical eyebrows, and got a laugh. Then came pudgy Mario's turn. Mario was one of the nicest in a class full of nice. I could see him making relatives laugh at a family picnic.

"Do anything I want?"

When the teacher nodded, Mario began to wander, then stopped.

"Anything?" he repeated.

"Yes."

He took a few steps and stopped again, as if stumped.

"Anything I want?"

"*Yes*," she said. I squirmed, embarrassed that sweet Mario was lost.

As he wandered again, she interrupted.

"What are you doing?"

"Anything I want!" He'd been waiting for the set-up to his punch line. We roared but Ms. Teach's smile was tight. Apparently truth-to-power didn't apply here.

While all our sessions had a comic inflection, Gags was the core class, repeated every day. After a *lot* of work on fake slaps, a key part of many gags, we began working through a two-month cornucopia—clownucopia?—of classic clown bits: Paper & Chair, Lean Shoe, Long Shirt, Boxing, Dead & Alive, Two-Person Horse, Pants Press, Echo, Hair Grower, Carpenter, Washerwoman, Snake Charmer, Balloon Chase, Dentist, Niagara Falls, Camera, Baseball. My favorite was the Levitation gag, with a hypnotist, a "volunteer" being hypnotized, and the stooge-assistant. When I tried the silliness of the stooge, it was like feet sliding into old slippers.

One night in the parking lot Dean and I expanded a mirror exercise into a gag. A Georgetown grad from South Jersey, he was the one who'd known

about circus that first day. As we worked, Georgia Jerry and his pals wandered over to watch and they laughed. Encouraged, Dean and I brought it to Lou Jacob's class the next day. When we finished, he said, "Spaghetti." That was Lou's ultimate criticism. "Spaghetti" meant mugging and flailing, like spaghetti all over a plate. He also didn't like my favorite idea: I hit myself and Dean reacted as if he'd been hit. Other teachers would have called it clever. Not Lou. I reminded myself he was a master but nurtured in theater's mantra of being true to your vision, reinforced by the 1960s ideal of self-expression, I couldn't avoid the guilty thought that he wanted us to copy how he'd do it.

This wasn't paradise after all. One morning Bill announced he'd be talking to students with low point totals—points for clowning?—a blunt reminder that some would not be offered a contract at the end. But the dip in spirits didn't last as it became clear Bill was only summoning the goof-offs. That included Terry's roommate and the roommate's boyfriend, who'd been skipping class together. Bill offered them a second chance but by lunch the turtledoves were gone. Bill made sure we knew he was no prude, but he couldn't allow a waste of the resources provided by Mister Irvin Feld. The departure left Terry with her own room. That would have given us privacy, if we'd been an "us." However, after I told her I needed some space, she'd given me so much space I could barely see her cold shoulder from afar. Smooth move, Casanova.

A couple times a week Phyllis taught History. A Penn grad student in anthropology, looking scholarly in glasses and a small bun, she doted on the mythic: the main makeup colors of red, white, and black are ancient ritual colors; clowns are kin to shamans and tricksters; the clown is always a stranger. Some nights after dinner we returned to the arena for movies, the cherry on top of ice-cream days. We watched Buster Keaton, circus films, Charlie Chaplin, *Freaks*, and Laurel & Hardy. Muting the sound on the Three Stooges showed how much their comedy is mostly sound effects. We saw the Lenny Bruce cartoon, *Thank You Mask Man*.

As Bruce and I drove back to the Villas past the airport, the rows of runway lights dotted green lines on the night, and the rotating beacon turned Bruce's hair into an alternating frizz of blue and red. Every night I went to the beach. I may have been praying except I hadn't prayed in years. So I pondered? Wished? Vibed with the stars as waves rolled on the sand? It might have been meditation but I doubt I was centered enough.

* * * * * * * * * * *

Bruce and I tried working together but never clicked. It may have been my fault, secretly thinking his big movements were *too* big, but finding

a clown partner was like meeting someone special: sparks have to strike. Still, at the Villas we settled into routine like an old married couple. As the pace picked up—sewing, magic, prop-making, dance—we skipped the parties. Satchel Paige said it: "The social ramble ain't restful." Instead we went to bed early, woke early, and left early for the arena, threading through the jabbering and cigarette smoke to Bruce's van. Glenn, the tall, stocky Wisconsin guy, teased, "Early again?" He and I were working on a Paper & Chair gag. "Do you old farts go to dinner at four, and bed at six?" In a quavering old-man voice, I threatened to smack him with my walker.

At the arena Bruce worked on his oversize highchair for a baby gag, while I alternated juggling and unicycle riding. Frustration motivated me more than ambition. I'd juggle till the drops annoyed me, then wobble on the unicycle till the falls annoyed me, and it was back to clubs. Still, I could now flip clubs without hitting myself in the face, and roll nearly straight on the unicycle.

By nine everyone had gotten to the arena but Bill waited in his aerie till the last smokers came in and we'd settled down. I think he liked his dramatic stride down the steps. If Opening was morning Mass, with Bill as priest in pink and white, Makeup was a benediction on the day. Every afternoon I communed with my face in the mirror. People say that makeup is a mask the clown hides behind, and maybe that's true—if *everybody* knows it, it *must* be true—but whether a notion deeply profound or profoundly shallow, that's not how it felt as I tried a new makeup every day, and ventured them in public on the run back to the Villas. Though my makeups were getting better overall, each one wobbled in its own way. I overcrowded one whiteface with swirls of red and blue. Bill said a clown makeup should look good close up while also being clear from a distance, but my "girl" makeup was neither, as exaggerated lipstick blurred visually with my nose into one blob. Trying a tramp face, I posed for a picture by scrunching my face to look sad: the photograph looked like a face scrunched to look sad.

I'd switched to baby oil to take it off. Now I smelled like a nursery.

The amorphous first weeks gave way to greater focus, with pairs and groups looking toward the graduation performance. The acting teacher, Chris formed a clown band, including Dean plunking his banjo and my year of sixth-grade trumpet qualifying me to blat something that sounded like "Won't You Come Home, Bill Bailey."

More clowns came off the road to teach, a week at a time. Peggy Williams, the first female Clown College graduate on Ringling, arrived with Frosty Little, boss clown on the Red Show. Peggy was warm as the sun; Frosty was friendly but like a bald shop teacher who kept class in line. He said that the giant arenas Ringling plays required noise and giant movements; when he demonstrated, he sounded like a carnival barker. Curiously, he used a

German accent like Lou's. All our clown-teachers came from Ringling's Red Unit, and rumors about clown trouble on the Blue Unit seemed the subtext when Billy joined Frosty and Peggy for a session about life on the road. Peggy emphasized the importance of getting along, Frosty said "You can't cause trouble," and Billy added, "Ya gotta stay flexible." I nodded. I assumed the advice didn't apply to me but would help the young ones, who'd never had a job or been away from home. Next to arrive was Steve, a stilt-walking clown. (Demonstrating a gag with Frosty, he used a German accent too. Was it an homage to Lou or unconscious copying?) He started us on painter stilts, three feet high. Though those stilts were stable, with a foot-plate on the ground and a foot-plate to stand on, some students held Steve for support. Did Terry hold longer? She'd told me she was cooking dinner for Steve because she felt sorry for him, here all alone. We were pals again, so I didn't point out that other teachers were here alone but she hadn't fed them.

Movie night no longer seemed a break. We studied the greats, figuring how to use, copy, vary, find inspiration in their moves. Buster Keaton's *The Cameraman*. Mel Brooks's *The Producers*. *The Greatest Show on Earth*. Chaplin's *Modern Times*. W. C. Field's *Fatal Glass of Beer*. The Marx Brothers' *Night at the Opera*. Film discussion was led by a local theater director, who focused on action. Keaton's deadpan worked not because the Great Stone Face was passive but the opposite: he was intent, poised to act. The focus on action transformed Fellini's *Clowns* for me. The first time I saw it, I'd regarded it as a documentary-like elegy by a highbrow European director on the melancholy death of clowning. But my collegiate sophistication missed the point: It's a comedy. Ostensibly searching for old clowns, Fellini and his crew do clown routines. They struggle in and out of a tiny car, drop equipment, and bump into each other. A guy with a big nose drinks and is bossed around by his mother, who looks like a clown in drag. The chaos in the film's concluding funeral isn't sad, it's an eruption of spirit. The joke was on me.

Mike—the rainbow-suspenders juggler from the first day—brought up Groucho's walk as an example of action. He was right. Still, when he declared that he liked comedy that was deep and his gang gushed, I thought that the only thing deep was his pile of... self-promotion.

Stay positive, I reminded myself.

* * * * * * * * * * *

As the sun traced a lower arc each day, it blazed more in the back door and around the bandstand, creating a glare that rendered Bill virtually invisible, a disembodied voice of circusiana. Beyond tidbits of info, he tried

to calm the rising tension. Urging us to be kind to each other, he altered Khalil Gibran. Instead of "Work is love made visible," Bill said, "Work *should be* love made visible."

Clown College was an ambitious experiment, mingling a motley lot. Superior tumblers flipped past bumblers, with a few of us literally falling somewhere between; I managed to jump off a mini-tramp onto a crash pad without major damage to myself or the pad. The dance teachers, dubbed Laverne & Shirley, had to blend accomplished dancers like Dale from Manhattan with kids who could barely move to music. Some thought mime was sissy, while those who'd had acting or mime classes adored the teacher's musings about art. Meanwhile, in a category of one, Pancho of the Baggy Tights, a street mime from Paris via San Francisco, waxed rhapsodic about his own artistry. I was figuring out that the skill classes couldn't create experts in two months, but introduced us to things a clown might use, with individual interest prodding extra practice. Just as I was learning corner turns on a unicycle, and new ways to fall. Adding to the complexity were the personalities. Like mine. Though friendly with everyone, I saw others forming deep bonds. Bruce and I were buddies but couldn't work together. My early lean to Terry had tilted. Even the guys I worked with, Glenn, Dean, Richard, hadn't become close. Did my law-school secret keep me from the general camaraderie? Even as I wondered if the real education was sharing this experience with others, I retained old habits as a student, focusing more on classes than sociability.

As Bill mixed all of us, not to mention two dozen teachers, he seemed mixed himself. He let the teachers set their own agendas, then got frustrated at the jumble. When the Robert Altman film *Brewster McCloud* prompted younger ones to pronounce it weird, Bill made it a controversy by assigning it to our weekly film discussion and then having us all write essays, which he said he'd send to Altman. He clearly wanted Phyllis to teach us about actual circus clowns but beamed when she raised the tone with comic theories and historical themes. While all clowns were whiteface when circus started in the late 1700s, she said, the Auguste's appearance in the 1800s symbolized the rising middle class, and tramp clowns emerged from the Industrial Revolution, an echo of the homeless created by unemployment. Some complained that history class was just like school, which was why I enjoyed it. Phyllis did get the attention of the guys in the back when she told us that a king in the Middle Ages used clowns for foreplay with his queen. Now *that's* comedy warm-up. Bill hinted he'd been a free spirit in the days of beatniks, thumbing his nose at authority. Maybe he chafed at being an authority figure now. Still, he kept course, navigating between our hopes and fears, teachers' intentions and egos, his aspirations, and the Felds' mysterious expectations.

Another movie sparked an insurrection. Guys joked that *Naked Night*, Ingmar Bergman's film about a traveling circus, barely showed anyone naked. Then when we got back to the Villas, people didn't scatter to party or watch TV but stuck around to complain. The jugglers griped about Bill firing the juggling instructors. Officially it was because the pair, a hippie duo that paraded in Speedos at the pool, hadn't been preparing a graduation presentation, but Bill couldn't have been happy that they spent class focusing on the expert jugglers and the cute girls, ignoring the rest of us. The grumbling veered to the kid who'd been sent home. Troubled, he'd been talking to a dead crab he dragged on a string. A teacher told me the kid's mother had filled out his application, hoping that Clown College would be therapy. Still, a few objected that he'd been sent away. Next someone protested that certain people were favored. She meant Terry. My ex-almost-girlfriend, who'd avoided this bitch session, was in more graduation routines than anyone else. Then Dean brought up that morning's kerfuffle, when he'd refused to do a samba mime train, saying it was like playing choo-choo. The routine *was* lame but I kept quiet. Bill submitted daily reports to the Felds, and somehow he'd find out about this meeting. They had a legitimate interest in learning people's temperaments but because we didn't know what Bill wrote, it left a vacuum for chatter. Somebody said they had our rooms bugged, which was ridiculous. Still, from then on, I saved private conversations with Bruce for the van.

The next morning Bill skipped Opening, and a cloud hung over the day.

The day after that, he said nothing directly about the griping, but implicitly responded in a string of quotations. Confucius says, "Order first your own state." Oscar Hammerstein: "Acknowledge your imperfections." Robert Oppenheimer: "Beware the terrors of fatigue." An African saying, "Don't insult the crocodile until you're across the river." Anonymous: "God answers all prayers but sometimes he says No." Then without another word, Bill turned and went back up to his office.

Clown College had seemed a bubble outside time, without jealousy or cynicism, free of competition. Though that was more wish than fact, ego had mostly stayed in check. Now with the graduation-performance-audition looming, it crept out. It didn't help that no one knew what the Felds wanted. The obvious answer would be that they wanted funny, but what kind? Not every comic impulse fit. Dry wit ignores physicality. Class clowns can make pals laugh but that look-at-me impulse doesn't necessarily sustain a gag. Skills were important too but all agreed that self-described klutz Richard, who couldn't juggle or do a forward roll, was a sure contract. Everyone assumed that the charming Terry was another. Both were nice, a factor Bill kept emphasizing, yet others just as nice would be going home. So what was the comic something the Felds sought?

In that vacuum, self-selection emerged. Repeating gags every day convinced some that they wouldn't like doing it as a job every day. It would be enough to return home with the memory of this special two months. Others pulled back, deciding they didn't fit the mysterious criteria. Dale may have pulled back. When Laverne & Shirley announced a "group movement" for graduation, I went straight to Bill's office on the next break, asking if I could create a two-person dance to Kabalevsky's "Comedians' Gallop." When he approved, I asked Dale to join me. I told her the musicals I'd choreographed and the ballet I danced, but that barely mattered to her. Like me, she simply wanted a real dance for graduation. Things went fine with our "Pas de Duh" until she missed an early rehearsal. During Bill's opening, she whispered that she'd overslept. When she missed again, Bruce suggested she may have been out late on a date but I'd never seen her flirting. It seemed likelier that she'd lost motivation.

It was tough being a female clown. In those days, just as some questioned whether women could really rock despite the evidence of Janis Joplin, others doubted that a woman could do physical comedy. Different standards didn't help: a male pants drop can be funny; a female dropping her pants seems sexual. But it was more than sexism, or at least a more subtle form. Feminism had revived interest in Isabella Andreini, the scholar and commedia dell'arte performer that Phyllis told us about, but the same feminism made women less likely to dig into rich comic veins like subservience and stupidity. Whatever the reason, the females in our class gravitated toward sweetness. The best were Terry's cute-rascal and the sweet-aunt approach of Dana, a young redhead from Tennessee, neither of which fit sophisticated Dale.

* * * * * * * * * * *

I fell in love. In Gags class, Richard and I tried Whipcracker, and it was love at first plight. Richard's 6'4" Lincolnesque elegance made him a perfect authority figure, as I, earnest Auguste, earnestly failed every command. I adored the beautiful simplicity: Richard, a few props—whip, match, blindfold, newspaper—and me as stooge. A stooge, or fool, for love.

Whipcracker had three primary parts, four if you count the blow-off. First came placement. We'd march in, Richard would indicate my spot, and he walked back to his spot, eight to ten feet away. Once he set me, I might turn away, slack-jawed, so he'd have to get my attention. Or I'd follow him to his place and he'd turn to have me in his face. Or I'd follow and walk past him when he turned so he couldn't see me behind him. That might be me trying to trick him or me being oblivious, depending on impulse; in any case, I'd be a dolt looking stupidly around.

Part two, the match. I'd have trouble lighting it. Or lit, the flame fright-
ened me, and Richard had to calm me. Or he'd take time to prepare while the
match burned toward my fingers. Then he'd snap the whip but, with the dis-
tance between us, not affect the flame at all. Panicked or perturbed, he'd blow,
signaling me to blow the flame out. Ta da! Facing the audience for applause
was a joke itself, teasing the circus acts that seek applause for every move.

The newspaper was next. Maybe he'd have to remind me to pull it from
my pocket. I might unfold it elaborately, the way Art Carney did small tasks
on *The Honeymooners*, exasperating Jackie Gleason. Or I could start reading
an article. Finally, with me wearing a chiffon scarf of a blindfold I could
obviously see through, Richard cracked the whip and I, lesson learned with
the match, would blow on the newspaper. I loved that stupidity. As I peeked
under the blindfold, Richard would mime a small tear, signaling me to rip
the paper. He cracked the whip again. I might make the same small tear,
leaving the newspaper intact, or I'd rip before he whipped. After the paper
rip came the blow-off, my arms going up for this Ta-Da! and my pants
falling down, with Richard, shocked, shocked at the outrage to decency,
chasing me out.

Bruce overheard Bill, say, "Good reactions. Perfect timing." That's how
it felt. Richard and I were like a grand rubber band, stretching, then snap-
ping together, always joined. But Bill's praise meant more than that. From
the day everyone arrived, some of the guys cracked each other up, mutu-
ally agreeing they were great, but it seemed more like guys partying than
something that would work with an audience. Still, I couldn't tell if that was
my performing experience speaking—it turned out I had spent more time
with audiences than most, maybe all, of my classmates—or envy of that
boisterous self-confidence. Or both. I'd made people laugh but was rarely
like these guys. So Bill's words suggested I was on the right track. Doing *My
Fair Lady* in college, my partner in the dances called me Crazy Legs. Maybe
Crazy Legs could play on a larger stage.

* * * * * * * * * * *

Classes gave way to projects and partners prepping for graduation, as grab-
bag days got baggier.

The Levitation Gag got repeated so often to fill gaps in the schedule
that it became a running joke.

Steve taught an optional nose-making class. Terry said makeup was his
real interest, that he'd attended Clown College originally to learn makeup
techniques.

A dozen of us worked on "charivari" for graduation. That's a running series of flips off the mini-trampoline and over a box like a gymnastics "horse" onto a crash pad.

Each of the clown-teachers off the road brought a different sensibility. Barry Lubin, who'd later leave Ringling to become "Grandma" on Big Apple Circus, was encouraging, and appealingly sardonic too.

Anne and Sally came from New York for costume classes. Beyond the basics, hand-sewing a button and running a sewing machine, they worked with anyone who wanted to make their own costume. Their specialty though was serenity. Every time I got on a sewing machine, wham, bam, the bobbin jammed, I Damned!—and one of our angels of the cloth shimmered into view, making the world right.

One day, Pancho declared that a pie in the face is not funny. I agreed. Though a thrown pie signals comic mayhem, it never seemed to me to generate spontaneous laughs. But Mike and his minions rose in pretend outrage at Pancho, creating a fun feud for a few days. It came up in most classes, until the final film discussion, when Mike smuggled in a pie and shoved it in Pancho's face. I had to admit it got spontaneous laughs, and Pancho smiled as he wiped off the shaving cream. (Preferable to whipped cream, which is sticky.) But he had little choice. Though comedy is regarded as a kind of antiauthoritarian weapon, it also reinforces the power of a crowd, making targets of outsiders like Pancho. That doesn't change just because insiders deem themselves antiauthoritarian outsiders. When the Great Pie Controversy seemed to have run its course, Phyllis brought it up in our last history class. I thought she was being a stereotypical scholar, killing a joke by analysis, but it was a set-up: she pied Mike. Now that's funny.

One bright day brought our elephant riding lesson, at Circus World, Ringling's theme park in Orlando. Following a performance, the regular customers filed out and we stayed, feeling special. Then Bill introduced "the great elephant trainer, Buckles Woodcock" and his elephants, including "the smartest elephant in the world," Anna May. Bill's habit of praising everything circus seemed silly; later I'd realize he wasn't trying to impress us, but to convey the privilege of entering this remarkable world. (Also, Buckles *was* great, and Anna May *was* brilliant.) As we stood in line, I slid back two places to make sure I got Anna May. The "lesson" was a simple walk around the ring but it thrilled me. The rest of the day in the park, I gorged like a kid at the circus, eating hot dogs, Cracker Jack, popcorn, ice cream, cotton candy, and more ice cream. I woke sick the next day. Who knew you could get a food hangover?

Watching *The Wizard of Oz*, I drifted off with the thought that I combined the Scarecrow's moves and Cowardly Lion's vibe. I skipped movie

Figure 1.2 A great day on Anna May. Author's collection.

night for a Jerry Ford–Jimmy Carter debate, and again to follow election returns, while practicing four balls. A baby will drop something one more time than you pick it up; learning to juggle reverses that process, picking up one more time than you drop. Thanks to that trick and the American political system, I learned a four-ball juggle.

Friday afternoon before our last week, Lou Jacobs performed again. Trying to do this work myself, I'd begun to see the craft in what he did. It was the old joke: The more I learned, the smarter he got. Now whatever he suggested, I tried. If he said a move was spaghetti, it was spaghetti. He wasn't stifling creativity, he was helping me be clear. That afternoon he sat down and pulled a saw out of a case, in specific, clean movements, with none of our fidgeting or shuffling. No spaghetti. Settling the handle between his legs, then arching the saw with one hand, he scraped a bow across its edge. Lou Jacobs playing "Silent Night" on a musical saw as the sun went down: it was beauty. Truth and beauty.

* * * * * * * * * * *

Our last Monday morning, a giant black curtain hung across the middle, floor to ceiling, with a circus ring laid in front of it. Two months gone. In pairs, groups, and alone, on both sides of the black curtain, in the back and the seats, we sped toward graduation.

A tempest flared when Bill expelled a girl because she'd admitted she wouldn't take a contract, if offered, preferring her boyfriend back home. Some were mad that Bill wouldn't let her stay the last few days—and others that Terry got her spot in a gag—but we returned to work. Knowing about nerves before a play opens, I tried to set a tranquil example, especially as gags got cut. When I lost Paper & Chair with Glenn, and Dean quit our Mirror routine for another gag, I didn't complain. The show was long, and some gags had to go. It helped that I had plenty to do. I'd be one of six announcers starting the show; one of six stilt-walkers; one of the dozen tumblers in charivari; one of ten unicyclists; and half of the band's trumpet section. I had a dance with Dale, which I got to choreograph. I was in Billy's big group gag, a Robot Restaurant. Though the gag was a mess, Billy remained a class favorite. Whenever anyone blundered, he said "Good gag" in an ironic way—a habit others picked up, though none of us ever said it about an actual gag. Most important, Richard and I had Whipcracker.

Then Whipcracker got cut.

I wanted to clown. That seems obvious but it ran deeper than I expected. There's something essential about two clowns alone, riffing off each other. Like a cartoon character running off a cliff, I had stayed in the air as long as I didn't look down. Now, looking down, I fell into my anger.

When I retreated to the seats to sew, Sally stopped to ask how my tie was coming. She wasn't really concerned about the purple polka dots I was sewing to the green fabric, she was trying to comfort me. But I mumbled and ducked into my sewing. For weeks, I thought maturity raised me above the swirling drama but that was baloney. It's easy to be poised when you get what you want. If anything, I had it easier than the rest. Assuming I'd be off to practice law, I felt none of the pressure the others did. Now, if I talked to Sally about losing a gag despite having so much else, I might seem petty. Or I *was* petty, and talking would reveal it. I couldn't even go to the beach that night because the red tide kept us away. So no praying or complaining to the stars or whatever it was I'd been doing down there.

The next morning I asked Bill to reconsider. He pointed out that the show was still too long and, nearly winking, said I had a "really good chance" for a contract. Once, that implied promise would have thrilled me. What I couldn't say is that I'd probably go practice law, so Whipcracker would be the closest I'd ever get to being a clown.

Back in the bleachers, sewing and brooding, I felt like Madame Defarge in *Tale of Two Cities*. The black curtain suited my mood.

After lunch Bill summoned me to his office. I expected a lecture about staying positive. The acting teacher was there, playing records to be used in the show. Playful and irreverent, he had proved great at organizing too. In addition to the band, he'd created a funny number, all of us barking and howling the "Hallelujah Chorus." Now Bill told him about my trip from the Army. He even remembered my laundry-bag luggage. Then he asked if I thought the music playing would work for Whipcracker.

Whipcracker was back!

How could I be a professional if disappointment shook me so badly? I pushed the question aside, and plunged back into the current. Stitching a pocket for my clown pants, I smiled benevolently on all these wonderful people. Bruce in his giant baby bonnet made me laugh. Cute Terry was a cute clown. Buzzy's $150 yak hair wig had arrived. I'd been reluctant to pay for one, so I'd be using a concoction from the optional wig-making class, orange fake-fur wig sewn into a green polka-dot cap, but the difference was palpable: a professional wig made Buzzy look professional. I watched Dale pull a pelican on wheels. It was pink. Maybe she was going girly, hoping for a contract after all.

Time came for the class photo. One of the last to finish my makeup, as usual, I pulled on the costume I'd sewn, eight-color striped pants and a green tie with a dog-toy squeaker tucked into one of the purple polka dots. Adding the clown nose I'd made and tugging on my "wig," I walked through the curtain to an explosion of color. The profusion of stripes and spots and colors was tacky but that didn't matter: the extravagance matched the extravagance we'd shared.

Dress rehearsal Friday was predictably ragged, because it was also our first rehearsal. Afterwards we spread around the ring, sitting, standing, leaning against each other as we waited for Bill. I lay on the floor, eyes closed, as Ned, the unicycle guy from the first day, said "Mixing metaphors makes my blood stand on end." My splendiferous roomie Brucie shot back, "That's the way the cookie bounces."

* * * * * * * * * * *

If Clown College had not proved to be a slice of paradise, the graduation performance was. Whipcracker flowed like a dream, as if Richard and I were old pros. I'll never forget Dale's face gleaming and elbows flapping as we ran toward each other on the first notes of "Comedian's Gallop." Backstage, I helped Buzzy tug his wig straight. Bruce did a terrific job, big

gestures and all. Suddenly it was intermission, and I floated, barely feeling my body, eight weeks gone in an instant.

Dad had appeared out of the blue that morning. Graduations hadn't been a big deal in our family. No one attended my older sister Jan's graduation or mine from Michigan, including anti-establishment me, and when I finished Berkeley Law, only my younger sister Suzie and I were there. Yet Dad came for this. After we talked on the beach, under high puffs of clouds that made the sky look bigger, I headed to the arena to paint my temporary clown shoes, slip-on sneakers with a ball of foam rubber glued over each toe. Back in my room, I watched the University of Michigan-Ohio State football game. Michigan won, 22–0. It was a good day.

In the second act, the clown band marched in to "When the Saints Go Marching In," played our songs, and marched out. Then the barking "Hallelujah Chorus" and applause and it was over and we were hugging and sharing deep looks. When we gathered in the ring, Mister Irvin Feld said a few words I was too excited to hear. Families clustered in congratulations, then got sent to their motels. Time to party.

First though I stopped in Dad's room. Trying to convey everything about this amazing experience, I told him about Bruce and his hopes, about the superb teachers, that "charivari" is from chivalry, related to "shivaree," a folk custom of raising a ruckus to embarrass newlyweds on their wedding night. It turns out he and Mom had been shivareed after their wedding, their friends banging pots and wheeling the shy pair in a wheelbarrow. Then I got to what was really on my mind. For eight years, and now eight weeks, I'd teased myself about whether I should do this. Trying to make a reasonable decision, I felt that "reasonable" implied the answer. So, I said, I probably shouldn't take a contract.

"Why not?" That stunned me. I'd never talked to my folks about joining the circus, figuring they'd be dubious. But Dad said that I'd paid my own way through school, so I could do what I wanted. He even seemed to like the idea.

As I left for the sprawling parties, I ran into Georgia Jerry's gang, and we joked for a while. Then I found Richard, sitting outside his room with Dean and Phyllis. My classmates were all wonderful, and so were all the teachers. Around midnight I told Sally she was beautiful. Was I drunk? Yes. Was it true? Yes.

As pink glowed in the east, my rambles took me to the beach. I still had to figure out what I wanted. Billy had once said, "If you don't take a contract, you'll never know. But if you take it, no matter what happens, it will live with you the rest of your life." He wasn't much older than me: how could he know about the rest of any of our lives?

A knock on the door jolted Bruce and me awake. It wasn't contracts yet, just Dad dropping off the Sunday paper, but people were already gathering in the courtyards. When Bruce joined them, I stayed to read the sports pages. If I went out, I'd cry, kiss all the girls, hug all the boys, telling everyone I loved them forever. I should have.

The buzz grew. As I stepped outside, a van drove away, taking the first handful to Irvin Feld at the arena for contracts. Bill got the thankless job of telling those who would not get a contract. That made a curious dance, people leaning toward the van on its return, like plants toward the sun, while turning from Bill, as if being hard to find would alter reality. The morning was a strange mix of joy and sadness, with both sides of that divide sharing others' emotion. I consoled Dale; she had wanted it after all. Mario was homey so I thought he'd prefer to amuse friends and family, but he'd wanted a contract too. One guy had gambled on a tramp makeup, despite word that the Felds didn't want tramp clowns; now he planned to look for clown work on his own. Mike wouldn't be on the circus. Predictably, he boasted of rebelling against corporate Ringling. Predictably, that irked me. Still, the show was losing a good one.

Then Bruce was crying in our room. As I stumbled to find something to say, Dad interrupted with a knock on the screen: they were looking for me. While I was gone, Bruce packed and drove away, leaving a note. "Well, you were right. I didn't die. Thought I would for a moment or two tho. Best of luck, and may all your days be circus days." Back at you, Bruce.

I rode over with Dean, Buzzy, Hollywood, and Lenny. Buzzy's excitement could have lit a small city, and little Lenny, just out of high school, was talking like a big shot who knew all about show biz. As we waited under the palm tree from my long-ago weekend pass, Dean had a running tally, like a political junky calculating precinct totals. Six would be on the Red Unit, and Feld had moved on to Blue contracts, more than six. I hoped Dean was wrong that they were finished with Red. If I said yes, I wanted to be on Red because I knew more people who lived on that route. Richard, Jeff, and Ned would be on Blue. So would Dana, the young redhead. In a surprise, Billy was returning to Ringling, a clown on Blue.

A bigger surprise nearly upstaged Contract Day drama. Terry and Steve were getting married. I *knew* it had been more than dinner. He was going to switch from the Red Show, to be on Blue with her. Only a couple years out of high school, he would be boss clown.

This process wasn't perfect. Were all five of us under that tree better than Bruce or Glenn or Dale? No. Skills apparently helped. Except for Richard and Terry, nearly all of us who got contracts flipped, juggled,

or played an instrument. Did it count that, though not best at anything, I was better than average at most things? None of us knew exactly what mattered. Still, maybe it had to be this way. Despite the hippie notion that anyone can be a clown, distinctions must be made. How can some clowns be judged good unless some are bad, even when the distinctions are imperfect?

Of course that was easy for me to say, waiting for my turn.

My turn. I walked up the bleacher steps, not going left to Bill's office, as I did on that long ago weekend pass, but right, to the office of Irvin Feld, a short bald man with glasses, who greeted me cordially.

It still rattles me to think that up to the moment I signed my contract, I might have turned it down, a dramatic gesture that would have kept me from something that would change my life. I still didn't say anything about law school. I wanted people on the circus to get to know me without any lawyer stereotype, but I also worried that if Mr. Feld found out, he would pick up my contract from the table and kick me out.

I later recognized that my Hamlet-like hesitation was about more than following the straight-&-narrow. Behind questions about being a lawyer lay doubt, bone-deep doubt. Did I have that alchemist's blend of talent, discipline, and spirit to be a circus clown?

Chapter 2 Bowl of Cherries ❦

January 1977: Rehearsals, Ringling Arena, Venice, FL

We will meet; and there we may rehearse most obscenely and courageously.

William Shakespeare, *A Midsummer Night's Dream*, 1.2 (Bottom)

"You a clown?"

The guy startled me, mid-gawk. The arena was transformed. What had been bare cement and echoing rafters for Clown College had turned into the frame of a circus for three weeks of rehearsals. Three rings spread across sea-green rubber mats, cables snaked between large blue boxes on wheels, and ropes webbed the air. A small, jeep-like vehicle called a Clark was pulling one of the boxes. The guy, short and bald, with a cockeye, repeated, "You a clown?"

I told him I'd "joined out," figuring if I used circus lingo, he'd welcome me, maybe offer congratulations.

"Truck's out back. Take ya to the train."

I paused to soak it —

"Comin'?"

I hurried after him, tossing my bags in his pick-up. As we pulled away, I told him my name.

"Camel John," he replied.

Do you work with camels?

"Horses now."

When I asked how long he'd been with the circus, he mumbled something that could have been "Leap off a high and distant cliff, you odious newcomer." In the old days, veterans wouldn't talk to a First-of-May for a few seasons, till he proved he was "with it and for it." Bill Ballantine told us that things had gotten better for rookies but Camel John didn't seem to

know that. Turning off the road, we rattled over tracks and turned between two lines of train cars, in the middle of a paint job from last season's dirty white to silver, with "Ringling Brothers and Barnum & Bailey Circus" on a red scroll along the bottom. We bumped through baby-poop colored puddles, and pulled up to a vestibule. Blue numbers said it was car 140.

Camel John was up the steps. I grabbed my bags and tripped on the first high step. I stumbled again pushing the heavy door into the corridor.

"The donniker." He opened a door to show the toilet. More doors stood on each side of the narrow hall, three each side, one low, one up a couple steps, and another low one, before the wall jogged to the right to the staterooms in the middle. Camel John opened the high door on the right, nodding it was mine. I thanked him as he left, and he turned back at the hall door.

"This ain't no bowl o' cherries."

I stepped up and noticed that the sliding door tilted. This 4' x 6' room was littered with McDonald's bags, an empty whiskey bottle, and something gray I hoped was a rag. My sneaker stuck on a patch of dried Coke. Every surface was stained, including the ceiling. I flicked the light switch. No bulb. The tiny fan up in a corner didn't work. The sink, designed to swing up into the wall, was stuck open. Shoving the door closed, I saw it tilted because it was missing one of two overhead rollers. A cockroach crawled away, sauntering more than scurrying, as if it knew it would outlast humans and was starting here.

I loved it. I was going to live on a circus train, and every gritty bit, including crusty Camel John, added to the romance.

As I cleaned my miniature Stygian stable, it seemed empty, which puzzled me. How could such a small—and cluttered—space feel empty? Then I realized it had no seat. Once upon a time a roomette like this was deluxe travel, with a cushioned seat its plush glory, but that had been tossed in some misguided remodeling. Behind the gap that should have been a seat was a Murphy bed, which I couldn't pull all the way down because the sink was in the way. Shoving the bed up again, I wrestled to close the sink till an eye appeared in the gap along the edge of the door.

"Hey, clown."

I tugged the door open to a kid, about 12, with close-cropped black hair above an open brown face.

"I'm Jerome. With King Charles. Hi. Bye." Laughing, he danced down the hall and slammed out the door.

The King Charles Troupe was an act of guys from the Bronx who played basketball on unicycles. Dean gave me the scoop when I saw him, somehow,

through my scummy window and joined him outside. This was the Troupe's car. They took the staterooms in the middle and most of the roomettes on either end, while First-of-May clowns filled the rest. The Troupe partied hard, Dean said, so second-year clowns moved out, leaving a few scattered rooms to rookies. He said that this train was like the one when he traveled in Kiev with his folk dance troupe. He repeated the same thing a minute later, either trying to impress me or reassure himself. His hands shook as he talked. I thought I was nervous but Dean was a basket case. I figured he'd quit by tomorrow.

When Flip arrived and heard all about the Kiev train, twice again, and the noisy Troupe, he left and returned minutes later asking us to help him move. Though everybody wanted a single, he had traded his room on 140 to share a double on 149. Car 149 was the car where most of the clowns lived. It was "the clown car"—not the same as "Clown Car," the routine with clowns crammed in a car. Flip kept saying that he switched so he could learn magic from Ned, his new roommate, but on our way back, Dean suggested that the Southern white guy didn't want to live with black guys. Later, complaining about the noise, Dean traded cars himself. Just as I started to feel stuck on 140, Richard showed up, content with his room. Then Buzzy moved in, happy for a single. Buzzy's face, grooved like a basset hound's and anchored by a long nose, looked dignified or funny, depending on the light. We didn't have much in common, other than military service, but I liked him.

The first night confirmed the King Charles reputation. As I pulled down my bed, revelry erupted up and down the car, with disco thudding against the wall at my head. I wished I'd traded too.

The next night I fell asleep to silence, deciding the noise had been an aberration. Then the vestibule door slammed me awake, and suddenly it was like New Year's Eve in the corridor. Boasts and insults about fishing banged through the car. Fishing at 2 am? Jamming my head under the pillow, I dozed, waking again to the smell of frying fish. Okay, I counseled myself, you're a professional now, and performers keep late hours. Instead of counting sheep (or fish), I chanted, performers party, performers party...The first morning of rehearsal, Richard and I walked from the train, across the bridge over the Intercoastal Waterway, and through a hole in the back fence.

The Clown College students, mostly, young, white, and English-speaking, had been replaced by a hundred people of different ages, races, and nationalities, Poles, Bulgarians, Hungarians, Germans, Mexicans, and Cubans, all gathered around the ring by the bandstand. Richard and I squeezed onto the ring curb next to Dean, who was talking to someone in

German. He not only wasn't quitting, he already seemed to know half the people and most of the gossip. His encyclopedic knowledge of circus acts, trivial in Clown College, now loomed larger. Other First-of-Mays seemed different too, the flamboyant one wilder, the shy one shyer, as if Clown College camaraderie had muffled the extremes of our personalities. Only tall Richard seemed the same, convivial but with a dash of sarcasm that kept the sweetness from curdling.

Charly Baumann stepped up, and noise stopped. A legendary tiger trainer, and the performance director, in charge of everything that happened on the Blue Unit, Charly supposedly had thrown a clown against the wall last season. Barrel-chested, with dark slicked-back hair on a large head, he certainly looked like a Teutonic tyrant, and his German-accented welcome sounded like a command. (You vill be velcome!) He introduced our boss, Irvin Feld, who said a few words. Then came Richard Barstow. With a hawk-like face and white hair, the show's longtime director could have been a grizzled prospector in a Western, except for his stylish loafers and the scarf draping his neck.

This short rehearsal period, preparing for the second half of the two-year tour of the 106th edition, was mostly aimed at adding new showgirls and clowns to the four production numbers. We'd be in the same glitter costumes for Opening and Finale, with similar parading. Spec was the spectacle that ended the first act. Menage featured elephants, with a showgirl and a few clowns on elephants in each ring, while the other showgirls and clowns danced on the track around the rings. Circus pronounced it "MAN-age" but I guessed that it started as the French "ménage," for a mixed act or—like the flamboyant First-of-May bragging about sex with a showgirl and act man—a ménage-a-trois. Barstow and his assistants peered at us over clipboards, deciding who would ride. Eager to get back on an elephant since the kick of riding Anna May in Clown College, I tried looking interested but not desperate.

They picked me! Did they sense special sensitivity with animals? My quasi-athletic agility? Charisma? Nope. I fit the costume of a fired clown.

Outside with the other riders, I was directed to a guy with a dirty brown mop of hair and a beard like a Brillo pad, in a t-shirt, brown or dirty. "I'm Bigfoot. You take Leutze. That big one."

Her name was actually Lucy but Bigfoot said the name with a fond elaboration that turned it into "Leutze" in my ear. Lyoot-zee. By the time I learned my mistake, I'd bonded with her as Leutze, and that's what she was to me, then and always.

"Get on her left side," said Bigfoot, shifting the toothpick in his mouth. "Grab the harness, there, behind her ear"—her shoulder was higher than

my head—"then when she holds her leg up, put your left foot on it... Your other left," he added drily. "When she lifts, swing your *right* leg over her neck."

I gripped the harness and placed my left foot on her leg.

"Up!"

Wow. Anna May had lifted carefully but Lucy/Leutze flung me. It felt like flying.

"Don't screw around up there." Elephant men didn't like us riding. Devoted to their charges, they want to display the animal ability and human skill in a well-trained elephant. After years of patience and positive training, they didn't want a clown diminishing the great gray dignity. I sympathized but didn't care. I got to ride an elephant! They also put me on Roma in Spec. I got to ride two elephants!!

"Halfway through, after we circle 'em, Leutze will get down and roll to her side. That's when you jump off. Be quick. I don't want her landing on you. And stay outta my way. I'll be rolling an elephant tub into place, and it's too heavy to stop. Then get right back on."

The handlers walked us through the routine slowly, a second time faster. That was for the riders. The bulls already knew it. Circus elephants are called bulls, though nearly all are female. Then we waited in the sun to go into the arena. That they are big is obvious but on top of Leutze, maybe second biggest in the herd, it was magnificently true. Releasing the harness and moving my hands to my thighs, I surveyed the world from this mobile mountain. No, not a mountain. These amazing creatures aren't stone. Elephant is animal. Leutze's skin was rough but pliable, with creases and folds and spikes of black hair—

She jerked, and I jammed my hand under the harness to keep from falling, but she wasn't going anywhere, just reaching her trunk for a cigarette butt. Elephants will check out anything that might be food. I snuck my hand to my jeans to wipe the blood off my knuckles, but Bigfoot saw.

"Don't worry if you fall. The bottom of an elephant's foot is tender, so she won't step on you." He paused, grinning for the first time. "Probably."

Leutze's trunk swept the ground like a curious vacuum cleaner, trying to search the ground without getting enough out of line to be noticed. It's hard for an elephant to be inconspicuous. When she shook her head, I stayed upright by shifting my weight. Unimpressed, Bigfoot rolled the toothpick to the other side of his mouth.

"Hang on. We're runnin' 'em in."

* * * * * * * * * *

When I'd returned home after signing my contract, the mail brought a notice that I'd passed the California Bar. So the same week, I became a circus clown and a lawyer. With no time then to be sworn in, I stopped on the drive south, at the courthouse in the old circus town of Sarasota, and found a judge in the hall. He scanned my paperwork with the stub of a cigar. "It says here you can be sworn in at a court of record at the place where you are." He looked around in an exaggerated way—cool: physical comedy—and said, "I guess this is where you are." Warning that smoking was a filthy habit, he swore me in.

Mornings, acts practiced in the rings, on the track, and in the rigging, before the clowns and showgirls arrived at nine to work on production numbers. During our lunch, the acts returned to the arena in a complicated schedule of sharing the space. After we finished in the afternoon, with the showgirls taking off and clowns working in the back, the acts took turns into the night. Considering the King Charles partying, it didn't surprise me that the Troupe had the last slot, around midnight.

Rehearsals felt familiar. It was like musicals, only with elephants. And easier steps. Some of the clowns only shuffled through the dancing, or goofed around. Smitty, who'd done these dances in 500 shows last season, acted as if they were new and guffawed at every gangly mistake. When Barstow stopped us to lecture about focus, Smitty sucked up to him by making a joke of sucking up. "You just tell us what to do, Mr. Barstow, and we'll keep doing it, until furthest notice."

"Mr. Smith," replied Barstow with a flourish of his hand, "there is such a thing as taste. There is also such a thing as lack of taste—and you have it." Smitty, unabashed or not getting the gibe, laughed along.

Barstow was Broadway royalty, having directed Judy at the Palace. I knew enough about Broadway to recognize the show-biz shorthand for Judy Garland in her legendary shows at New York's Palace Theater. His assistant, the jolly-faced Bill Bradley—not the NY Knick/NJ senator—had his own Broadway claim to fame. In a chorus—a "gypsy"—in 1950, he'd decorated his tatty robe and made a joke of presenting it to a chorus member in another show on opening night; now the Gypsy Robe is an opening-night tradition on Broadway, with new decorations added each new show. The info was catnip to me. The first thing on my train room wall, covering a stain, was the *Newsweek* cover of *A Chorus Line*, featuring Donna McKechnie. Loving Broadway and dancing, I suppose I embodied the knock on Ringling clowns, that we were only chorus boys, prancing accompaniment to the glitz-&-tits. I even did the showgirls' hitch-kick: there's nothing like a good hitch-kick. Still, I understood the sneer. In that free-spirit era, large-scale choreography

could seem dull and regimented, unrelated to clowning. That's how Ringling had seemed to me when I saw it in college. Of course this hippie attitude about dancing bordered on homophobia, with those who sneered at Ringling sequins the same ones who, ironically, saw themselves digging deeper than appearance. Dancing is simply another skill but many clowns treat it as sissy stuff. On the other hand, one of our gay clowns did his best to reinforce the stereotype. One day I spun past him.

"Save it," he chirped.

I'm having fun.

"Spare me. You're showing off." Talk about the pot calling the kettle pink: he kicked higher than the showgirls.

I'm just dancing.

"*Please. I* am a dancer."

Yeah? I was doing musicals before you were a twinkle in your own eye.

"Ooh, listen to *her*. You sound curious about twinkling." More flamboyant than he'd been in Clown College, he was pretending to flirt with me. Or not pretending. Swinging his arm in an arc, he snapped his finger at me. "*Are* you curious?"

You wish.

"You didn't say No, sweetie."

No, I retorted in a deep voice.

"So *butch*! You must be in denial."

If I were, I'd find someone cuter than you.

"Maaaa-ry, I'm better than anything you'd get on your own."

Though I'd known homosexuals, in theater and out, naïvely I hadn't considered it in circus. Now I saw the makeup and sequined clothes in a new light, along with the muscled acrobats to admire, and the opportunity to be *fabulous*. More important was tolerance. On circus, do your work and you fit. Yet even as I congratulated myself for being worldly, I missed the signals when a PR guy took me to dinner to thank me for doing a TV gig and, over dessert, invited me to his room "to continue the conversation."

* * * * * * * * * *

"The Eagle shits!"

Which was more surprising, that I knew it meant payday or that Prince Paul, who yelled, was running?

The Prince was an old dwarf clown. I would learn he preferred "dwarf" to "little person," probably because he didn't see himself as little. Barely moving, he sat in the stands on breaks, nodding Hello, like any old guy

watching the world from his porch. With a face that could have been a model for the Easter Island heads, age furrowed his square forehead and framed his mouth in parentheses, echoing the curve of his stumpy legs. A second-year clown had talked about Prince Paul being senile but he was sharp enough to get to the pay table first. Right behind him, I got $132, in cash because checks were a hassle on the road. Once full deductions started for taxes and union dues (AGVA, the American Guild of Variety Artists), it would droop under $100. Some grumbled that the showgirls got more money for less work, only the four production numbers. Officially that was because of their dance training but I could do all their steps, and another clown could kick higher. Regardless, having eked my way through college and law school, I was happy to have dough in my pocket.

Counting his cash, Prince Paul looked up at me. "Hey, kid, save your money. It might be worth something some day."

That was about the only advice I got in rehearsals. I had expected this to be comedy grad school, with advice and encouragement, but it was sink-or-swim, from the Felds down. Steve, our boss clown, mostly set schedules. The Red show boss clown Frosty apparently ran a tight ship, including guidance, but Steve was young, and a rookie boss. Then we only had two pre-Clown College veterans, Prince Paul, who did little but spout old vaude-ville lines ("Be true to your teeth, or they'll be false to you"), and Mark Anthony, usually off by himself in the prop shop. They were old guys, maybe not interested in First-of-Mays, but the younger veterans, ten from earlier Clown College classes, didn't offer feedback either. Though I thought of them as older, most were younger than me, and half only in their second year. One second-year, called "Mama" because he fussed like a mother hen, specialized in the obvious. Once, as we were about to repeat Opening, he announced "Don't start till the music starts." Another gem: "Don't stand where the horses are running."

Maybe veterans avoided advice because half the clowns were First-of-Mays. Not only did that make us a major presence, two Clown College routines transferred intact, so the veterans were in effect following our lead there. Charivari, the acrobatic flips from a mini-trampoline to a crash pad, added a few jumpers, while the others clustered around the ring to make the routine seem bigger. Meanwhile the Clown College band added a trumpet and tuba to become Clown Band, with the same repertoire, "When the Saints Go Marching In," "McNamara's Band," "Blue Danube Waltz," and "Won't You Come Home, Bill Bailey." The other big group number was Clown Car, with half the clowns squeezed into the car, and the rest of us running into the ring to enhance the cumulative effect. I wasn't in the car

because I was one of the tallest, 6', so instead I ran around the track ahead of the car in a white coverall with "TV Repair" on the back—the routine's theme was television—and carrying a five-foot wooden prop wrench painted yellow.

Clown Band came near the end of Come-in, the clown preshow. Come-in started with a three-trumpet fanfare—or two trumpets and my trumpet-like noise. Next, clown gags spread around the track, two on either side of Ring Three, near the back curtain, another pair of gags flanking Ring Two, and a larger gag in Ring One at the end. After three minutes, more gags rotated in. Whipcracker was slated in the first slot by Ring Two, front track, center. Ring Two used to be called center ring but the Felds had declared democracy of the rings, officially because all their acts were stellar, while whispers said that acts playing Ring Two could be paid less than "center ring" acts.

I lost Whipcracker again. Steve shifted Richard to his wife's statue gag. This was worse than losing it in Clown College because the loss would last the season. How could I be a clown without a gag? Terry clearly felt guilty because she came around with the baby-talk that had once charmed me. I felt justified rebuffing her but secretly worried that I had so little inner strength. Goethe wrote, "Know thyself? If I knew myself, I'd run away." I'd already run away to join the circus, so where did that leave me? Then Steve offered to do Whipcracker with me. If Terry couldn't charm me, she could charm her new husband. But Charly vetoed that. He wanted Steve concentrating on his job as boss clown—while doing his Pizza Gag with Terry. The next day Steve assigned Dean to Whipcracker. Though Dean and I had worked okay together in Clown College, I didn't see how his little-kid character, with that stiff-legged waddle and a toddler's splayed fingers, could be an authority figure commanding my character. Still, I had Whipcracker back.

* * * * * * * * * *

I woke with a strange feeling. It was the silence. Camel John had warned that fluctuations in the train's generator could affect the electricity but I'd assumed that meant lights might flicker, not that the power would go off, stopping my electric alarm clock. I pulled on my pants climbing down into the empty hall, shouldered my way out the vestibule door, and tugged on my shirt as I jumped down the steps. Charly was going to kill me. I shot over the bridge and scrambled to the arena, running in, out of breath —

"Cloun!"

Was a German accent to be the last thing I heard in this life?

"Get en place!" Charly barked. "Un don be late again!" That's all? Don't be late? Maybe Charly didn't eat clowns for breakfast after all.

Just as the clowns were less bonded than I anticipated, my fantasy of befriending people from around the world faltered too. Most groups hung by themselves. When I offered to help guys—act men? stars? ring workers?—toting bags from the grocery, all I got was the verbal shrug, "No-spik-English." I barely saw my King Charles neighbors at the train, only heard their noise as I fell asleep. One Sunday I followed the sound of a football game on TV to the double stateroom in the middle. I was trying to think of something to say, when lanky Smitty blew in and began blatting about how he, Scandinavian pale, was almost black himself. They didn't seem to mind, probably because he was a goof, innocently amiable.

Romance wasn't in the cards either. It was tough getting to a showgirl through the crowds of act men, animal workers, band members, PR guys, corporate suits down from Washington, King Charles guys, and other clowns around each woman. More showgirls might have helped: the Red Unit had web, the act with showgirls spinning on suspended ropes, so they had twice as many showgirls as our 14. A second-year clown said not to worry, the showgirls were "all looking for a good time, just wait your turn," but between his bottle-thick glasses and habitual sneer, that sounded like the fantasy of someone who never got a turn. On a break I did find a gal by herself, until Flip did a back flip and squeezed between us. Another day someone said Margie liked me. My first thought was, Are we in middle school? and my second was, Which one is Margie? I seemed to be making progress till I invited her to my room.

"I'm not that kind of girl!" I didn't know anyone really said that.

The showgirls surprised me. Instead of the stereotype of tall, blonde and buxom, they looked like a random mix that could have been found at any mall or campus. Returning from the grocery store, I caught up with our one Tall & Blonde. As we walked over the bridge, and a fish jumped picturesquely in the water, I asked about meeting people, hoping she'd catch my hint that "people" meant her, and that "meeting" meant more than a handshake. She not only caught the hint, she smashed it back like a tennis pro returning a lob.

"Oh, it's easy to meet people on the show."

Sure, if you're tall, blonde, etc. Soon she was girlfriend of short, dark and handsome Tito Gaona, our trapeze star, who flew through the air with the greatest of ease and all the girls he did please.

My hopes glimmered when I stuck with Dolly, our only veteran woman clown, on a group trip to watch Ringling's Red Unit in St. Petersburg. The Red show had rehearsed through December, and now was on tour in the

first year of the 107th edition. Backstage in St. Pete was a mini Clown College reunion. Peggy Williams spread her usual warmth, and I talked to Barry Lubin. I was proud that Lou Jacobs remembered me.

Lou's Hunting Gag with Knucklehead looked different, as I saw details I'd missed in Clown College. Lou's tall hunting hat, echoing Elmer Fudd's, emphasized his height, a comic contrast to his tiny dog in rabbit ears sitting up, front paws in the air, looking up at him. Lou scanned the horizon, oblivious to the obvious dog at his feet. Then, extravagantly surprised spotting his prey, he slowly knelt in Kabuki-like intensity, while Knucklehead stayed steady in his earnest Chihuahua way. When Lou took aim and "shot," the dog lay down so carefully that it was funny itself. Lou put Knucklehead in a bag, which had a hole in the bottom to run out. Frosty had said Ringling's big arenas required big gestures. Lou used small gestures too. Maybe clarity mattered more than size. A clown Picasso, Lou had honed his craft to precise strokes.

Watching Gunther Gebel-Williams with his wild animals, Dolly and I were joined by Dean, who said Gunther was great but circus insiders considered Charly's Bengal tiger act on our show a classic. Already loyal to Blue, I agreed. (If Blue and Red combined, would they be purple, thus the Grapest Show On Earth?)

After spending so much time with Dolly, I envisioned us together. But the next day in Venice, when told to fetch me, she asked which First-of-May I was.

* * * * * * * * * *

Snow was ridiculous. The local paper agreed, putting that news on the front page. It was the first newspaper I'd seen since arriving. Would the bubble of this life keep me from news? I'd already missed Jimmy Carter's inauguration.

With an unheated arena, showgirls and clowns were released early. The showgirls hurried back to the warmth of the trains, and acts divvied up the arena, while clowns worked in the back. I helped Steve arrange props in one of the large blue boxes for the tour. (Boxes on the Red show were painted red.) Then on the train in "the drape of the day"—I was reading Walt Whitman—I left my door open. Jerome reached in to snatch a few of the cookies my mom had sent. Key Wash, following Jerome, smacked his hand.

"Don't grab."

It's okay, I said.

"He has to ask. Jerome?"

"May I please have a cookie?"

I pretended to think about it.

"Oh, please, Mister Man." He put his hands together like prayer and batted his eyelashes in exaggeration. "Please, please, please?" Cute and charming, Jerome could have gotten away with a lot but the Troupe kept a collective eye on him. I think Key Wash—a toddler nephew's attempt to say "car wash"—took the lead. Short and stocky, Key Wash had a solidity emphasized by his sturdy head, which he shaved for performance. During their act, he wore a giant Afro wig and then pulled it off for a surprise pass of that instead of the ball. I was glad I hadn't switched off the King Charles car. After a day with clowns, it felt calm, even when noisy. Rehearsals had turned the Troupe's hours regular, and when a racket did flare, I had no trouble sleeping. We also bonded over basketball. One break, they'd put their act's portable hoop near the bandstand for three-on-three, so I drifted over and called "Winners." I could see they were worried that I'd clown around, to coin a phrase. Smitty later did just that, barging into the game to patty-cake dribble the ball and push up a shot as if shoving a box on a shelf. But rules are rules: street ball says that calling Winners meant I got the next game. I chose Key Wash and Sly. Though no star, I passed the unspoken test: I could play. When Charly whistled the break done, our game ended on an inadvertent flourish, as I shot falling over an elephant tub. Swish. Sweet.

As night settled on our snow day, I wandered to the showgirl car, and dropped in on Lynn. My showgirl partner in Opening and Finale, Lynn was a dancer from Pittsburgh, with short, straight blonde hair and a fringe of bangs over a round face. Now she offered to "read" my color. I said I must be plaid. She frowned at my frivolity, then turned to the serious business of studying my face, before declaring that my aura was blue. I'd have made a pun about aura sex but she'd have liked that joke even less. Lynn said she was a red herself, though a quiet red and not the cheap, flashy kind of red like, "well, you know the person I mean." If I had known which person, I'd have been in her room.

Finishing a second beer with Lynn, I said good-night and toddled to 149, the clown car. As I passed the open door of a dark room, a voice called. It was Cuz, short for "cousin." With a roundish body topped by a chubby-cheeked face, he looked the picture of innocence, even more in the arena where he blinked without his glasses. Though about my age, he seemed to have the weight of years on him. I'd heard a showgirl broke his heart and he quit, then returned.

As he poured us whiskey, he said, "Keep working hard. They notice. J'know they spy on us? Report to Washin'tun evry day. Know who yer dating',

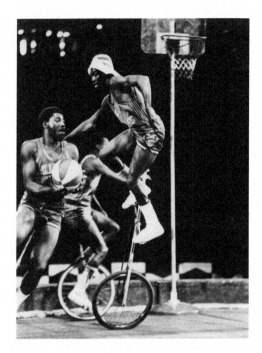

Figure 2.1 The King Charles Troupe: my neighbors, their act, our hoop. RINGLING BROS. AND BARNUM & BAILEY and The Greatest Show on Earth are registered trademarks of and are owned by and used with permission of Ringling Bros.-Barnum & Bailey Combined Shows, Inc. All rights reserved.

ever-thing." Lost love seemed to echo through each word. A genuine sad clown. A sad, drunk clown.

Pouring us more, he mumbled, "Yer one a tha good ones."

It was booze talking but I grabbed it as sober truth. We're sharing a spiritual union, I thought, fellow clowns, compatriots—

He snored. Taking the bottle from his hand, I put it on the floor and closed his door.

Weaving down the vestibule steps, I looked up at the night sky, seeing Cuz's heartbreak in those stars. This was real backstage stuff, romantic and sad. Plus a veteran had praised my clowning. Swaying, I sort of knelt my way to the dirt. Like Knucklehead's slow-motion fall. I remembered the old joke, you're not drunk if you're lying on the ground and don't have to hold on. If a clown falls in the forest, does anybody hear? Can you see the forest for the trees? Can you see a clownie in a tree, k-i-s-s-i-n-g?

Who's kissing? Not me. Not me in a tree, or in a car, or anywhar, here I are. Lighted windows of my train car stretched horizontally across the dark. I forget what I said to the star-splattered sky but I'm sure it was profound.

* * * * * * * * * *

The final dress rehearsal was chaos. Backstage, clowns bumped into each other, hopping into pants, grabbing props.
"Hey, watch it! You almost hit my head!"
"Outta the way!"
"If you put your junk on my trunk again, I'll toss it!"
Not even Billy could calm things with his hippie-Zen "It is what it is."
My theater experience told me that the bedlam would pass. Timing gets worked out, glitches unglitch, angry words are forgotten. Even when the trumpet Steve loaned me for Clown Band smeared the makeup on my lips, and I jammed my toe in Charivari, I stayed steady.
Opening night was better, and the next show better than that. The skill of these riding, flying, tumbling people was awe-inspiring. Clowns joked about Elvin's "Wheel of Death" as a giant hamster wheel but there was danger and impressive showmanship when he walked on the 3' wide, 9' diameter wheel as it rotated on an arm that swept floor to ceiling. It was the same for his other thrill acts, the motorcycle on a wire to the ceiling, with a woman on a frame underneath, and his single trapeze act climaxed by a forward dive, catching only by his heels. The dancers combined training, makeup, and figure-enhancing costumes to transform into that figure of legend, the Showgirl. Seeing old-timer Mark in costume and makeup was strangely appealing. He had a fake fly on his clown nose, and painted a pink semi-circle under his lip, as if his tongue dangled permanently out his mouth, an effect that looked almost real. His raggedy coat of dirty turquoise mashed together tramp-clown dark and happy-clown bright, and a buzzard he'd carved out of foam rubber perched on his battered top hat, with a spring in its neck so the head bobbed when Mark walked. Plus, he—Mark, not the buzzard—wore a dog collar with a bell. Why? To suggest he was a dog, like his dogs? Whatever the reason, he said that without the collar and bell, he'd feel like "a burlesque dancer without her g-string." That only added to the weirdness yet somehow it all worked.
This was a massive, spectacular, and well-organized enterprise with style. Like its "style." The circus "style" is noun and verb for arms raised in a V to acknowledge applause. Instead of taking a bow, circus people *style*.

Sometimes it's done palms up, but I liked the nonchalant version with palms down, as if saying, Clap if you want. It's cool. Whatever.

* * * * * * * * * * *

Our last day in Venice, I woke to my new wind-up clock tick-tocking. The cockroaches and I had forged a nonaggression pact: I wouldn't squash them and they wouldn't crawl on me in my sleep. My door still didn't close all the way, but a lift-&-nudge tucked my sink into the wall, and the light worked after I scrounged a bulb, so the place felt sumptuous, which it had been when sleeper cars were luxury travel. Apparently a couple of our cars had been on the famous 20th Century Limited. Enriching my opulence, I'd made a foot locker for a seat. When I'd gone into the prop shop to make a bench, Mark had suggested a box with a lid, and showed me how to attach hinges.

I stretched in my bed. My toe was still sore, and I had a paper cut from a sequin on Roma's Spec blanket, but I reveled in the signs of my body alive and working. One advantage of a bed that covered the room was being able to reach everything. I lifted my shade. Silver flooded the morning: the silver gray of the ground, cars painted silver, and the blue-gray silver of early clouds.

You're wrong, Camel John. This is a bowl of cherries. With cream.

In our final performance in Venice, people in the audience laughed when I tripped in my new, 10"-wide, bulbous-nosed, yellow-&-red wingtips. It was an accident but I was sure I made it look funny. Approaching a little girl near tears, I passed with a wave, pleased when I heard her sniffle, "Look, mommy, that clown is waving at me." Later, Bigfoot bent from his craggy worker dignity to say, "You're crazy, man. You're fun to watch."

My comic genius didn't last long. We hit the road, and the road hit me.

Chapter 3 Rubber (Nose) Meets the Road ᕲ

February and March: Lakeland Civic Center/
Atlanta Omni/Savannah Civic Center/
Asheville Civic Center/Raleigh, Dorton Arena/
Fayetteville, Cumberland County Memorial
Arena/Columbia, Carolina Coliseum/
Charlotte Coliseum

> *The true adventurer goes forth aimless and uncalculating to meet and greet*
> *unknown fate.*
>
> O. Henry, "The Green Door"

The Friday night show in Lakeland felt as if it should have ended our long first week, but the weekend loomed. Saturday morning, I woke earlier than reasonable and sprinted to the arena to apply my makeup, rushed through Come-in for 20 minutes, and ran in and out of the arena a dozen times over three hours. We grabbed a bite, then did it all over again. That night, third show, we plowed through another three-and-a-half hours. Earlier, while making up, I had snorted at Smitty's jabber about the "bad advantages" of three shows a day but by midnight, his nonsense made a kind of sense.

I had assumed I'd adjust the way I had to other ventures that initially overwhelmed me—fire-fighting, the Army, law school, dating—but the road mocked my assumption. At Wednesday's opening night in Atlanta, 16,000 people made the Omni buzz, but excitement faded by Thursday's matinee. On the arena floor after Whipcracker, I tried some meet-&-greet with the front rows till Clown Band, more chaotic than comic. As Mark

took over Ring One for a solo gag with his little white poodle Fanny, the band ran backstage to change for Opening, with only the duration of Mark's gag to tear off our own costumes, grab spangled outfits out of the wardrobe boxes, throw them on, and get to the back curtain before lights went up to start the official show. Somewhere between tearing and grabbing, I bumped Hollywood's trunk.

"Take it easy, man." Hollywood had finished Come-in early and was lounging in his chair. For all I knew he'd had a cocktail. He got his nickname from trying acting in LA, his movie-star looks, and the jaunty self-confidence of a short man. During rehearsals, Bill Ballantine had come by to ask him, Flip, and me to help at a Ringling Museum benefit in Sarasota, where we shared dressing space with the famous clown Emmett Kelly. By the time we got back to Venice, they were telling people we'd worked with Emmett Kelly.

"Take it easy," he repeated. "It's a small house. There's nobody out there."

It's still an audience, I rasped in my sore throat.

"Be cool," Hollywood said and strolled out of the Alley.

Yanking on my Opening pants, then off again after sticking my foot in the wrong leg, I muttered about standards. That "nobody out there" was more people than had attended all the plays that I (or Hollywood) had done. But he'd hit a nerve.

When Clown College teachers had warned we'd need to pace ourselves over the long season, I wondered if that was a hint to goof off. Lenny made it explicit when he announced our first week that he'd coast through production numbers because he worked so hard in the acrobatic routines. Yet even as I harrumphed to myself, the Omni did look bare, a few thousand matinee-goers spread thin through the stands. That was no problem for Ringling, which earned most of its income on nights and weekends, when attendance peaked, while lightly attended midweek matinees still brought in money, with little added cost because most expenses were weekly. Still, my spirits sagged at the vast patches of empty seats. As if—guilty thought— nobody was out there.

Scaling another Saturday, I already felt next weekend's climb, and the next, and the next, till the last syllable of recorded time, or December, whichever came first. Instead of a learning curve arching gracefully up, I stumbled on a rocky road with no apparent direction. Philosophers puzzle about infinity but it's easy: Infinity is a Ringling Saturday.

Opening swallowed my energy, and Spec, the spectacle ending the first act, felt sluggish. The *Atlanta Journal* reviewer agreed, writing that he felt as

bored during Spec as the diminutive bride looked in her "wedding" to "The World's Smallest Man." Meanwhile my clowning wobbled. For every bit that worked—surprise at the car of Clown Car behind me—another thudded. Jumping to get my pants past my hips in the Whipcracker pants-drop killed the laugh; it turned out the joke wasn't bare legs and underwear, it was the surprise, which my jump wrecked. Unable in rehearsals to come up with my own walkaround—a quick clown bit or wandering visual joke, like Billy's "Kisses 5¢" sign, a distraction while the rigging gets changed behind us—I'd grabbed at Allan's offer of a giant pair of foam-rubber bread slices, 30" square, and got an apron and made a chef's toque to follow his giant fish skeleton on a pole, but I couldn't think what to do except walk behind him. Crowds laughed one show, and ignored us the next. And so, another show. Another Whipcracker. Wandering. Clown Band. Running, costume change, running.

I had favorite parts. Those sporadic laughs. Meet-&-greet in Come-in. The energy in the teeterboard troupes' sprinting entrance. The elephants running into the arena, as I used my legs to stay on Lucy—Leutze to me. Another pachyderm pleasure, holding the head harness and leaning back when she reared up on her hind legs. Jeff's walkaround: a funny acrobat, he got esoteric in Walkaround, strolling while doing nothing more than holding a rubber Coke bottle by thumb and forefinger. (Funny or not, it fascinated me. Lynn pronounced it artistic, though he didn't make that claim for himself.) It also tickled me to enter in the sudden dark of Opening while kids waved lighted souvenirs, like July 4th fireworks on mute. Our very first Opening, I had bumped into Buzzy in the sparkly dark, and we shook hands, swapping good wishes. Ever since, it had been our ritual, repeated every show.

Have a good one, Buzzy.

"Have a *great* one, David."

There was fun here. But living on my skin, grateful for a smile, bruised by a frown, I was sinking.

And sick. I'd always been healthy, not even taking aspirin, but now I cycled through clogged heads and hacking coughs like a one-man commercial for cold medicine. Every time the Omni's industrial-sized back door opened to Atlanta's harsh winter, wind blew backstage, fluttering the curtains of the Alley. "Clown Alley" refers to the clown dressing area, and by extension, to clowns collectively on a circus: the Alley dresses in the Alley. In the old days under canvas, Clown Alley was a separate tent next to the big top, but now it was any backstage space large enough for our trunks and the wardrobe boxes that held production costumes, all tucked behind blue curtains hung on poles. In the bowels of the Omni, that placed us a quarter of the way around from the back curtain. More running.

The wind chilled my throat hoarse. Barely able to speak after a week —after I'd bitched at Hollywood, Richard said "I could hear you yelling at the top of your quiet"—I went to a free clinic, where the doctor prescribed rest and quiet, precisely what I couldn't do. There's no downtime in circus. You can't do a half flip, or partly ride an elephant. Before our elephant-riding lesson in Clown College, Bill asked, "How do you get down off an elephant?" It was one of his rare jokes—that you get down off a duck. But the other meaning, descending from an elephant, hit here. I lost my grip as Roma, my Spec elephant, lifted and I flew backwards, slamming to my butt. The elephant guys laughed though, dammit, they knew Roma was spacey, with a weird, syncopated lift, and the large bell shape draping her side, dammit, made it hard to get my leg over. Dammit. Adding injury to insult, when Bigfoot bent to help me up, his short staff hit my forehead. Staying quiet, the other half of the doc's prescription, was theoretically possible. Many clowns don't speak. Dean didn't. But I chattered with people in the first few rows and talked to myself on the track. I'd also discovered that falsetto carried a long way so I yelped to the top of the arena, though it scraped my throat. Already, my voice was a key part of my clowning, nearly as important as physicality to me.

I live in how my body moves. Moving got me out of my head, into instinct. That's why I had adored Whipcracker with Richard in Clown College. We looked funny together, him a taller authority figure looming over my tall bumbler, but the real pleasure came when we matched actions on the fly, following whatever impulse came up between us. But my new partner Dean wanted to set things to counts, like his Russian folk dancing. He may have been right but I worried that specific counts would make us rigid. That's why slapstick has a bad reputation: a lack of physical expressiveness leads to aimless antics, a lurch between half-felt gestures and stereotypically broad ones. As Dean and I struggled, I tried to subtly suggest spontaneity, he subtly advocated restraint, and we each subtly hinted that the other one was an idiot.

We'd all been warned that circus would be hard but this was *hard*.

* * * * * * * * * *

The second act had a small break when I could just sit. Up again, I dressed early for Menage. Its blue-and-red production costumes had to be unembellished for riders, so the pants were plain with only a stripe of sequins on the side, the sequined vest was better than the heavy Opening jacket, and the hat, a plastic boater with a plume, sat lightly on the head. Turning to leave the Alley, I nearly tripped over Prince Paul. I hadn't seen him close to

the floor on his low folding stool, stumpy legs crossed at the ankle, poking an orange dental stick in his teeth.

"Hey, buddy, watch it! There's a person down here!"

Going out, I thudded into Gumby. Once upon a time I'd been graceful. Peeling a buttered bagel off his ripped t-shirt, he grinned and said, "Wanna dance?" Skinny, he looked like a marionette in the show's jazz boots, tall striped socks, short shorts, and baggy cap. He had bought the bagel at Pie Car, Jr., the grease wagon parked backstage. Pie Car was also the dining car on the train. The name came from the old days when the Greatest Show on Earth had a separate baking car for pies and bread, part of three squares a day for a thousand people. Eras had changed. Now we grabbed food where we found it, and paid for it ourselves.

"Gumby," Smitty yelled across the Alley, "Didja get my bingle? I'll pay ya later."

Smitty's slips of the tongue proved to be constant. In Lakeland, when Charly had explained the policy for comp tickets, Smitty interrupted. "So, Charly, like, y'know, what happens if a friend comes on the sperm of the moment?" We laughed, and so did Smitty, though it wasn't clear if he'd said "sperm" on purpose, or blundered and laughed to be part of a joke he didn't quite get.

Life backstage stretched like a curving village square. In a narrow stretch of concrete shadowed by pipes and vents, four Bulgarian riders were playing soccer with a crumpled Coke can. Further around, Polish workers lounged on the blue tarps covering the pink Spec floats. Two act women walked by, arm-in-arm, that charming habit of European women. I nodded to a pair of showgirls, the extravagant show makeup a contrast to their plain terrycloth robes. The robes were short, barely covering their hips, so they were single. Married showgirls wore long robes.

I was early because I was eager to get to Leutze. Before Menage every show, high on her neck, stroking the gray wrinkles of her head felt like meditation. I had assumed that my favorite poet, Theodore Roethke, had no personal experience with these amazing animals when he wrote, "I know a dance the elephants," but now, my own experience made those words ring true, sing truer. The elephants stood side by side near the back curtain with the elephant guys talking in a clump around Siegy, who ran Leutze and the other five elephants in Ring One. With a German father and black mother, Siegy—Siegfred—combined the scruffy air of the animal workers with a hint of class in his arched eyebrows and scraggly black hair, like a nightclub magician or a gallery owner. While Leutze and I waited for Bigfoot to come over to command her to lift me, I looked in her eyes. An elephant's eyes,

bigger than a horse's, are still the warm eyes of a mammal. Circus originated in horses and people working together, bonded, and every show we repeated that animal–human partnership.

Leutze must have gotten tired of waiting too because she lowered her shoulder on her own and held up her leg. Grabbing the harness, I braced myself. I had no energy for flinging today. I didn't want to land on my butt again or, like Dana with her elephant yesterday, to flip over the top to the floor.

I love animals but scorn sentimentality about them. That's human gush more than anything about an animal. But Leutze, without a word from anyone, lifted gently, as if she knew I was sick. I loved Leutze.

* * * * * * * * *

In a challenge to scientific principles, circus proves infinity ends. At the conclusion of an infinitely long Saturday in Atlanta, the Alley reconvened at a bar, where we gossiped that Ringling might be making a movie. Apparently the show's schedule had an unexplained gap in July. Jeff, of funny acrobatics and weird rubber bottle, read *Variety*, and reported that the Felds were negotiating with a disaster movie producer, so we speculated that our movie—it was taking on the heft of reality—would feature a smash-up like the train wreck in Cecil B. DeMille's *Greatest Show on Earth*. Prince Paul had been in that movie. When asked to repeat his line, he usually obliged, undaunted by sarcasm in the request: "Sebastian's back! Sebastian's back!" The Prince wasn't senile, he was forgetful. He called all of us "Buddy" because he couldn't remember names. The senility rumor also stemmed from his dry humor. Instead of the yuk-yuk delivery common in the Alley, he'd slide in one of his old vaudeville lines, and not everyone recognized "pees" in "She sits among the cabbages and peas," or the slang for sex, "to ball," in "She sits on my lap and bawls."

Flip suddenly climbed on the bar and did a backflip to the floor, attracting a couple of women. When I couldn't sway their attention, I decided they were shallow and returned to the conversation.

Billy said that a circus movie would need large gags, and he had some in mind. Under his country-boy cornpone lurked a natural leader, so I liked that he talked about becoming a tightknit group. That's what I'd hoped the Alley would be. He added that we had to work hard to earn respect, after last year. In Clown College, I'd gotten the impression that last season's Blue Show clowns had been rebel heroes. Maybe not.

Since his drunken praise that night in rehearsals, Cuz had only talked to me once, after my tiff with Hollywood, saying, "It's good to see a First-of-May who cares." Now he turned to me.

"Long day."

I agreed, and mentioned my frustration in Finale, when I'd wanted to run over to a little girl who'd been waving wildly at me from the front row.

"Ya shoulda."

But we're supposed to stay on the track. Charly—

"Just get back before he sees you. We may look like chorus boys in those stupid production costumes but we're still clowns."

"Yeah, do what you want," chimed in Smitty, "just for the shells of it."

"Do what *you* think is funny," continued Cuz, "and find people who are enjoying it."

Billy added, "You can't play to thousands, not unless you're featured. An arena isn't a larger version of a theater audience, it's the opposite, it's individuals. Focus on one person, or one group, and build your own audience."

Wouldn't that ignore the rest of the crowd?

"If what you're doing is good, it'll radiate out. Even if the back row doesn't catch the details, they'll be with you."

Cuz added, "Look in people's eyes. How are they taking it? Eyes are key."

The next day, I woke at the crack of noon. Between the money spent buying a round and this groggy head, I wondered if the night life suited me. I also wondered about their words. Having imbibed theater's creed that heeding reactions was pandering, I suspected their advice was New Age mush.

* * * * * * * * *

The train was like a turtle with its shell, bringing home along. Arenas and towns varied but the train stayed the same, making me simultaneously tourist and resident in each stand. In Lakeland I had wandered shady streets of shacks to a small art museum where a pianist was playing, then to a little bookstore smelling of musty books and old wood. Atlanta brought big-city sights on Peachtree—including peachy looking women. In Savannah, which looked like Philadelphia with Spanish moss, I found a basketball game on a lighted court Monday night after we pulled in. Wednesday noon in Savannah, Billy and Tim—the clown I'd met backstage a couple years ago, now assistant performance director—told me about Miz Wilkes Boarding House, Southern-all-you-can-eat in an ancient brick house. I squeezed in a second lunch because, on a two-day stand, it was my only chance to try the place.

Each move-out night I stayed awake till the train started. Working my way through a bag of ginger snaps and a six-pack of root beer, I'd nod off

reading but force my eyes open again. I wanted to feel that jerk of the train that said we were on our way.

Going to Asheville, slowing woke me. I'd heard the train would be split into three parts to make the grade up the mountains of western Carolina so I raised the shade to look. It's a good thing I adjusted my blanket first. I slept naked and we were rolling down a main street, people staring. On the outskirts we reverted to our usual urban view: splotchy backs of buildings, rusty pipes, car bumpers, and splintered boards in the weeds, with plastic milk crates adding squares of color. Reaching the piney woods, we picked up speed.

I went to the vestibule, and opened the top half of the Dutch door. Buzzy joined me as we crossed a river through a narrow valley. Buzzy was an enigma. Warm in performance, he did double takes that still made me laugh, and when he gestured big, it looked natural, not stilted like most First-of-Mays. Yet he had a lot of anger. Outside that Atlanta bar, he got a block ahead of the rest of us, and when we yelled to him, he threw a bottle in our direction. Still, though we didn't hang out together in towns, Buzz and I had a bond. Every Opening we shared our greeting, "Have a good one"/"Have a great one," and each train run, we got together on the vestibule, like Huck and Jim on their raft, watching the country go by.

If backstage was the show's village square, the hallways through the train cars were our social center on runs. Dean came by with gossip that the non-union band we were carrying hadn't been paid last week. Could that be true? A drunk roustabout leaned in my door, to confide, shh, that his parents, who owned a ski resort, had paid a $2,000 bribe in Argentina, to get him out of a drug bust. After he left to whisper his secret to the rest of the world, Lenny popped in to show off his new clock radio. He already had a clock and a radio but, just out of high school and getting his first paychecks, he seemed determined to support the economy by himself. I envisioned a sudden stop burying Lenny under a pile of consumer goods.

Like a turtle with its shell, the train sometimes moved turtle speed. We slowed frequently and occasionally stopped, passed by trains with higher priority. Though a stop could be a minute or an hour, people sometimes opened the bottom half of vestibule doors, pulled up the plate covering the steps, and climbed down to stretch their legs. Braver souls would go on a snack run. Scattered across the country are stores that had their best day ever, swarmed by showfolks. Shopping was risky though. If the train left, you had to find your own way to the next stand. Stopping near Spartanburg, South Carolina, we hit the mother lode, a brewery. Forget Twinkies and Slim-Jims, here was alcohol. Guys slid down the gravel of the train bed, passing a rusting plow to the fence, and soon were toting cases back like ants from a picnic, until only a scrawny Bulgarian worker was left. He'd been late to the

party, having to scrape up money with his pals. I'd heard that ring workers only took home $50 a week, with the rest of their pay being sent back to Eastern Europe. When it came to circus, Communists loved capitalism.

The train lurched. Everyone instantly knew the guy's dilemma. Returning without beer would mean losing his money but if he waited much longer, he'd be left behind.

The train reached a walking pace. Then faster. The guy looked back and forth like an agitated metronome, brewery to train. The train picked up speed. The beer came out! He grabbed his prize and scrambled up the incline, dodging a tractor tire. Running on the sloping gravel of the train-bed, he tossed the case in the first vestibule that passed. The next one, he jumped but missed and staggered to regain his footing. Falling by a moving train isn't healthy. At the last moment he grabbed a handle and got pulled aboard, to cheers up and down the train.

Between Asheville's tiny backstage and steep streets outside, it was impossible to crap out the herd. That's standing the elephants on their hind legs before Menage so they'll take a dump, making it less likely they'll do it during the act. Here, as the previous act finished, the uncleaned-out elephants were lined up along the end track facing away from the seats. Sometimes people complain that circus has become antiseptic, that they miss the animal smells, but that was probably not the reaction of the guy jerking his tassel loafers away from cascading elephant poop.

Spring chill peeking through the Blue Ridge chill lured me to the cemetery with Thomas Wolfe's grave. Near a stone with names that sang— Papa Jay, Daddy Mother, Boogie, Tillie, Mooma—I fell asleep in the thin sun. Waking feeling something like healthy, I walked back through town, encountering Wall Street, no bastion of finance here but a few blocks of artsy Asheville. In a cafe, a tiny etching caught my eye. When I looked closely, the serendipity startled me: the 2" x 3" piece was titled "Clown." By an artist, Jean Wall Penland, it cost a hundred bucks. I thought about buying it but, paying off school loans—and cheap—I wouldn't spend that much for *anything*, so I left. I came back to look at it again. I left again. Returning again, I bought it. I owned art.

On the train back down the mountains, seeing signs for Durham, I decided to visit Duke. Locking my room, I went to the vestibule, opened the bottom half of the door, lifted the floor plate, and got on the bottom step. Below my feet, gravel flowed like jagged water. The train slowed through towns so I waited to calmly step off or, like Buster Keaton, jump into a forward roll and come up walking, a smooth extension of the train's motion. Gothic towers that had to be Duke's campus slid into view over the trees. Soon, I knew, the train would slow. But the breeze increased on my

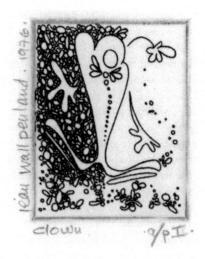

Figure 3.1 "Clown": I'm an art collector. Jean Wall Penland, WNC artist (Pollock-Krasner Foundation and Adolph & Esther Gottlieb Foundation grantee).

face. We weren't slowing, we were speeding up, heading out of town. The gravel below me blurred. Later I tried to estimate the speed by driving a car with the door open to look at the ground but numbers—30 mph, 40 mph, 500 mph—don't capture the shaking in my stomach.

Whatever the speed, it was too fast to jump.

I jumped.

Smacking the ground like a bag of pipes, I panicked about careening back toward the train. A stuntman carefully arranges his "gag"—movie stunts and clown routines share the label—so it looks dangerous but stays safe. This *was* dangerous. Once I stopped flopping, I scrambled to my feet to wave to the train. Anyone seeing my tumble might pull the emergency brake, thinking I'd fallen or been pushed, an old circus practice called "redlighting." Adrenaline made my wave wild. As the last cars slipped through the underpass, I realized my hand was still flapping.

* * * * * * * * *

In *Leaves of Grass*, Walt Whitman wrote, "To touch my person to someone else is about as much as I can stand." To *not* touch was now about as much as I could stand. Nothing had clicked with any of the showgirls. Elegant Colette with her delectable coffee leché skin had confided in me about

two boyfriends back home, a stable one and a sexy jerk, but by the time I realized she hadn't been seeking advice but a third boyfriend, she'd moved on. Nor were girl clowns going to be this boy clown's someone else. Dolly forgot who I was after our visit to the Red Show; Dana was young, and seemed younger when she pretend-pouted for hot chocolate from my new hotpot; and Terry was married. It felt awkward when Terry confided that marriage wasn't what she expected. She'd been the center of attention in Clown College, but now married, she attracted little flirting. When she said that she worried about one of the showgirl's reputation, her own frustration seemed the subtext.

I may have figured out which vixen she meant. Wandering Asheville, I ran into our kewpie doll of a showgirl on the arm of a short, distinguished old guy, who looked like the Monopoly Man, complete with walrus mustache and blazer. I hurried to the arena with gossip about a mismatched pair but Janet, our cheeriest cynic of a showgirl, trumped me. She said that Kewpie Doll had been turning tricks since Venice. It didn't occur to me that someone I knew made money from sex. I routinely consider myself sophisticated, despite repeated evidence to the contrary.

The foreign women were off limits. Though their male compatriots were constantly on the prowl, the women had reputations to protect in each nationality's tight community. The only act woman-clown pair was married, Danusha from Poland and Spike, who called himself "Spike-a-wopski" in her honor.

One woman had caught my eye. Dawnita, who hung on the trapeze underneath Elvin's slant-wire motorcycle he drove to the ceiling, looked like a young Elizabeth Taylor, with dark hair and a quiet smile. When Charly volunteered the clown band to play Happy Birthday for Elvin backstage, I tooted with the others, then let them swarm the cake while I edged to her side.

Oh, hello, Dawnita! (I'm so smooth.)

"Hello." Her voice was musical, with a British lilt.

Nice party. (What a wit.)

"Yes, it is."

Uh... (her smile froze my brain), please give Elvin my birthday wishes.

"I will. It's my birthday as well. We're twins."

Oh. I'm sorry. That is... I... Happy birthday to you too.

"Thank you."

With a mumble, I drifted away. The Bale family was circus royalty, and it felt as if a princess had graciously overlooked horseshit on this commoner's shoe.

Of course, in matters of the heart and other parts, there was always what Smitty called "local talent." Searching each town's neighborhoods, I told myself I was an American Marco Polo, but the women I saw made me feel like a pin in a field of magnets, constantly drawn this way and that. Still, how to meet? Inviting someone to see my new etching was like a bad joke, and it didn't seem alluring to say, "Hi, I'm only in town a few days, busy every night, and have no car or money. Want a date?" This wasn't just about sex. As P. G. Wodehouse put it, "the impulse to leap across the compartment was merely the natural desire of a good-hearted young man to be decently chummy with his species." On the other hand, it wasn't *not* sex either. I needed to talk to a woman, to laugh with her, to loll in her lap. I needed to get lolled.

I failed spectacularly in Atlanta. In the Omni shopping mall, I'd spotted assistant performance director/ex-clown Tim and asked him about meeting women. A Mormon, he counseled celibacy. That may be a good thing but I didn't want too much of a good thing. Maybe his advice reverse-inspired me, as I immediately spotted an attractive clerk in the posh Hermés store. Hoping my Army field jacket suggested wealthy chic, I lingered over the scarves. Wild about her Southern drawl, I returned the next day. Learning she was mar- ried—I didn't yet have the habit of checking ring fingers—didn't stop my flirt- ing because it didn't stop hers. When she mentioned that her horse-set friends had casual affairs, I wasn't sure how to respond, so I leapt for the dramatic-but- safe gesture, inviting her *and* her husband to hear Bobby Short, the Manhattan cabaret singer, in town for Valentine's Day. It's a measure of my desperation that I didn't see how bizarre that was. She suggested a friend instead. Though reluctant to reveal how quickly my interest could flip, I said Yes, looking for- ward to romantic songs while touching knees under a tiny cabaret table. The blind date picked me up, we went, we chatted, we listened, we did *not* touch knees, I paid more than a week's salary, and she drove me back to the train.

Then came one of the most embarrassing moments in a dating career full of them: I asked her to kiss me. I immediately pretended it was a joke but the request hung in the air like drool on a St. Bernard. Mortified, I knew it couldn't get worse, until it did. She kissed me. A pity kiss. It was worse than the time I ate a caterpillar—I was four, my sister persuasive— and tried to scrape the taste out of my mouth. As my Valentine date drove away, I struggled to scrape the memory out of my brain.

* * * * * * * * *

Raleigh was a tough stand. Dorton Arena looked peculiar—the ends swooped up, like a tuna can with the middle smashed down—and it played

peculiar, with glass walls that prevented a blackout, and "backstage" down wooden stairs from the arena floor. Up and down those rickety stairs a dozen times a show while ducking the low clearance turned my legs to jelly. The Alley was bad too, overlooked by a walkway into the seats. Curtains on the walkway were supposed to shield us from view but it only took one peeker to draw a crowd, with kids heckling as we changed clothes. When hecklers were black, racism reared its ugly ass. That wasn't new. During a show of mostly black school children in Atlanta, one clown from the South groused he didn't get laughs because the audience "wasn't real smart." This, from one of the dimmest bulbs in the Alley. Another time, after Jerome popped his head through our blue curtain, chirped "Hiya, clownies," and left laughing, another dim bulb sniffed that the King Charles' teenager had been "brought up bad." Now the pair jeered in minstrel dialect at the hecklers that they should go back to the jungle. When Cuz objected, Dim Bulb One proclaimed that some of his best friends were black, and he was "only talking about the majority."

Illness and injury surged. Billy was out with bronchial flu, Gumby hurt his back and had to see a doctor, Lenny groaned about his elbow, and Danny limped on a sprained ankle. Cuz had it worst. He'd been waiting in Smitty's van when a thief had pistol-whipped him. To hide the bruises on his face, Cuz had to use a tramp makeup.

I'd lost my voice after walking to the arena in a cold rain rather than pay 25¢ to ride on the show's school bus. I'm not sure which was cheaper, the show or me. Feeling sluggish, I decided the solution was to try harder. I'd be *dynamic*, the James Brown of Clown. I ran higher into the seats in Opening. I spun faster in Spec. I was determined to break through to something real that must lie beyond moderate effort. My nonstop action was probably too much for the audience. It certainly was too much for me: no James Brown of Clown, I was a ground-down clown. Lonely and sick, I'd become a walking cliché: in a photo a friend took in Raleigh, I could have been a sad clown about to cry. Prince Paul found *les mots juste*: "You look like someone hit you with a sock of wet owl shit."

Sick turned into fever, which broke in Fayetteville, where I woke to sheets soaked with sweat. I tried sightseeing but the itchy bravado around Fort Bragg made me edgy. I'd seen the same thing at Fort Knox, pawn shops, gun stores, used car lots, strip clubs, and boarded-up windows, with GIs strutting through it all. Whatever happened to the strong, silent type?

Fayetteville's small arena shoved the seats down to the track. Looking in audience eyes, I saw this was too close. They preferred a little distance. The place was so small that people had to walk on the track to get to their seats,

which threw off the timing in Whipcracker, and Dean hit me in the face. Backstage he said that I'd leaned in at the wrong time. I apologize my face hit your whip.

Sick again/still in Columbia on Friday afternoon of another split week, I slumped in my room as noise filled the car, I knew I wouldn't be able to make it to the arena with the others, now scurrying to get ready. It felt like a taunt when a radio blared Ringling ad's about "the world's funniest clowns." I'd never missed a performance, and like the Fort Bragg studs, I told myself I was tough. Not so tough now. The vestibule door kept slamming until everyone was gone.

The door banged me awake. Key Wash was grumbling that Jerome always forgot something. Slam.

I woke in the dark. The show must go on, without me, thousands of people in a bright arena I wouldn't see. Hungry, I shuffled to the vestibule. At the end of the train I looked at the lit capitol dome but couldn't go further, and shuffled back. It took two tries to open the heavy vestibule door. Stepping into my room, I saw my reflection in the window. In the harsh overhead light, my face looked like a skull, my shadowed eyes like sockets. I slumped on my pine box, wrapping myself in a hole darker than my eyes. Easier to sink into self-pity than fight it.

Sunday night Richard cooked us steak on his hot plate, saying he'd heard I was quitting. Just then, the rumormonger Herbie happened by. I barked at him about spreading that lie (while wondering if it should be true), and he barked at me. Back to normal.

* * * * * * * * *

After the Sunday matinee in Charlotte, most of the cast and crew went outside to enjoy the first day of spring. Roustabouts in blue coveralls, act men and women in tight shorts and t-shirts, showgirls in makeup, and clowns, ditto, spread over a sunny slope between the arena and the parking lot. I kept an eye out for a woman I'd been flirting with, pausing near her front row seat every time I passed. Eventually I made her giggle just by wiggling my eyebrows. Groucho would have been proud. Now, listening to the gossip about Michu falling down in Spec, apparently drunk, I spotted her looking for me! Recognizing my clown face—clowns kept our makeup on between shows— she steered toward me through the crowd. Here she comes. Say something.

Thanks for coming. (I sounded like an usher, not a potential date.)

"Sure."

Bye now. (Really?! It sounded as if I were dismissing her. Which is obviously how it sounded to her.)

"Oh. Bye." She walked on. I'm an idiot.

Once cars started to pull into the parking lot for the second show and a policeman got out of his car to direct traffic, I ambled over to the curb. He nodded at me. I nodded back. When he motioned a car to turn, I mimicked him. I was taking a chance. Most MPs had been prickly about their dignity, and here I was, a clown in full makeup copying his moves, but when I did it again, he gestured me to join him! He pointed another car in and I did the same, adding a spin of the wrist. He put up his hand to stop cars, and I pumped my palm as if dribbling a basketball horizontally. As an MP directing traffic, I smiled; now as a clown, I adopted an earnest look.

Then he told me to take over! That astounded me as he went back to lean against his car. He must have sensed I knew what I was doing but he was taking a big chance. Beyond understandable worry about me clowning around, directing traffic is more than signaling cars, it's keeping the flow smooth by being clear. So looking in eyes, drivers' eyes this time, I made sure they understood what I wanted. Big wave, clear direction. Index finger crooked, then pointed: clear direction. But still a clown, I gave things a comic twist. I spun after I pointed. I pretend-glared one driver to a stop. I sat on a car's hood while families crossed from the parking lot and the kids inside the car bounced in their seats. I acted as if I had to push a pickup. I pretended a van ran over my foot. When a driver hesitated, I got on my knees, begging him to go. My audience paraded past, car by car, pedestrian by pedestrian.

Buzzy came to get me: it was time for Come-in. As we ran past show folks on the grass, they applauded! And Charly was laughing. I was a hit. During the show, showgirls mentioned my traffic directing as we danced, and Doncho, in the Bulgarian high-wire act, gave me a thumbs up. Then that night on the run to Knoxville, Sonny, who led the elephants in Ring Three, waved me to his booth in the Pie Car. Sporting an incongruous mix of nerdy glasses, long bleached hair, and tattooed arms, when tattoos were unusual, he imitated what I'd done, his arms like animated cartoons. Now, maybe, I was circus.

On my way to my room, rolling like a sailor down the rocking corridors of each car, I bumped into Buzzy.

"Hey, man, guess who loved your bit today? Elvin!" Elvin Bale. Circus royalty, and a star. That clinched it. I was accepted. An insider. With-it-and-for-it.

"Except he confused us, and congratulated me."

So much for being circus.

Chapter 4 The Show Business ✧

March and April: Knoxville, Civic Coliseum/ Cincinnati, Riverfront Coliseum/Washington, DC, Armory/Largo, MD, Capital Centre

Even a fool learns something once it hits him.

Homer, *The Iliad*

T he animal walk in DC gave me a great opportunity but it faded to a crisis of conscience. Or confidence. Or something. All I knew for sure was that the business of show business was tying me in knots.

Getting the animals from train to arena was usually a late-night amble, unannounced and unnoticed. Even when publicity made the animal walk a bigger midday deal, it was nothing like the old circus parade, with bedecked performers, exotic animals in decorated cages, the band thundering atop a spangled wagon, and an ear-piercing calliope. (Troupers pronounce it CAL-ee-ope.) Still, elephants draw attention. In the 1800s, "see the elephant" referred to experience of the world, the phrase from the astounding sight of them. They continue to be astounding. Everyone's seen pictures, and some people are lucky enough to go on safaris, but it's special to experience these magnificent creatures live, especially walking down your street.

Because DC was Ringling headquarters, the PR department expanded the usual walk, with showgirls and clowns enlisted to wave from convertibles. I don't know how Miss America does it, just waving. Bored, I soon slid off the back to mosey toward a clump of people on the curb. I ignored their excited calls, as if I were simply a person crossing the street. When a boy yelled "Clown!," I spun in surprise, pretending to look for a clown. Subverting expectations is an old comic technique, reinforced

for me in the Army. An MP, I'd make fun of the role. If I was on a traffic stop and another patrol car approached, I'd say, "Cheese it, here come the cops." Now, people expected antics but I acted as if I was like them, only an observer. The beauty of the bit, it slid past assumptions, opening the possibility of genuine connection. They saw clowns waving from cars; I did too.

Yoo-hoo, clownie, I yelled to Lenny. Pretending to scratch his nose, he gave me the finger.

As the cars crawled past, followed by the horses, I ran along the curb to catch up, and a handful of kids skipped along with me. The cars and horses passed again, then the elephants, so I ran again, followed by a dozen or so laughing, dancing kids. At each stop my crew grew, till 40–50 hopped and bopped around me. I was the Pied Piper of 19th Street NE.

But no TV camera turned its lens to the tail end of the animal walk, no *Washington Post* reporter roamed back to investigate.

Conventional wisdom says performers have a childish need for attention. That may be true but attention is a showbiz necessity: people don't attend a performance they don't know about. The animal walk was a business transaction, TV cameras getting eye-catching shots, circus getting noticed. So I should aim for notice, right? If I'd moved my movable feast to the front of the walk, it might have led the evening news, helping Ringling's publicity, but knowing I *wanted* my posse to be noticed made me feel pushy. In college, I rarely asked people to attend a show I was doing. Otto would have been content at the back. Cuz had told me that circus folks consider the tramp clown Otto Griebling to be the best, better than Emmett Kelly, but he was never famous because he had no use for reporters. Kelly, the best *known* clown, was a master of publicity, his talent enhanced by movies and TV. Cuz said he'd rather be Otto, focused on the people who were there. I decided I did too. So this rolling street party was exactly what I wanted, right? I bounced with my youthful crew, ambitious enough to want attention but not enough to grab it. If a clown pratfalls in the forest, does it make a sound?

* * * * * * * *

Tension had increased the closer we got to corporate headquarters. In Knoxville, two stands before DC, the usual practicing in the arena between shows became arguments over time slots. The anxiety reminded me of the Army, when the secretary of defense was coming to see recently released POWs, and the post had a collective hissy fit, the higher up, the hissier. Clown Band had to come in

early to "fix" what had been good enough for three months of audiences. I suggested a faster tempo but Spike mocked the idea, and instead Cuz got added to chase Mama, in a polar bear suit, to fall on balloons. Though I grumbled about the change, maybe it did look better, like Smitty's eagerness to be noticed, jerking around as our conductor providing a jolt of energy.

I expected Charly, Prussian par excellence, to increase the tension but he surprised me, approaching something that, in the right light, might have looked like tranquility. Opening night in Knoxville, as the ringmaster introduced the Guest Ringmaster, a PR gimmick of a local bigshot blowing the whistle to start the show, I lunged forward as if I were the celebrity. Charly growled "Not you," but in pretend gruffness. He had a sense of humor! That didn't mean our Teutonic tyrant had gone warm & fuzzy. Sunday night, dressed for Finale, I'd stepped outside to enjoy the warm night, and noticed the red tip of a cigarette, attached to Charly. Testing my hypothesis that he might be human after all, I said Hi. Flipping his cigarette away, its glow tracing an arc in the dark, he growled as he went in, "Don' be late, cloun." Didn't he know my name yet? Didn't he trust me to be on time? I grumbled—after the door closed, no fool, I—that he treated his tigers better than us.

As I got to the back curtain—early as usual, Charly—the showgirls were gossiping about our ringmaster, a young substitute for the veteran Harold Ronk, on a year's break. According to the rumor, the replacement had been in bed with a showgirl when an intense moment inspired him to burst into a song from the show. Veni, vedi, voce: I came, I saw, I sang? We laughed again when he started that very song, our cue to enter.

Both my partner Lynn and Gumby's partner were out, so I scooted down the track to dance with him. He had merrily conceded he'd been one of last year's goof-offs and was lucky to get a second chance. He shared a double on the showgirl car (!) with Scotty, another skinny second-year juggler, until they argued and Gumby moved out, sleeping in Bigfoot's van. The third of the second-year jugglers, a Southern boy, seemed only interested in juggling. I'd seen him yawning during performance! On his elephant!

As Finale clattered along, Dawnita glided around the end track. Lovely dark-haired lass with the lovely name, and its tidy triplet rhythm: Dawn-neet-tah. Neat-o. I'd been getting bolder with her. At least in performance: I hadn't talked to her backstage since my blunder at her birthday party. Now I fell into step beside her, swinging my arms and hips in broad exaggeration. Lynn would have been offended but Dawnita only arched an eyebrow, her regal show-smile edging toward a real one. Steve came around the end track on his 10' stilts, his head 16' up as he took the slow, giant swinging steps of those poles strapped to his legs. In circus lingo, it would soon be all out and

over. Steve passed me. I'd heard Dawnita recommending the steak across the street. Maybe I'd ask—

Steve fell. Or was falling, I wasn't sure, it happened so fast. When he hit the concrete, Spike and I got to him first. He didn't move, his face in a tight grimace. Charly, tux coat flapping, got from the other end of the arena almost as soon as we did, and told us to unbuckle the stilts from Steve's legs. As we pulled the gold lamé pants up, an ugly crack showed the break on the aluminum pole. Faces in the crowd looked as stunned as I felt. Usually when a performance is interrupted, the band plays "12th Street Rag" to signal an emergency Walkaround for clowns, rushing out to divert attention from some calamity, but this time we were the calamity.

"The show must go on." I love the image of dedicated troupers surmounting setbacks but the phrase also refers to business. Early circuses operated day-to-day on little capital, so no performance meant no money, no food. To make the nut, meaning to cover expenses, came from circus: A farmer would sell provisions to a touring show but take the nut from a wagon's axle as collateral, preventing the outfit from leaving town till it paid him from the day's receipts. Of course Ringling is a big corporation, so no single day's receipts are crucial. Still, the show must go on.

An approaching siren joined the music. As performers exited, the ringmaster kept repeating, "He's fine, thank you for coming. See you next year." Unsure whether Steve was fine or not, I stayed to say the same. This was business too: we couldn't let people leave unhappy. Everything's fine, even when it's not. The ambulance backed onto the arena floor, past workers stacking ring-curb sections. Move-out night, the show must go on, to the next town. Steve's face was pale as he was lifted into the ambulance, and Terry climbed in with him.

"Hey!" Camel John yelled. "Get outta your costume! They need to pack clown wardrobe. You're holdin' things up!"

By the time I got back to the train, after stopping in a bar—and sliding out the side when someone waved a gun in front, Steve was already with Terry in their stateroom. Amazingly he hadn't broken anything. Teaching stilts in Clown College, he'd instructed us to twist to our back if we fell, a technique that worked here. I still wouldn't want to try it. Steve rarely joked, I think because, barely past a First-of-May himself, he decided the responsibility of boss clown required reserve. But now he told Terry that the doctors had okayed him for sex, only she'd have to do all the work. Relief amplified our laughter.

* * * * * * * *

"Katie, you're giggling." She giggled more, and ran off to the swings.

Since January, my time had been anchored to the train and each succes-
sive arena, home and work, with sightseeing in between. But things flipped
in Cincinnati. Here, Riverfront Coliseum—and the increasing tension as
we neared DC—seemed temporary, while a white frame house in Delhi, the
southwest leg of the city, felt like home. That's where my Army buddy Mike
lived with his wife, Mary Jo, and their toddler, Katie. Now a Cincinnati
cop, Mike had picked me up from the train, which he'd followed on a
police scanner through Kentucky, over the Ohio River, and around the
big sweeping circle past the old Art Deco terminal to park near Riverfront
Stadium. Diving into domesticity, I enjoyed a home-cooked meal, while
playing peek-a-boo with Katie. That began a cozy pattern. Mornings, Mary
Jo and I took Katie to a park or the fountain downtown, and then I'd use
the car Mike loaned me to drive to work, like a commuter. The shows
themselves scarcely registered, a lull until my return to Delhi. Then, as we'd
done in the Army, Mike and I played Yahtzee into the night. Making it even
homier, after early Mass on Palm Sunday, Mike's and Mary Jo's families—
grandparents, parents, kids—squeezed into the living room to watch me
apply my clown face.

As greasepaint covered my face, a little cousin of Katie's whimpered. His
mom apologized but I told her not to worry, and once he retreated behind
her leg to watch, he was fine. I rarely had trouble with scared children. I
approached gently, to ease my way in with the quiet ones or to quiet the
noisy ones. Parents could be a different story, a few acting as if I were toxic,
in effect teaching their child to be afraid, while others were so determined to
get a photograph that they shoved a crying child at me. Fortunately, worry-
wart or insensitive parents were rare. As I roamed the stands, I always based
what I did off each child. Often their comfort level was a matter of distance,
which could be remarkably specific. Eighteen feet or eighteen inches, if I
got closer, a child might cry but then stop once I took a step back over that
imaginary line. What I did increasingly came from them.

My makeup had been getting simpler, clearer. Though the changes had
been small, they were enough that my early makeup now embarrassed me.
The biggest change was turning the red circles on my cheeks into shading to
frame the white around my mouth. Cuz had stopped by my trunk to chat,
a rare occurrence, and said that circles on my cheeks looked amateurish,
so though I didn't change anything right away—I told myself I needed no
advice—a few shows later I started experimenting.

Simplicity was sinking in. I'd been thrilled in rehearsals to add a horizon-
tally striped rugby shirt to my vertical-stripe pants, and green tie with purple
polka dots, but eventually realizing that was too busy visually, I'd bought a

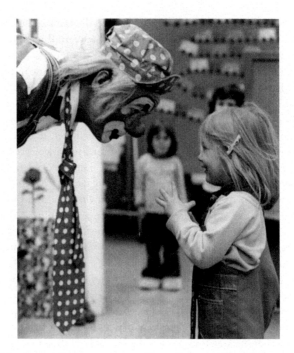

Figure 4.1 Something important to tell me. Author's collection.

short-sleeve white shirt at Salvation Army, which calmed the visual effect. My clowning was calming down too. For Clown Band, tying a helium balloon to the battered cornet I'd found in a Knoxville pawn shop for $25, I pretended the balloon was lifting my new-old horn, but where once I'd have had it flying all over, now I kept movement small, a slow rise till the cornet pointed up and I was on my tiptoes, and then raising the other hand to nudge it down. Simplicity hadn't yet helped Dean and me. Knoxville was where I tried grabbing the whip in Whipcracker, and he stormed out. Another show I used a Harpo Marx bit, lifting my leg at the knee and putting it in Dean's hand. Instead of playing along, he simply said "Ah, Harpo" and dropped my leg, content to show he got the reference. The closest we came to really working off each other was the time he accidently ripped the paper with the whip. That was a fun change of pace but he suggested we keep it that way. Didn't he get that the whole point of the gag was to be inept, not ept?

After the second show Sunday, I returned to Delhi one last time. Mary Jo had baked a cake and Mike had decorated it in a clown face. A friend of theirs I'd gone out with called to say she hadn't returned for the weekend

as promised because she was too attracted to me: it was the sweetest blow-off I ever got. Katie, allowed to stay up late, ate her cake and then helped me with mine till she fell asleep in my lap. When Mike drove me back, we turned the corner to the train and saw it moving! Allan was on the vestibule, waving me to hurry. Fortunately it had just started chugging so Mike pulled alongside on the tracks in the street, and I jumped out and ran around the car. Mike kept driving, keeping pace with the train as I stood in a stunt-man straddle, one foot on the bottom vestibule step and the other in the car window, while he passed up my stuff, including the cake. As we approached an overpass support, he veered away, with a goodbye honk.

* * * * * * * * *

In DC we stayed for a month in one spot, a siding next to the Amtrak line along New York Avenue. That made it something like home, as we played two weeks at the Armory, and another two weeks at the Capital Centre in suburban Maryland. Back from the show at night, we'd sit on lawn chairs or railroad ties from a tumbled pile, looking across the street at the locals on their front stoops looking at us. But the homey feeling was illusory. One night Allan and I got off the bus to see Sly with his bags, waiting for a cab. A veteran member of the King Charles Troupe, he'd been learning trapeze with the Farias, so I figured him for a lifer but he said he had no future here, and was off to California with his girlfriend. Home life on the circus was strongest with families and each nationality. The rest of us—King Charles guys, showgirls, clowns, workers—were unbonded ions. During rehearsals in Venice, I'd snickered how Mama and his wife, who worked women's wardrobe, acted like an old married couple but it tempered the instability of this life.

Mornings I turned tourist, visiting the Smithsonian, the Corcoran Gallery, the National Gallery of Art. My trip to the Supreme Court was doubly dramatic, its massive doors swinging open as I climbed the stairs, as if welcoming me, while—by remarkable coincidence—the Court was hearing a circus case. The Human Cannonball, Hugo Zacchini, had sued a TV station for broadcasting his entire act, from launch to landing in the net. The station invoked the First Amendment, while Mr. Cannonball's lawyer won by arguing that showing the whole act would make people less likely to pay to see it. One night off, I attended American Ballet Theatre's *Firebird* at the Kennedy Center. Inspired, I got up early the next morning to take an ABT class, though my sneakers and shorts looked silly among the dance shoes and leotards—invented by Jules Leotard, the original Daring Young Man on the Flying Trapeze.

A tour of the White House for circus folks was fine but a letdown after expecting we'd meet Jimmy Carter. He and Rosalyn had a young daughter, Amy, but they didn't attend the show. I guessed it was because Carter wouldn't cross the musicians' union picket line, protesting Ringling for only using the small band we carried instead of adding locals each town. Carter's press secretary Jody Powell did come with his family. That's when I violated Ringling's rule against politics. Powell and another Carter advisor, Hamilton Jordan, had been accused of being male chauvinist pigs, so for Walkaround, I borrowed Dean's foam-rubber pig from Clown Car and used duct tape to put "H-A-M" on it. I saw it working on three levels: most of the audience would get the small jest of a pig named "Ham"; some would catch the hint of "Ham" Jordan as a pig but consider it inadvertent; and a few would enjoy the political joke, *and* assume I did it intentionally. (Maybe Jody teased "Jerden" about it at a staff meeting, and Jimmy laughed.)

My sightseeing gave me a new perspective on Irvin Feld. Knowing that Irvin and his brother Israel had expanded their drugstore into records, then concerts, then circus, I assumed he was in the circus business by accident, and might as easily be selling insurance or tires. Compounding this view, the 1960s framed business as enemy of creativity and freedom. So riding up the elevator on a visit to Ringling's headquarters, 18th Street NW, I assumed I'd be venturing into the belly of the beast. There was a beast but a stuffed one, Gargantua in a glass case just off the elevator. The whole office shimmered with the same showbiz flair. The carpet was vibrant purple, while rectangles of lights framed the hall like a row of marquees. This was no control-freak control center for a business that could have been pumping out anything, nor was the plush purple carpet mere decoration, a designer's splash, it was the favorite color of this circus man. And he had a significant job, to keep "Ringling Brothers and Barnum & Bailey Circus" simultaneously traditional and modern. Circus seems eternal but it's the same age as the United States, and even an American institution like Ringling must do more than sustain. Mr. Feld had many responsibilities, including keeping both units profitable; soothing stars; dealing with foreign governments, animal regulators, and railroads; assessing ads; and administering Clown College. He also had to grab attention. P. T. Barnum didn't join circus till late in life, out of retirement, and historians argue how much he took credit for what circus men did. Still, he's an apt symbol for circus because he was a master of that key circus skill, publicity.

Passing Feld's office, I saw his infamous computer. Computers had only recently shrunk from room-size machines so it was weird to see something small enough to fit on a desk. Charly's daily reports were apparently keypunched into this machine, including, rumor said, sexual histories. I wondered if I could access Tito's seduction techniques.

Business is personal. Even as Feld focused on the bottom line, other human impulses—ambition, pride, worry—remained in play. He wanted publicity in the *Washington Post* to sell tickets, but also because it was his local paper. He wanted to be proud of his show among people who'd known him starting out, or his rich pals puffing cigars, or with intimates. Just as clowning expressed me, Ringling expressed Irvin.

* * * * * * * *

I liked the Armory. The old wooden floors were easy on the legs, and the bleachers made it a cinch to climb through the seats. Also, that's where a dream came true: I became a basketball star.

Every Saturday between second and third shows, the King Charles guys set up one of their hoops for a pickup game. At the Armory, it attracted locals who sold popcorn and Coke, sellers called "butchers" in circus lingo. When I emerged from the Alley in my yellow shorts and clown makeup with red nose, the butchers hooted. As we shot for teams, one told me to go away, that I'd embarrass myself, and when I hit a basket to make the third on a team with Frog and Bosco, he yapped, "That's luck, man!" Mr. Yappy got the ball to start. Figuring me for the weak link, he drove but I blocked his shot. Next he backed me to the basket, till I sliced around him for a steal, leaving a streak of white greasepaint on his black back. Now I had the ball and, faking a pass to Bosco, I took a quick step and scooped a reverse lay-up. It was street rules, make-&-take, so we got the ball again. Frog fed me and I made another lay-up, despite a hard bump. When they dropped back against another drive, I hit from the outside. Recognizing the hot hand, Bosco passed me the ball. I drained it. The guys waiting for a game mocked their pals, though it wasn't clear what was more insulting, that they were being beaten by a white guy or a clown. Then the mockers lost next. Frog, Bosco, and I held the court till Charly yelled "Doors," the signal to let the audience in. It was the best I ever played. Later in the seats, one of the butchers who'd played slapped me five and told customers about my moves. Another butcher did the same. When I ran into Yappy, he offered me a Coke off his tray. Having sold beer at Philly's Vet Stadium, I knew he had to pay for it, making his offer a tribute.

One afternoon, changing for Charivari into my cowboy chaps and clown boxers with no pants—mumbling under my breath at the clown who copied my clown boxers after he "lost" the tights of his caveman costume—I went out a door by the Alley to the smell of lilacs. If I squinted, the broken bottles on the cracked asphalt in the sun could have been diamonds, and the newspaper scraps blown against the sagging chain-link fence looked like fluttering pennants. As I leaned back on the sun-warm bricks of the

building, Cuz wandered out and sat a few feet away. Had he come to apologize? In Charivari, Dean, I, and two others did our hop on the box one-by-one to stack prone on top of it, with others diving over us, until another pretended to vault but pushed us off instead. With the pusher out sick, Cuz had taken his place but didn't realize it was a pretend push, allowing us to control our fall. Instead he shoved hard and we landed on each other, banging shoulders and shins. Backstage, Dean sniped at Cuz, who sniped back. Playing peacemaker, I went later to Cuz to tell him that it did need a lighter push. I intended a friendly gesture but he barked, "I'm sick of working with amateurs!" and stormed out of the Alley.

Now he observed it was a nice day. I agreed. He asked about my cold. Snot had been gunking up my rubber nose, so badly that I had to stop wearing the nose, which made my face feel naked. Cuz suggested allergies but I'd never had them. I'd never had headaches either but *something* was waking me nights with my head throbbing.

I ventured that the clowns had been arguing a lot.

"Yeah. It's the least together Alley I've known."

I said it's hard to be united when we're treated like chorus boys.

"Eh."

They just want cookie-cutter clowns who fit the costumes and don't care if our clowning's good or not.

There it was, the suspicion, the critics' sneer internalized, that had haunted me since Venice, that Ringling didn't care what we did, only that we showed up and looked like clowns. Cuz had said the same so I expected him to agree. Instead he threw me a curve.

"Doesn't matter. Maybe they care, maybe not. But in the middle of all the glitz-&-tits, you can clown."

You can clown. Those three words broke a logjam. After the early shock of the schedule, I'd acclimated, getting more comfortable, but something had been missing. I knew I was supposed to be *like* a clown but what did that mean when I *was* a clown? Unable to square that circle, I kept feeling uncertain, as if I didn't fit. But when Cuz said "You can clown," a light clicked on. Each show offered opportunity. Whatever management thought, they *gave* us that opportunity. It came in small gags, group routines, and, for a few of us, in the seats. Even production numbers, with the choreography and cumbersome costumes, had gaps for clowning. What I'd done directing traffic in Charlotte, and on the animal walk here, I could do in performance. Sometimes in the seats I'd worked off whatever came up between individuals and me. Now I recognized that I could—should?—do that all the time. Being a clown meant doing things the way I do. It meant being like me. Being me.

* * * * * * * * *

"First-of-May" is history on the hoof, the label for rookies a hint of old-time circuses, waiting for April roads to dry before rolling out the wagons in May. Just as every baseball team in spring training is a potential World Series champ, every circus in spring sees blue skies and grass lots ahead. May 1 was also Law Day, my private joke as a (still-secret) lawyer-clown. And this first of May, this First-of-May presented his first routine.

Getting my own cornet had inspired me to a gag, borrowed from the comedienne Gracie Allen. In "Concerto for Index Finger," Gracie—George Burns's partner—sat at a piano with an orchestra and, after they played a passage, she'd play an incorrect note. I asked Allan, our best musician, to work out a variation with me.

It was ironic that we partnered on this, after I'd unhitched myself from him in Walkaround. At first, the bread slices he'd given me had been the best thing since sliced bread but the fun faded as Allan kept doing the same thing every show, walk-stop-turn-to-me-repeat. That gave me little to do except follow-stop-act-innocent-repeat. Maybe he was expecting me to do something else but we didn't talk about it, and after a while I found another fish to fry, so to speak, leaving Allan to chase Lenny in a giant fish costume on his unicycle. Then I started putting others between the slices, till I no longer walked with Allan at all. I'd discovered that most of my bits worked better when I didn't seem to be making a joke; my bread bit transformed when I turned as earnest as a sous-chef du cuisine seeking a third Michelin star.

Yet despite the demise of our personal bread-and-circus, Allan and I had become buddies. We goofed together by the back curtain, and when he stopped on the track near me, I leapt into action. Or rather inaction: I pretended to be immobilized and—oh, joy!—he picked up my invitation for an impromptu Dead-&-Alive routine. He pulled my right arm down and I lifted my left, he pushed a leg and I kicked with the other one. Now with this horn gag, I saw us becoming a team, improvising amid the chaos of Clown Car, thinking up new gags backstage, gabbing about Buster Keaton at the train.

As we rehearsed backstage at the Cap Centre, a new arena in the middle of nowhere in Maryland, lessons of half a season emerged. First, a good gag has structure. "Antics" piled on each other, with mugging and flailing, get laughs but that spaghetti is unsustainable. Usually it isn't even funny, despite the apparent endorsement of laughter. People often laugh because something *signals* humor. But a good clown gag, like good movies or plays, has a beginning, middle, and end, organically connected. An initial conflict leads to the mid dle, the middle complicates matters, till the end—a resolution called a blow-off—is either predictable, so there's fun in anticipation, or in the

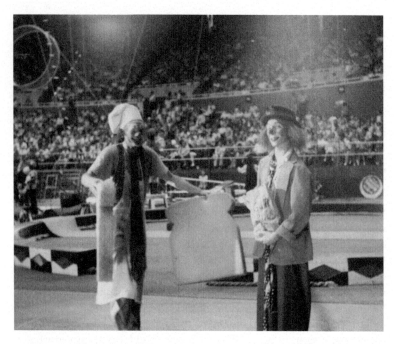

Figure 4.2 Gumby and I smile for the camera, usual for him all the time, unusual for me in Walkaround. Author's collection.

surprise. That doesn't mean a rigid structure. (Dean.) But between structure and silliness lay the sweet spot.

Second, my notions of art were wobbling. Doing theater, I'd embraced the idea that the best, the highest, the most important performers are "artistic," with the audience as refined connoisseurs of higher sensibility. Now, flirting with heresy in the Church of High Art, I began to think that what people called "art" looked suspiciously like the "artistic" and the "refined" in mutual self-congratulation. Nuts to that. Instead, I focused on the work, how something played *between* a crowd and clown.

Allan and I hadn't finished putting our gag together when Steve asked us to perform it the last day in Largo. With guys out sick—or giving themselves a day off to make a longer weekend before we opened Wednesday in Hartford—there was a gap in the second act for us to try what we had so far.

Allan led us out, me dragging a chair behind. After I placed it, oh, so precisely, we did some Alphonse-&-Gaston business over who would sit.

Lou Jacobs would have called it spaghetti but we could fix it. Allan sat and prepared to play. I stood next to him, face intent, ready to toot.

Nothing.

I glanced down at Allan. He was staring straight ahead, immobile, trumpet clutched on his leg. Stuck, he was doing nothing. My insides pin-wheeling in panic, I did the same nothing. Instead of our spontaneous Dead-&-Alive routine, it was dead & dead. Kids, dizzy from cotton candy and blinking toys, and parents dizzy from the cost, watched two clowns not moving. Bangs from gags around the track said time was ticking. I would have played something from my vast repertoire of four songs except that I forgot them all. I forgot the cornet in my hand. I forgot to breathe. For all our trouble over Whipcracker, Dean and I at least kept going. Allan and I could have been deer in the headlights, except we'd already been run over.

Looking in eyes in performance had been hard because I'd been shy as a kid, and my youthful self-protection had turned into habit. Now I discovered another problem with looking in eyes: it reveals when you stink. The eyes in this crowd showed their growing recognition that this was no comic pause, but a brain-freeze. When Allan unfroze enough to look up at me, it was spooky, as if the real Allan were inside his skull, looking out, pleading. Desperate, I made a face at the crowd. That got a trickle of laughs, prompting another lesson: they weren't spontaneous laughs. With a shock that would have stunned me if I weren't already stunned, I realized they were *pity* laughs. These people not only knew our gag was rotten, they knew that *we* knew they knew, and were trying to help. They were being *encouraging*, as one would encourage a tot's magic trick. No response would have been better. Or booing. Boos would have been nice, suggesting we were pros who could take it.

I'm surprised Allan and I didn't have to be carried off like props. When George Burns said circus is the only place left to fail, perhaps he foresaw this horror.

Chapter 5 Love 'Em & Leave 'Em ✑

May: Binghamton, Broome County Veterans Memorial Arena/Hartford, Civic Center/ Portland, Cumberland County Civic Center

> *"A child said What is the grass? fetching it to me with full hands;*
> *How could I answer the child? I do not know what it is any more than he.*
> *I guess it must be the flag of my disposition, out of hopeful green stuff woven.*
> *…*
> *Or I guess the grass is itself a child, the produced babe of the vegetation.*
> *…*
> *And now it seems to me the beautiful uncut hair of graves.*
>
> Walt Whitman, "Song of Myself," *Leaves of Grass*

Every move-out night, Gumby yelled "Love 'em and leeeave 'em, boys!" His merry delivery, with its long, singsong "e" like a train whistle sliding into the future, turned the seducer's boast into a song of hope for the horizon. Are crowds sluggish? Did a gag flop? Forget it, drop the past like the station just passed, and start over. And when things go well, roll with enthusiasm to the next stand. Young and footloose, we were like Huck, lightin' out for the territory, eager for whatever came next.

No stand brought a fresher—or weirder—start than Binghamton. For one thing, after staying on one siding in DC for a month, it felt novel to be on the road again. The arena enhanced the novelty. With no big openings on either end, the "back curtain" was on the side, which altered the timing of entrances and exits, with flurried dashes in and out to catch up to the staging. Opening night was especially slapdash with two major acts

out, Elvin's Wheel of Death because the ceiling was too low, and Charly's tigers because he'd gone to Portland to check the new arena. After 150 performances, it felt like dress rehearsal again.

I needed a fresh start. Beyond the trumpet-gag fiasco, I'd been feeling bland. Cuz's "You can clown" had seemed like revelation itself but I was still figuring out how to use me in my clowning. Whatever talent I had, I still couldn't tap it on command, performance after performance.

A punk continued my education. Late Thursday afternoon between shows, most of the Alley was outside in the sun, emerged from our concrete cave and lounging on the Spec floats in their blue covers. Early arrivals for the evening performance watched us, curious. Even in jeans and t-shirts, we were clearly identified as clowns. The makeup had given me a sense of how celebrities or pretty women must feel, because I was aware of every eye turned our way, somehow even people behind me. Each of us found our own balance dealing with off-duty attention. Today, Cuz wasn't in the mood, so he retreated inside. Gumby kept up his conversation with Bigfoot while tossing out an occasional Hi-there! to awestruck kids. After trying the first weeks to amuse anyone I encountered between shows, I settled into Gumby's detached cordiality.

A scruffy kid in a torn t-shirt zoomed by on his banana-seat bike. His second pass, he yelled "Hey, ya fuckin' clowns!" Lenny swore in reply. Barely older than a kid himself, Lenny seemed to think that punks required a tough-guy response. Of course Lenny's swearing brought the kid right back. Skidding to a stop, he looked to be about eleven. I was closest so he addressed me. "Hey, bozo, does your nose honk?"

No, does yours?

"Lean over, clowny. I got a secret." He side-hopped his bike on to the grass next to me and beckoned with his index finger. That's what kids did when they wanted to grab my nose, crooked a finger and said they had a secret, as if there were an instruction manual for smart alecks. Lenny hadn't figured out the signs yet: his nose got pulled off weekly. I leaned close to the kid, then jerked back as he grabbed air.

"Ya fuckin' clown!"

Cool it, there are children around.

"You're a clown, ya—ya clowny clown." Implying he wasn't a child helped.

I'm not a clown. See the stripes on my pants? I'm a zebra.

"Gimme a break."

Zebras have stripes, and these are stripes, right? So I must be a zebra. That's logic. I learned that in college.

"Oh, yeah? Zebra's don't go to college."

I laughed, hoist on the petard of my own reasoning.

Steve poked his head out the door. "Ten minutes! You guys better be ready!" He barked as if he had caught us screwing around. Charly must have told him to crack down. A handful of guys had given themselves Sunday off in Largo, before the run here. In addition, the Alley had gotten especially contentious lately. Two of our gentler clowns had a fake fight that somehow escalated into swinging fists. Then there was the controversy after Mark's dogs chewed Dean's foam-rubber parrot. A couple First-of-Mays muttered that he should control his canines while older clowns, unhappy that Dean's foam-rubber parrot on the shoulder of his pirate costume echoed Mark's foam-rubber buzzard on his hat, said Dean shouldn't have put his trunk within reach of the dogs. Squabbling wouldn't have been allowed on the Red Show, not with Frosty in charge. But to be fair, even Frosty would have found it hard to wrangle our wrangling crew. Anyway, I was beginning to see the benefit for me in this loose oversight. With no one strictly in charge, that gave me freedom to try things. Like engaging this young punk.

Time to go. See ya later, alligator.

I expected the usual response, "In a while, crocodile," but he surprised me. "See ya 'roun', clown."

Later, as I walked along an upper aisle in Come-in, there he was. I worried as he followed me that he'd swear again, but when I stopped to greet other kids, he stood to the side, watching. When I had to climb down for Clown Band, it was "See ya roun', clown" and "See ya later, alligator," so I called him Gator when he showed up again the next show. He didn't look to have money for a ticket, and kids can't sneak under concrete walls the way they could under old-time canvas, but somehow he found a way in. Dialing back his attitude, Young Master Urchin had appointed himself my sidekick.

Not seeing him the next show, I climbed over a few seats—why walk along aisles and rows when there are seat backs to climb over, balancing my 9"-wide shoes on 2"-wide seat arms?—to sit next to an elderly woman. She reminded me of my grandma, in a light-blue pants suit and high-necked blouse, her plump face framed by coifed white curls. As usual, I pretended I was waiting for the show too but her response as I sat made me pause.

"Honey," she said, "my husband just died. This is the first time I've been out."

Real life. Going for a laugh didn't seem right, so I simply said that's what clowns are here for. It felt like a stupid cliché as I said it, a poor

response to grieving, but she put her hand on mine and said "That's nice." Maybe it wasn't stupid. Awkward and inadequate, it was human at least, like comforting a friend. When Cuz had suggested looking in people's eyes, I thought it was technical advice, a way of making sure a bit is working. It was more. Looking into eyes, windows to the soul, you can see if what you are and what you're doing fits that person. It felt too grand to say this widow and I were sharing fears or hopes but something deeply human flowed between her eyes and mine. I told her I was sorry.

"Thank you."

Dean walked to the front of the seats below us, waggling the whip to summon me. If he weren't careful, I'd make him wear that whip.

I have go now, gotta make funny.

"I know."

I kissed her cheek and headed down. Dean and I had been moved to Come-in's second slot. In the first slot, where we started the season, few people had gotten to their seats yet, plus we had to compete against noise from Billy and Buzzy yelling in their Sputzo Escape Artist up the track, and in the bangs of Spike's car in Ring One. Now that we'd moved to the later slot, we enjoyed less noise and more people watching.

Finished and in the seats again, I saw my new partner, Gator, who joined me roaming. If no kid said "You're a clown," Gator fed me the straight line. Once when I didn't use the joke, I heard him saying, "Nah, he's not a clown. See the stripes on his pants..." When we were alone moving to another section, he'd ask about clowning but otherwise he stayed in the background, letting me work. He noticed that I waded past the shouters in a clump of kids to get to the shy ones at the back and he started escorting them up to me. When I called him my valet and blamed him for my baggy pants, he shot back, "They're baggy like your head." It wasn't a great joke but we were playing. Not that Gator turned into a paragon. He still looked as if he had cigarettes in one pocket and a switchblade in the other. The surliness did have advantages. Before I could deal with a kid trying to stomp the temptingly bulbous toe of my clown shoe, Gator tugged him aside, saying, intensely, "Do not. Be mean. To the clown." Then he winked at me as the reformed stomper rejoined the group.

He was quite a kid, the little f —

* * * * * * *

Stevie Wonder's "Songs in the Key of Life" became the soundtrack of 140, playing from one cassette player to the next. If each stand was a fresh start, the train runs were time suspended. Monday, after Richard cut my hair, I

joined Buzzy on the vestibule. People in cars driving by or working outside waved at us, and we waved back. No need to act distantly cool, we *were* cool. On long curves, silver cars stretched in front and behind us, shining in the sun. The train was more than its component parts—stock cars, concessions cars, generator, flats carrying rolling stock, the Pie Car, sleeping cars. Though Isaac Bashevis Singer was referring to oil cars, he got it right in his book *In My Father's Court*: "I know exactly what I saw at that time—a train with oil cars, but there was a sense of mystery then that still remains with me."

A chilly afternoon sent Buzzy inside. As the train glided along a stream with a beaver pond, I leaned out to sing into the cold. It may have been the merry month of May but snow shriveled the leaves whipped by our passing. Seeing a horse in the fading light of western Connecticut, I tried a haiku:

Up a long green hill
Under a swirling gray sky
A black horse gallops.

Lured by rumors of pie in the Pie Car, I bumped along the narrow corridors, through the stuffy warmth of onions cooking in one car, out to another cold vestibule, then another warm car, this one smelling of garlic.

In the last booth, Prince Paul and Back Door Jack were playing gin rummy. At each arena, Jack, a fat guy who limped from an old circus injury, guarded the back door, the entrance for performers. Last year after the Bar exam I'd flown to LA to see Ringling, and with rare bravado, I'd snuck by him at the Forum, ignoring his yells to stop. When I found the clowns, they were amazed I'd gotten past him. If I told him now that had been me in LA, he'd probably kick me out on general principles.

I joined Allan and Colette in a booth. Despite the debacle of our gag, Allan and I stayed pals, thanks to her. He was much younger than me so I didn't understand how she could have switched so casually from me to him. What was she, a guy? His youth had been driven home when he asked my help with his taxes because, he said, math had given him trouble "in high school last year." Still, she hadn't stopped flirting with me. When they'd rented a motel room in DC, she'd invited me to share it. Still, the flirting edged into sparring, with Allan always agreeing with her. He knew which side his bed was buttered on. Now we three got silly together, talking in goofy voices till the gin game objected. When Billy's crew came in, she took Allan on their way. The five musketeers—Billy,

Cuz, Buzzy, Hollywood, and Taz—usually rode overland in the van of the sixth, Smitty, but this time he drove two lovebirds, despite their bitching that he charged $20 for gas.

Prince Paul stopped on his way out and cocked his head up and to the side, his habit before a joke.

"Never leave your buddies behind." He said that so often that it had become an Alley mantra. Now I caught a hint of Bob Dylan's lyric, "Just a ragged clown behind," but as always the double entendre leered: Never leave your buddy's behind.

* * * * * * * *

Gumby's merry "Love 'em and leeeave 'em" wasn't *only* about yon horizon. Spring had sprung in Hartford, luring me to Bushnell Park, where a jewel box of a building, all gleaming glass and polished wood, housed a carousel. As it turned, a young woman with dark, bushy hair walked among its horses. When it stopped, she took tickets—letting some kids on free—and then continued her stroll among the horses and chariots rotating to plinky-plink music, as if she were hosting a party.

As I sat on a bench along the wall, she hopped off to take care of something that happened to be right next to me. I said it was a pretty carousel. She said she'd rebuilt it herself, figuring out the job as she went along and cranking it to turn faster than usual because she liked speed. Her assistants, kids from the neighborhood, had been taking tickets, and as it started, she hopped back on. When it came around again, she leaned out from a pole and winked. Her next time off, I told the Carousel Queen I was a clown. If I intended to impress her, it didn't work. She showed more interest when one of the kids said he'd seen the big bread I mentioned that I carried. Asking her name—Tracey—I invited her to the show. Nope. She was leaving for Ireland tomorrow and had to pack. I suggested dinner. When she agreed, I went outside to wait, soon followed by the kid delivering a helium balloon from her. I tied the string to my shoe and lay back on the green grass, watching the red balloon dance against blue sky. Then Tracey closed up and joined me as a bum wandered over, announcing he could guess my age. As we listened to his spiel, she touched my arm.

At the restaurant, she seemed to know everyone, including Governor Ella Grasso, leaving as we arrived. I discovered why being a clown wasn't a big deal to Tracey. She already knew circus folks from a circus film festival she'd organized the year before, with midnight screenings so they could attend. That was the first time Ringling had been in Connecticut since the worst disaster in circus history, the Hartford fire of 1944.

When I invited her to the show again, she agreed, I think because I added that I could sneak her in a side door. The roguery appealed to her. At the arena, I pointed out the door and told her to wait. Around at the performers' entrance, was it my imagination or did Back Door Jack give me a suspicious look? Running to that door, which I'd noticed while practicing juggling off by myself, I cracked it open and slid her in. I joked we were like undercover agents. When she grinned at the double entendre in "under cover," I kissed her. She kissed back. Hot-diggity.

Leaving her, I hurried to throw on my makeup. Back in the arena for Come-in, I didn't see her till I noticed the cluster of act men and clowns. Showgirl Janet said that Come-in should be called "Come on," for all the flirting that went on. As I waved at Tracey on my way to Whipcracker, I heard Smitty call her "very contractive." She subtly extricated herself from him by giving him carousel passes to spread among the clowns. Leaving, he told me that he could have had her if he wanted. That reminded me of his boast about his "great imaginary mind."

When I finished Whipcracker, the cluster had evaporated and Mark was leaning on the railing by her, chatting. Somehow it was clear that he wasn't flirting. Partly that's because he was an old guy, and always placid—he never got embroiled in what roiled the Alley—but Mark managed to seem simultaneously a clown joking with Tracey and a friend in conversation—albeit a friend with a foam-rubber buzzard bobbing on his hat. It turned out they had become buddies from her film festival. Watching them together, I saw a clown whose quirkiness was the seam where personality and clowning joined.

Be yourself. I'd known that lesson for years. Between acting, books, and 1960s influence, I'd often said it myself. And that's what Cuz had told me in Atlanta, "Don't be clowny, be yourself." But "be yourself" is a performance paradox, a gumbo of instinct, habit, and self-conscious awareness as you try to act, as a clown, in an exaggerated way that is simultaneously who you are. Watching Emmett Kelly at that Sarasota benefit in January, I hadn't been impressed. He seemed to be doing nothing except nodding and greeting the crowd as he shuffled along. Now, more experienced with crowds, I recognized that he had been masterfully weaving a web of connection. On TV and in movies, directors show clowns getting gales of laughter—at bits that would generate no laughs—while the same directors turn the camera backstage to display genuine human connection. But good clowns create human connection, whether big laughs or, like Mark with Tracey, a quiet moment. Just as importantly, "be yourself" meant not pandering. As Buster Keaton said about comedy, create a character, and then the character does his best, but with no begging. Connect by meeting as equals.

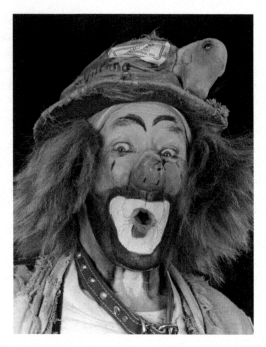

Figure 5.1 Mark Anthony: No bee in his bonnet but a buzzard on his hat. Author's collection.

My clowning had been inside me all along, like Bert Lahr's Cowardly Lion and his courage. My bits weren't different than me, comic buttresses to the work. They *were* me; *I* was the bits. The same with my costume, or, increasingly, costumes. The size 60 blue jeans my parents had found? They were a totally different look than the pants I'd made in Clown College, but using suspenders to bounce the voluminous pants was me, was my clown too. I alternated pairs of shoes once I added size-20 Converse All-Stars, provided free by the guy who built shoes for NBA stars. A wide, red-and-white striped bowtie I'd made for fun in Clown College joined the wardrobe, for times I felt snappy—it could be pulled out and snapped back by its elastic—while my knee-length green-and-purple tie emphasized my height. The growing variety fit different modes, different moods, all me. After I got a full, orange yak hair wig and stopped using the green hat with white polka dots sewn with fake fur, I found a replacement hat at a Scranton Army-Navy store on the bus ride to Binghamton, and discovered that

pulling it off and on made it more than a hat, more than a prop, it helped constitute who I was. So too in production numbers: when I got off Leutze during Menage, I ran over to dance with Susu on the track, because I liked—my clown liked—to dance. Cuz had been absolutely right. Precisely because Ringling's show was so big, it had gaps where I could clown, adding me.

Seeking my clown character, I had focused on the noun "clown." What is my clown? Now I searched for the verb: to clown. I never imagined that grammar would improve my clowning.

Leaving Tracey to Mark, I walked up into the seats, where a large family huddled over their tickets, figuring out where to go. Looking over shoulders, I said, Wait, is this the right day? A quiver rippled through the group till they saw who spoke. Then they laughed, partly in relief that it *wasn't* the wrong day, partly because a clown had approached them. The daughter giggled, which prompted my Stop Giggling bit. That was also me. I'd watched my dad do it long before circus, and used it myself with the preschoolers I tutored in college, and with my sisters. It was a lovely bit, building a laugh the way puffing on sparks in kindling makes a fire blaze. But because it was familiar, I had dismissed it as just me saying stuff, not real clowning. But like Mark with Tracey, it was me, connecting to others.

With this girl giggling, I turned mock-serious: Young lady, this is serious business.

She giggled more.

Please, miss, do stop laughing.

She tried to stop, which made her laugh more.

You dooooooo realize you're giggling?

She nodded, giggling.

Are you a giggle-puss?

Now she couldn't stop. Her family, which had been smiling indulgently, succumbed to real laughter themselves.

Same song, different verse: My clown was me. Kids are people. Adults are people too. Whatever happens is, as Billy would say, "what it is, man."

After the show, I walked Tracey to her apartment, as slowly as I could to prolong the moment. I told her I had a great sense of spatial relations and could help her pack. She grinned but shook her head as we detoured to the park. She had to pick something up from the carousel building. Unlocking the door, with traffic thrumming beyond the trees, she didn't turn on the lights because it would attract attention and she could see by the glow of the park lights. Waiting, I sat in one of the carved cars on the

carousel. When Tracey joined me, she teased that I had picked the Lovers' Chariot. Then she kissed me. A polite person, I kissed back. On lucky Friday the thirteenth, when I found her and would lose her to Ireland, the Carousel Queen and the Circus Clown made out in the back of the Lovers' Chariot.

* * * * * * *

Portland sparkled, with the train swept by breezes off the Bay of Fundy. A new arena brought Ringling here for the first time in decades, and we were greeted royally. Nearly every store sported a window card for the show, an old-fashioned touch. Richard and I fell in love with the place. He said he wanted to move here, that he'd return after he left circus, maybe to work with puppets. As we walked into Boone's for its $6 lobsters, Mark and Prince Paul were on their way out, while Billy and the gang had just gotten served. Afterward, we had to wait behind a fire truck hosing down a fish spill on the road. This was definitely a sea town. After Thursday's shows, Billy organized a cruise.

The only drawback was the six-pack. With the show returning after many years, management anticipated massive crowds so they scheduled a six-pack, the usual three shows Saturday followed by another three on Sunday. A Russian proverb says, Don't overwork a willing horse. Management apparently didn't know Russian proverbs.

For me the feel of a performance increasingly depended on small moments and private pleasures. That always included Leutze. Waiting on her neck one afternoon, I draped my leg on her head, like a hand on a pal's shoulder. Bigfoot said the other elephants wouldn't tolerate it, that I was lucky. Amen, brother. Here I noticed for the first time that the ringmaster's intro of Menage promised "tons and tons of thundering tribute" just as the showgirls rushed in. I didn't share my observation with Lynn. I was a trial for her. Though I always swung or swayed her exactly as the choreography required, I varied my own steps for fun. That bugged her, and she said it made me look foolish. Guilty as charged. Anyway, my goofing made her look better by contrast. Susu got that. When we danced in Menage, she lit up. Dawnita got it too. I'd stand in front of her as she was posing on the track, then suddenly "notice" and hop out of her way, full of faux-apology. I loved watching her Mona Lisa smile light a shade brighter.

Portland gave me another treat. The first performance in town, I'd noticed the ring of follow-spot operators, spread evenly in the dark

around the catwalk above the highest seats, the spill of light from the back of their instruments casting each one in silhouette. They noticed me too. In Clown Car, the car chased me with my 5' yellow wrench up the back track as usual, and I didn't run around the end track as usual, instead going straight out a door in that corner to hurry behind the seats to the next corner, so when I poked my head out, a spotlight hit me. The operator's light chased me down the front track and into Ring Three with the car. Billy was right. If one person gets the joke, it can radiate out to others, especially when that person has a big carbon-arc lamp.

Despite Portland's pleasures, facing three more shows Sunday felt leaden. I dragged through the first one, for a small crowd, our tiniest of the week. The geniuses in marketing couldn't draw enough people to fill the regular schedule but we had to do an extra show anyway. Second show Come-in, halfway up into the seats, I was turning back down when a young woman approached.

"Hi, could you do me a big favor? Say Hi to a little girl?"

She pointed up. Near the very top of the seats, a few rows below the catwalk, a girl was waving. Many reasons said to decline. Clown Band would start soon. The girl was way up. I couldn't get to everyone; for every child I engaged, I had to pass many more. I was weary from the long week. I was annoyed at this useless six-pack. Still, out of antic perversity, I started up. The family inadvertently created one of my private jokes. People always buy tickets in a row, and the sight of early arrivals stretched horizontally in an otherwise empty section amused me.

No problem finding this kid's comfort zone. With my first step up, she started jumping in her seat. As I got closer and could see her chubby cheeks, the woman whispered,

"Her name's Kimberly."

Good. I could say her name while asking her name. Kids loved the absurdity of that.

"She only has a few weeks to live."

I stopped. I was stunned. I felt embarrassed. This was too private. But I took a breath and continued up.

Halloo, Kimberly, what's your name?

"Kimberly, you silly! You just said it!"

Wait just a minootski, cute-ski! Are you giggling?

It is what it is. She and I played, the way I did with other children. I kidded her, she kidded me. I'd been learning to widen or narrow my focus, like the aperture of a camera, to concentrate on a family, then expand to

the section, or narrow down to one child, then go wider again or back down, depending on how things developed. (It was the focus I'd later use in hospital visits, ignoring all the people around—nurses, the photographer— hospital visits often have publicity in mind—even the family after a greeting and assessment of the situation—so the child and I played in our own world.) Here I centered on one little girl.

Allan tooted at me from the track, to signal that Clown Band was starting. Acting flustered, I slapped palms with Kimberly and ran down the steps, yelling the whole way at the band marching up the track, Wait for me!

The rest of the show was fog, Kimberly's face up there my lighthouse. Every time I walked in front of her section, she spotted me and waved wildly. Even in production numbers with all of us in the same spangles, she found me. I tried to tell Allan about her but couldn't get the words out.

At intermission I went up to her seat. I'd never gone out at intermission but I wanted to give her a balloon. I also never did balloon animals. The only time I'd come close was when the Prince handed me a limp balloon for some reason, saying, "Hey, Wilbur, you went to college: Blow this up." Anyway, as a clown, I didn't like giving things to kids. They get intent on the *stuff* rather than on what's happening. But I wanted to do more for Kimberly. Not knowing how to make a balloon animal, I blew it into a circle. I started to put it on her head, then realized that looked like a halo, so I switched to playing a pretend tambourine. She wiggled along. Then through Clown Car, Menage, and Finale, Kimberly and I waved at each other.

After the show I went out back and sat on a Spec float, hoping her family would find me. Within moments Kimberly raced around the corner. I pulled her up on the pink float next to me, where we joked more.

Nothing special. Something special. Starting to lose composure, I pulled my long tie over my face, pretending she had disappeared, till I pulled myself together.

Of all the circus clichés, clown with dying child may be the cheesiest one, often trite, maybe exploitive. As I write what I remember, that Kimberly was not dying but lively, is that saying too much? Not enough? I did the best I could in a situation I'd never faced. Unaware, I'd been preparing, learning to be more open to whatever happened, thanks to the widow in Hartford, thanks to Mark's implicit lesson as he talked to Tracey, thanks to Cuz's "You can clown" in DC. So in those few moments with Kimberly, I tried doing what the cliché predicts: make her happy.

They had to go. Her mom handed her a $5 bill to give me. I tried to decline but like my balloon, it was an urge to honor the moment, so I let Kimberly push the crumpled bill in my hand. Thank you, sweetie-pie.

I walked with the family back to their cars. As she bounced ahead to tell her mother some nonsense I'd spouted, an uncle fell in step with me. She was seven. Leukemia. No one had told her but they thought she sensed it. At the car, Kimberly and I looked deep in each other's eyes, then hugged. As they drove away, we exchanged goofy waves. God be with you.

I had another show to do. No time to honor the memory. Or wallow. Or whatever it was I was doing, standing in the middle of the street.

The show must go on. The last performance rattled around, last of the day, last of the six-pack, last of the Portland stand. If I'd been conserving energy, there was no need now. When clowns entered for Walkaround, the end track was empty so I ran down there with my bread.

A spotlight lay on the ground. Frowning in fake consternation, I stepped on it. It skittered away, then came back toward me. Oh, joy, a spotlight operator wants to play. Acting frightened, I held up a giant slice of bread as a shield and the light hit it, the "bounced" to the track. Dropping my bread, I stomped on the light and it grew. I hopped up and down on it fiercely—and it disappeared. Peeking under the bread, I stumbled back when two lights appeared. I dove, belly flopping on them and suddenly there were three, then four, five. The spotlight operators were having fun too. I tiptoed away and the lights jiggled up and down as if tiptoeing themselves. I captured light between my two slices—a light snack?—then spots turned me polka-dotted. Jumping and running and diving, earnest in every move, I emptied the tank on this stretch of comic nirvana. Only aware of the other clowns passing enough to dodge them, I danced with light.

At intermission, Skip, the show's lighting guy, said the whole end of the arena had been laughing, and the spotlight operators themselves were laughing so hard on the headsets that they missed their cue for Jeannette's horses.

Henry Miller's *Smile at the Foot of the Ladder* is about a clown who decides big laughs aren't enough and dedicates himself to shared smiles. The first time I read the book, I dismissed it as sentimental. The second time, I found it powerful. Sharing smiles is important. But, lordy, laughs are fun too. I'd gone into the last show thinking I'd put Kimberly aside. Never.

No lesson. No past. No next. Just is.

Chapter 6 Good Ol' Days? ❧

May and June: Troy, RPI Field House/
Providence Civic Center/Niagara Falls,
International Convention Center/Wheeling
Civic Center/Charleston Civic Center/
Memphis, Mid-South Coliseum

"The past," he thought, "is linked with the present by an unbroken chain of events flowing one out of another." And it seemed to him that he had just seen both ends of that chain; that when he touched one end the other quivered.

Anton Chekhov, "The Student"

Polish workers and a couple King Charles guys watched their lines, waiting for fish to tug, while I half-dozed over my book in the sun-speckled shade. Instead of our usual chain-link fences and gravel, the train in Troy sat in a grove along the Hudson River. Butterflies danced their aerial jazz above thin curls of current on the mud, and behind us pink wildflowers ringed a weedy pond, with a leftover sign tilted in the summer heat, "Danger-Thin Ice." Norman Rockwell could have painted the scene. Then Billy cruised ashore with Norman Rockwell's nurse. Billy was the schmoozingest person I knew. If someone interesting or famous was in range, they'd soon be buddies. Now he invited me aboard for an excursion back in time, to the mouth of the Erie Canal.

Circus has always carried a whiff of nostalgia. The first American circus opened in 1793, and within decades newspapers sighed about its good old days. A peripatetic institution, circus sang to a peripatetic country fired by the restless and fueled by immigrants. Though circus was urban from its beginnings, like that other urban institution,

baseball, it too conjures dreamy looks back at grassy country fields under blue skies. The old river towns we played early summer enhanced the feeling.

It started in Troy with an old-fashioned parade on Memorial Day, our horses and elephants joining local high school bands down streets of ram-shackle buildings that looked as if only layers of dirt kept them up. The local paper, encouraged by Ringling's PR team, estimated the crowd at 25,000 people. The arena itself was an ancient barn of a field house, with rickety bleacher seats and windows framed by peeling paint. But nostalgia turned sour with stifling heat, no air conditioning, and cramped quarters. The clowns, shoved into a tiny Alley, bumped each other rushing for Opening, which knocked a support pole onto Richard's head and sent him to the hospital for stitches. A second-year also needed stitches after putting a drunken fist through a window. When Cuz sat in a doorway off the Alley hoping for a breeze, he got into a yelling match with kids, and one threw a sno-cone that broke his glasses. Many in the Alley were indifferent to children, being at heart what clowns have been for most of history, adults amusing adults, but I was good with kids, so I assumed I was immune to problems.

A sultry afternoon taught me otherwise. I was heading to the arena floor to preset the Sword Illusion box. The box, like a square-edged wooden suit-case, had to be placed flat on the track, its three slots anchoring the hilts of three upturned swords so that Lenny could seem to be laid on their points. We'd started the season taking turns lugging it out during intermission until inspiration struck: I was a clown, which made the box a prop. (I kept relearning the same lessons, or learning them better.) So I nominated myself permanent pre-setter, and had been finding different ways to play it. I'd drag the box out as if it weighed a ton. I'd wrestle with it and end up lying on the green track rubber with it on top of me. I'd shift the box delicately, as if calibrating the location to the precise millimeter. Standing on top of it, I struggled to step down the six inches to the track. In Troy I'd persuaded a cute usher to carry it while I pompously supervised. This afternoon, I looked for another usher in the milling crowd. As I fended off darlings try-ing to stomp on my right shoe, a cherub attacked my other flank, jumping full force on the left shoe. Jerking my foot away knocked us both off bal-ance, and he dropped his cotton candy. By accident—probably—I stepped on his spun-sugar confection, my 9" x 13" shoe squashing it flat, a pink oil slick on the green track rubber.

The unruly crowds made the Alley a refuge in Troy. Saturday morning, applying makeup while waking to the day ahead, we nursed hangovers,

grudges, or dreams in a bubble of silence. This Saturday though, Smitty blasted into the Alley.

"Hey, guys! Guess what! That party last night? This chick came up to me and she said—can ya believe it!—she said, 'D'ya wanna fuck?'!"

To say that clowns swore like sailors gives sailors too much credit. Though I'd never been to sea, no locker room or barracks I'd known could match the Alley. Jocks and soldiers swore as punctuation; clowns swore as a form of breathing. Prince Paul had a personal variation, *nearly* swearing during performance. Maybe to keep himself sane as a dwarf clown treated like a child, he spewed *almost* outrageousness: "Gah-dal-rushin-fugga-shell." The near-obscenities hinted at the double meaning of his vaudeville lines, like stretching "as" in "He kissed her *ass* she leaned out the window and he went off in his uniform."

Smitty bounced around the Alley, retelling his tale. "Really! She said, 'D'ya wanna fuck?'! *She* asked *me*."

If he was surprised at the novelty of a woman propositioning him, we were astounded. A guy who thought foreplay meant begging, Smitty seemed poster boy for the involuntarily celibate. He was an amiable puzzle, always saying, "This is serious, man" without being serious about anything. I wondered if playing the fool was an act. Maybe having been teased as a kid, he acted ridiculous to control the jokes at his expense. Smitty reminded me of the character in Turgenev's *Fathers and Sons*, "bustling around the room like a man who both imagines himself delighted and is anxious to show that he is." To be fair, despite the guys who would be happy to print lists of their conquests, it was unclear who did what with whom. Because I didn't say anything about women, some of the guys thought I was gay. Others didn't seem sure about themselves: limp-wristed mincing to tease gays sometimes looked like the teaser trying it on for size. But whatever individual inclinations, the road was lonely. Freud taught that romantic words camouflage lust. The Alley flipped that, sex talk hiding the yearning for romance.

Still hee-hawing about getting "starch naked" with his unconquered conquest, Smitty ended up over Prince Paul's trunk. The Prince came in earliest, got into makeup and costume, and then stared into space from his low stool. Though he was no prude, occasionally declaiming his Ode to an Amorous Midget—"Nose to nose, his toes are in; toes to toes, his nose is in"—he had ignored the braying. But Smitty wouldn't shut up.

"Hey, Prince, can you believe it?! *She* said, 'Wanna fuck!'"

Cocking his head, Prince said, "What do you suppose she meant by that?"

Laughs exploded, doubling when Smitty tried to explain. The irresistible force of the Prince's wit clanged against unmovable Smitty-ness.

After a week of heat and hassles, Sunday night felt peaceful as our bus rattled back to the train. Lynn, her bowl-cut hair quivering at each pothole, told Susu it was the first time in months that no showgirls or clowns had been absent. It wasn't surprising that showgirls missed. They were young dancers out for travel and adventure, with no particular allegiance to circus. But shouldn't clowns be loyal? Commitment varied widely, including those who regarded Ringling as a year-long party, interrupted by some—not all—of the performances. In addition to skipping for slight injuries and ambiguous illnesses, some simply gave themselves personal days. After Dale, my dance partner in Clown College, came to Troy, Billy left with her. (So *he* was why she'd missed our morning rehearsals.) No wonder veterans regarded us dubiously. Only a hospital stay would keep them out but many young clowns returned from time off with grinning excuses too thin to be called flimsy.

Something flew in the window and Susu screamed. The driver slammed on the brakes and we tumbled out like fighter pilots scrambling for their jets, to chase a scrawny teenager running up the hill of a side street. The strife of the week had felt personal, jerks giving us grief, but now I sensed a class issue, this kid staking a claim to his turf in a tough town in hard times. I doubted anyone would catch him. He knew the neighborhood, and had a head start. But chasing is fun, so I ran too. I started at the back of our posse but as the hue and cry of short acrobats faded to huff and puff, my longer legs kept passing people. The kid turned right at the top of the hill and ran along a long block, as I neared the front of the pack. He turned right again, down to the street we'd started from. I was now closest, a dozen steps back, when he made a mistake, slowing to knock over trash cans. That tactic always delays pursuers in movies but seems stupid to me. Why not jump over the cans? I jumped and the two of us rounded the corner almost in step.

Then I made *my* mistake: I caught him. As we grappled by the open door of a seedy bar, he screamed and I instantly realized what its denizens were seeing, a stranger grabbing a boy. To save an innocent—or protect an accomplice—they swarmed like bees from an angry hive, so fast that the first one missed me. The rest didn't. Trying to hang on to the flailing kid, I failed. Trying to duck, I failed.

"Hey Rube" is circus slang for a fight. The phrase emerged from the mid-1800s, either as a sneer at townies as "rubes" or a cry for help from a pal named Reuben. Despite the golden glow of nostalgia, old-time circus came to town as outsiders, automatically suspect. Suspicion was often warranted: Some shows carried pickpockets and rigged games of chance. Jealousy

brewed more trouble, as men on flying trapezes, all the girls they did please. And every town had drunks who simply liked to fight. Hey-Rubes especially erupted in places with many young men. College towns like Ann Arbor and New Haven were notorious, as were mining and river towns. Troy in the nineteenth century, mixing Erie Canal boatmen and blue-water sailors up the Hudson, had been one of the worst. Now it was my worst.

A smack to my jaw proved the last blow in this Trojan war, as things fizzled into a yapping stand-off once the Hey-Rube crew finally chugged around the corner. When the police arrived to sort things out, the kid had vanished and it turned out Susu hadn't been hit. The only wounded were the two least likely fighters, quiet Ned and me, in the second fight of my life. I did my best to use my shredded shirt to cover my t-shirt, with its clue to my lawyer secret. Emblazoned "U.S. Attorney's Office," the t-shirt had been the office softball uniform, sporting a legal citation, *Berger v. U.S.* 295 U.S. 78 (1935): "hard blows... not foul ones." Clearly, the men of Troy didn't regard that as binding precedent.

* * * * * *

The past pulsed through these river towns like a wave through water. Despite the modern sheen of Brown University, Providence's old buildings looked like decrepit 1930s. That's how it felt one night when a shabby street led me to a dive. Regulars eyed me when I walked in, then returned to their beer. I joined them eying the next person in. No woman wears that much makeup so I figured it had to be a drag queen. But plunking quarters in a jukebox, climbing on a wide shelf of a stage, and disrobing roughly in time to the music, she proved me wrong.

Our next stand brought William Faulkner's words to mind, "Memory believes before knowing remembers. Believes longer than recollects, longer than knowing even wonders." Thinking about my first and only circus as a child, I only recollected the heat, splintered wooden bleachers, and a chameleon that died. The rest, including location, was a blank, until my family came to see the show in Niagara Falls. "Slowly I turned"—phrase from a classic comic bit called "Niagara Falls"—and memory hit. On a family trip around the Great Lakes, seven of us traveling—and sleeping—in a station wagon over 2,500 miles, it had been here that we saw the circus. My family's arrival also highlighted a lesson I'd been learning since February. In that Atlanta bar, Cuz and Billy had said that connecting with a few could radiate to people farther away. Regarding those words as alcohol-fueled sentimentality, I shrugged them off. In Niagara Falls though, engaging my family

during Come-in clarified that I'd been doing just that, and it *did* radiate to others. When I made faces at Rick, the row behind noticed. When I fake-cried to tease teary Jan, people 20 feet away grinned. The next section over laughed when I courteously asked for Scott's box of popcorn, then politely dumped the contents on his head. (A great straight man, he muttered "Where did I go wrong?") Those unrelated folks stayed connected to my jokes with family when I was down on the track. Ménage concluded with a cross mount, one elephant standing in the center of the front track facing the audience while the other elephants spread on either side up and down the track, front legs on the back of the elephant in front. This time, as Leutze hoisted her front legs up, I tried a new stunt, inching my feet up her back, till I stood up on her shoulders, holding on to nothing. It was risky, but standing high on Leutze, I waved across the ring to my family, and to my temporary extended family.

"My son, the clown" may not resonate like "My son, the doctor," but it did for my parents. That's what made Sunday breakfast hard, when I told them I might quit. I edged into the subject by mentioning Ron. A laidback First-of-May with stringy blonde hair, he shared his single across the hall with his sweetie, who worked as a butcher selling souvenirs. Undaunted about squeezing two people into his 6' x 4' room, they'd made it homey with seat cushions, a rug, and blue contact paper for the narrow shelves, then added to the domesticity by buying a puppy. Though they regularly said "shit" and "piss," they talked to their "baby" about "poo-poo" and "tinkle." The euphemisms made me want to regurgitate an undigested meal. But when a wastebasket, decorated of course, clanged against my door, I recognized trouble in paradise. The next day, she was gone. Soon after, he called a lemonade butcher a bitch, a shocking word then. He should have apologized anyway but her being the sister-in-law of our assistant performance director Tim made it obligatory. When Ron got back to the Alley, Herb was boasting in a singsong voice that he was the only clown with style, while Spike bellowed over him, "Never hit your mother with a shovel, it leaves a dull impression on her mind!" and the Prince muttered, "Hey, you jerks, take it out o' the Alley." In the cacophony, Ron screeched, "This is *exactly* why I'm leaving!" I was annoyed that he blamed the Alley but he'd hit a nerve.

Now, telling my family that I might quit, I had reasons: life on the road, lack of praise, the quarreling, loneliness. What I didn't tell my family, because I couldn't face it myself was that I hadn't figured out how to really clown. I had started well. I'd have been totally clueless not to spark *some* laughs, and as I improved, response became less random. But I felt no

mastery. What I had learned, ironically, made clearer how much I hadn't learned yet. And this life was too hard to just fill a costume. That week's move-out night didn't help, reinforcing my loneliness. At a party locals threw for circus folks, a woman in peasant blouse and India-print skirt asked to see how we lived on the train. In my room, jangling her bracelets, she announced she would read my Tarot cards. (The matriarch of one of the riding acts, Mama Slavovi, read gypsy cards for her daughter-in-law, stopping once the younger woman got pregnant. No tempting fate.) As my new friend laid out the cards, I patiently waited for the evening to unfold, putting no moves on her. But maybe she wanted a move. Suddenly she gathered up her stuff and left, with no explanation. Not tonight, honey, the cards say I'll have a headache?

What happened to keep me on the show? Wheeling happened.

We had an old-fashioned circus backyard outside the arena, spread along the bluff overlooking the Ohio River. Usually folks who traveled by trailer stayed at an RV park away from the arena but the Civic Center had space out back so a village formed, hoses and cables webbed between trailers, with lawn chairs, wading pools, and grills around the door, and children everywhere. One afternoon, Carmelita, the eight-year-old in the Flying Farias trapeze act, dodged around me, chased by Pinky, Elvin and Jeanette's daughter, who'd joined us after her school year was over. The end of the school year shifted us to our summer schedule, 2:30 and 7:30 performances rather than afterschool 4:00 and 8:00. Though it only gave us an extra hour between shows, it felt like more. It was fun being around so many children. One night the Romanian star Eby gave me her baby to hold while she did her single trap act, climaxed by a headstand on the trapeze. I'd taught Tata, Carmelita's little brother, also in the family act, how to tie his shoes. Waiting for the bus once, I'd joked with Bisi, the toddler of a Bulgarian performer. Bisi, who looked like the cartoon character Dondi, spoke no English, and I knew no Bulgarian but we traded nonsense sounds. He giggled when I said "Boomba." Doncho, in the wire-walking act, told me it was a Bulgarian superlative, meaning enjoyable. Then in Wheeling the elephant trainer's wife asked me to tutor their sons. I probably should have agreed but I was jealous of my time wandering.

One day downtown, I ran into Prince Paul. He offered to buy me pie, "my treat 'cause I know what you young fellas make." His overture was unusual, as was his offer to pay, but when we sat and he asked about laughs in Spec, I knew what he had in mind. During that brassy first-act finale, before riders got on our Spec elephants, we were on the track and each got a pair of kids from an usher and had them wave until they got collected again

to be loaded into wagons going around the track. That week, as the Prince paraded past me and my two kids, there'd been laughs, and he suspected I'd made him the butt of a joke. I hurried to explain that the laughter hadn't been about him. Early in the season, only having the kids wave had felt dumb so I'd come up with a bit. I showed my pair how to style, arms up in a V, palms down, then told them to do it on a count of three. I broadly mimed my instructions so the audience could see what I intended. (I never whispered instructions to shape the response. It was a point of pride that I always genuinely improvised, dealing with whatever came up.) With that set-up, when I styled, one of two things happened. My kids shot their arms up in an energetic style and they got enthusiastic applause, or they just stood there, shy, arms at their sides, and people applauded in support, while laughing at me acting befuddled by the "mistake." Either way, the kids looked good, and we all—kids, audience, me—shared a comic moment that seemed to be extra special because it appeared to have been accidental.

The Prince eyed me. If he didn't believe my explanation, I'd be dead to him the rest of the season. I braced myself for one of his vaudeville insults, like "You know, if they paid you what you were worth, you wouldn't work that cheap." Instead, he said, "Okay. Good job." But then, as if regretting praise for a First-of-May, he tossed out a different line. "Be it ever so homely, there's no face like your own." Watching the new movie *Star Wars*, it struck me: Prince Paul was Yoda, the pair of them small ancients uttering enigmas.

As I ate blueberry pie and the Prince rummaged through lemon meringue, he talked about his partner, Paul Jung—pronounced like "jungle," not the Germanic "yoong"—a great producing clown, the one who creates gags. Between seasons, Prince was in vaudeville, including a New York "Giants" baseball act of little people. He talked about the strike in 1939 that led to the formation of the American Guild of Variety Artists, our union, in solidarity with the Rockettes, cabaret singers, and honorary president George Burns—and maybe that stripper in Providence. I'd paid off AGVA's $300 initiation fee, bumping my take-home pay to $130 a week, a magnificent sum if you didn't do the math: ten bucks for each three-and-a-half hour show, including Come-in. The musical *Gypsy* shifts from vaudeville's "small time" to its "big time": Minimum wage on The Greatest Show on Earth put us simultaneously in the small time and the big time. Then during World War II, he worked as a welder in an airplane factory, small enough to fit inside fuel tanks to weld from the inside. The Prince also talked about Ringling's tents going down in Pittsburgh in 1956 for the last time. I remember reading about it in *Life* magazine. Though I was

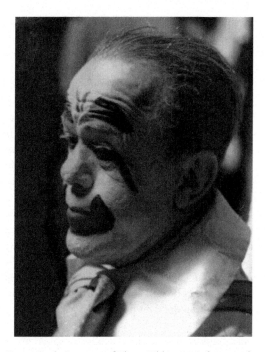

Figure 6.1 Prince Paul. Courtesy of Elmo Gibb, circus photographer and clown.

a kid who hadn't been to a circus yet, it made me sad. The Prince then hit a rough stretch. His partner Jung was murdered by junkies in a Manhattan fleabag, and Prince became a drunk, until Jung's widow helped him quit cold turkey. He was only 65 now but those rocky times played rough with his memory. On the other hand, ancient history to me was alive to him. He mentioned the show had played Wheeling "a few years ago." Thinking he was forgetful, I pointed out that Ringling advertising proclaimed the show's return after decades.

"Well, about '41. Yeah, a few years ago."

Nostalgia can be emotionally sloppy, even phony, but the past was more than that. Like old river towns, the Prince was circus past, in living memory and ancient lore.

Feeling more connected to circus people, I was relaxing into this. Sitting on the bluff over the river, with the smell of the Mail Pouch Tobacco plant in the air, I was watching a sliver of light squeeze under distant black clouds when Dana joined me. She wasn't her usual cheery self. She did a terrific job as a clown when she could be like a favorite aunt surrounded by adoring

children but the show provided few opportunities for that. She could have found it in the seats but that's risky territory, like working the streets; adults are leery, teenagers get aggressive, tykes shy away. Sweet Dana was floundering backstage too. Her pals in the King Charles Troupe were black and she was white, causing whispers about her and "those people." She also seemed caught between Dolly and Terry. Dolly had been the good girl clown last season but Terry was good too. Meanwhile, Terry was the boss clown's wife, so she got the best publicity gigs and the Felds's attention, but the real power in the Alley was Billy, with Dolly now his lady auxiliary. For maybe the first time in Terry's life, she wasn't in the popular group. She confided to me that she kept hoping Steve would be more demonstrative but that seemed unlikely. The quiet strength that had attracted her was the flip side of a guy who had little empathy for what she'd have called artistic sensitivity. Her public displays of affection, draping his shoulder and cooing "I love you," seemed counterproductive. To help, they bought a van to be by themselves between towns.

Right or wrong about Dana's awkward situation, I could at least be a buddy. As a string of barges floated far below us, she asked what they were for. I told her it was to keep the river down.

"Really?"

I didn't usually prank people but her "Really?" inspired me.

Yep, I said gravely, river water's like bread with yeast. Ya gotta knead it to stop it rising. Those barges are smushing it down.

She stared at the river, and I continued.

See those barges on the far side? When they get to that bridge, they'll turn and smush this side. Otherwise the river tilts.

At the Wheeling Jamboree the night before, Billy had sweet-talked our way backstage to meet Kenny Rogers, and they talked about Hank Williams. Now I told Dana that Williams ended his shows saying, "I'll see ya again if the Lord's willing' and the crick don't rise," because he'd been a barge man, keeping the cricks from rising. Did she know what caused spring floods?

"Melting snow?"

Yeah, but mostly it's a barge shortage because, in early spring, they're hauling in the winter crop of left-handed monkey wrenches.

"Oh, you." She swatted my arm. "You're so silly."

That's what the toddler in Sunday's departing crowd thought, that I was silly. He was hanging on his mother and, though she was gorgeous, I kept my focus on him. Joking in my toddler-teasing way, I talked only to him. Kept eye contact with him. Alternated grins and solemn looks with him. But as he clung to his mother's leg, when I asked if he wanted

to trade places, he heard more silliness, while she got the *other* meaning, and I got a date.

* * * * * * *

Tripping down memory lane took another personal turn in Charleston. During my internship with the US attorney in Philadelphia, I'd written a fan letter to Richard Neely, a judge on the West Virginia Supreme Court, praising his article proposing that legal education should embrace the humanities. Replying, he invited me to stop on my drive back to Berkeley. The country's youngest high court judge, he was an intriguing combination of Ivy-League patrician and free-thinker. Our conversation stretched through the afternoon as we talked about theater; the left-to-right orientation of Western art; licorice; the proper color of suit for different occasions; his Army service as an officer, mine as an enlisted man; and his observation that when a lawyer says "Your Honor," he usually means "you asshole." Then the Judge suggested I apply to be his law clerk. I later did, and was his second choice. What if I'd been first? None of my job offers had lured me from clowning but I'd have said yes to this fascinating judge.

Now he'd come to watch his almost-clerk clown at the Civic Center. After the show, as the Judge waited, I ran to the only working shower for guys. Dodging workers tearing down the rigging, I ran to the beat of "Satin Doll." The musicians' strike was over so Ringling was hiring locals each town, and tonight the band was jammin'.

At His Honor's, I sank into a leather couch and drank Scotch in his wood-paneled den as he declared that he'd brought candy for the elephants because his father had told him they prefer candy to peanuts. (Bigfoot later told me that elephants will try anything.) The Judge then said I was the best clown in the show. I loved these unbiased testimonials. He also said he'd fallen asleep in Spec. Though the pink extravagance could be soporific, I defended it. Michu was out, having broken his arm wading in a stream. The little man was often rude and occasionally drunk—maybe how he'd broken his arm—but he did add energy to the show. Hizzoner advised me to reveal my lawyer secret, saying that taking cases from circus folks would prepare me for my career. Even as I nodded, I wondered. I'd become used to my secret, to people knowing me only as a clown. Anyway, was law my career?

Back to the train through the rain, I was giving the grand tour of my room, the size of his couch, when the train jerked. Circuses that move by truck are called "mud shows," because rain is more noticeable with wet equipment and soggy ground, like the growing puddle off the vestibule.

How many jurists, local, state or federal, have given career counseling to a clown before jumping into mud from a moving train?

* * * * * * *

Lightning chased us across Kentucky. The train was due to arrive mid-Thursday in Memphis but as I joined Richard for beer and Italian sausage, night found us still chugging. I visited a showgirl, who'd gotten chummy lately, maybe to quell rumors that she and an act woman were lesbians. Once I arrived though, she reverted to cool civility. As she gave her opinions about people on the show and the world, I watched the water between the planes of her window slosh back and forth with the motion of the train.

Friday morning, Buzzy and I reconvened our vestibule tour of America. Rumors variously put us on time, or starting the show at 10:00 pm, or stuck behind a derailment. Slow was not new. We'd been late into Charleston because the train had missed a switch and needed to back up 80 miles, while the 200 miles to Providence had taken 21 hours. Meanwhile, this jump was one of the season's longest, 600 miles. At 4:00, cancellation looked likely. At 5:00, it was certain. It took six hours to lay the track rubber, hang ringing, pull cable for sound and lights, assemble the ring curbs, plus everything that had to be done backstage. Afternoon folded into evening as an elephant swung her trunk out the stock car door toward leaves by the track on the outskirts of Memphis. The train was spotted at 7:30. Before heading into town for blues and ribs on Beale Street, I decided to stop at the Mid-South Coliseum to watch the set-up. Jim and Biscuits pulled their pickup over to offer me a lift. He was a short, wiry ring worker with a bushy red mustache and a grizzled face tanned by his cigarettes; he could have been a skinny Yosemite Sam. Biscuits, who ran a souvenir stand, was short and plump, with a round, open face like a cartoon fairy godmother.

We entered the arena to an amazing sight. The seats were full, 6,000 people watching early spurts of activity among the clutter on the bare concrete. We were doing the show! Jim trotted to his crew, Biscuits hustled to her stand to unpack, and I started helping pull track rubber onto the concrete floor. Disappointment about losing a night off disappeared as I tugged, shoulder to shoulder with the rest. That included the stars. Circus uniquely blends flash and blue collar. One minute, a star is sparkling in the spotlight, the next, he's shoveling elephant shit. The prodigy who dazzles audiences helps put up her own apparatus. The strutting performer becomes an ordinary grunt when it's raining, there's no room for elephants backstage, and they need a tent raised.

I joined Skip unpacking his lights. When he no longer needed help, I moved to the Poles unloading poles. I nearly became a clown gag myself as I ducked a swinging shaft. Toting an empty box backstage, I saw clowns and showgirls unpacking wardrobe, hanging costumes, setting out hats, lining up shoes, setting up the curtains for dressing areas. Back on the floor, TV cameras had arrived to broadcast this rare sight. Meanwhile butchers were hawking their pennants and flashing lights. Biscuits told me later that customers got so eager they were pulling inflatables out of boxes and blowing them up themselves. Around 9:00, as the other clowns climbed into the seats, I helped Doncho erect the double wire for the Bulgarian's act. Lenny wasn't complaining about aches now but was helping Monastyruk raising the rigging for his Monkey Man act to the top of the arena.

At 10:00 Lenny and I ran backstage, last to put on our makeup. Usually I took 40 minutes, this time did it in ten, partly by skipping the white under my eyes. It looked good. Maybe I'd keep it that way. As I joined the clowns working the seats, workers down on the floor tightened bolts and pulled the last wires. Doing an extended Whipcracker required Dean and me to adjust. I wanted to say "I told you so" as we improvised but it wasn't him suddenly being flexible, it was both of us adapting to each other. After an hour in the seats, the Clown Band gathered. Allan was out with the flu, and Steve had stopped playing the opening fanfare so I was the only trumpet player. Fortunately six months of Clown Band had made me an almost competent player of nearly recognizable tunes.

Wilson Pickett recorded "In the Midnight Hour" in Memphis. In the midnight hour in Memphis, with most of the 6,000 still watching, we began The Latest Show on Earth.

The weekend blurred. Saturday's three performances made four in twenty-four hours, so through Sunday, most of us were either at the show or asleep.

Washing my clothes on move-out night meant I wouldn't see Memphis at all. The laundromat, over a brush-covered rise from the train, was a square of light alone in the rain. Others were there, including Dawnita. Every Finale I tried to crack her official showgirl smile into a real one. Once overhearing her say she liked chocolate chip cookies, I snuck one into the next show and placed it in her upraised hand as she paraded by.

When a washer came free, I pulled clothes out of my Army green bag, the one from that ride to Clown College. All but Dawnita finished and hurried back as the rain increased. Alone, our conversation bumped along like the storm, rumbles of chat followed by silence. Fourth-generation circus and keen on horses, she said she wanted her own act. Her gorgeous

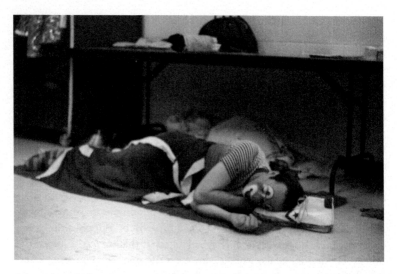

Figure 6.2 "I have an exposition of sleep come upon me." Author's collection.

eyes tempted me to turn the conversation personal but, stuck for what to say, the opportunity was floating away like the lint in the air. When she pulled her clothes out of the dryer, I blurted over a clap of thunder that maybe we could go out, get to know each other. Dawnita smiled, saying she was a private person. At the door, she added that she avoided relationships on the road because scrutiny was so great. I knew what she meant. One night on the bus, everybody had heard Lynn tearfully telling a beau that she couldn't take his silence anymore. It's hard for things to develop naturally with a hundred witnesses. I also detected caution. Dawnita was in this for life, and couldn't know how long I'd be around. Me neither. I'd done too many things to trust that I'd stick with this for good. But at least I'd stick the season. Back in Charlotte, I thought circus folks' laughter at my traffic directing had forged a bond between us, but that had been me, solo. Now my clowning was both more me, and more circus too. We had worked together. I'd stay.

I shoved clothes from the dryer into my bag. As drips plopped from the leaves and clouds cleared to a black sky of stars, I pushed through the wet bushes on the ridge. Below me was a campfire, with pots cooking, and around it, people dancing. What could have been an ancient world or an old-time traveling show in the American wilderness was our circus.

Chapter 7 Rodeo Route ✌

June and August: Little Rock, T. H. Barton Coliseum/Huntsville, von Braun Civic Center/Dallas, Convention Center/ New Orleans, Superdome/Houston, Summit /Abilene, Taylor County Expo Center/Lubbock, Civic Center

Same ol', same ol'.

<div align="right">1960s Army phrase</div>

Keep on keepin' on.

<div align="right">1960s hippie phrase</div>

The slog through summer made clear why this half of the two-year tour was called the Rodeo Route. In Little Rock the clowns got dumped in a barn because of the cramped coliseum on the state fairgrounds.

"At least we each have our own stall," Buzzy joked as we dragged our trunks away from a thunderstorm shooting rain between the boards. The thunder frightened Mark's Weimaraners, Zip and Mo, who ran away. Mo was pregnant, and Mark was worried. If they didn't return by the end of the two-day stand, he'd wait for them or miss shows. That night he yelled at jugglers for dropping a club on his trunk, the first time he'd raised his voice all season. Fortunately Zip and Mo trotted back the next day, with puppies.

When Mark and I ran into each other one day, he invited me to his trailer for a beer. The invitation surprised me. We hadn't really talked all season. The few times I'd tried a conversation, he'd laughed and mumbled something I didn't quite catch, leaving me unclear if he was being evasive

or just in his own world. When he opened the door to his trailer, the dogs went wild, the way they did when he entered the Alley. I loved that hubbub: Zip and Mo yapping, the little poodle Fanny yipping, tangling their leashes as they jumped over each other. He always yelled at them—"What are you so riled about! Pipe down, ya troublemakers!"—but that only got them more excited. Fanny wriggled so much it looked as if she'd jump out of her curls, and Mark would pretend-complain: "Quit waggin' your tail, Fanny Cakes! I'm givin' you hell!" A good trainer, he could have made them stop, so he clearly enjoyed the turmoil himself. Maybe allowing their commotion was his protest against all the Alley arguments and boasts, the fake-gay screaming, the nonstop sex talk. In his trailer, which felt like a cave with the shades drawn against the midday sun, Mark brought out saltines and peanut butter with the beer. When he shared a cracker with Zip, I gave one to Mo.

The visit was a revelation. Mark wasn't aloof, just gentle. He laughed easily, with no irony or sarcasm. He still didn't quite answer what I asked, and at first it felt as if we were speaking different languages. But patience helped. When I mentioned Fanny, he mumbled something, but a moment later, pulled out a picture album of his dogs. His family. Ringling didn't aim to insult the old-timers with its catchy publicity line about the need for Clown College—the old clowns can fall down but can they get back up?—but it must have stung. Its implicit disparagement permeated the Alley, bolstered by youth's indifference to age. I asked about carving—he was a wizard at sculpting foam rubber—and he launched a tale about the year that Ringling went to Russia. Figuring my question was lost, I settled back to listen, scratching behind Fanny's ear. They'd told him not to bring anything, that Mother Russia would have whatever he needed. However he'd been forced to shop for household items and turn them into props because—back to my question in a circumbendibus way—he couldn't find foam rubber in Russia. When he told me about a large foam-rubber elephant he'd carved, I suggested that it must have been hard, but he said "I knew there was an elephant in there, I just had to free him." That line, similar to what I'd heard attributed to famous sculptors, didn't seem artsy coming from Mark, just straight forward. We weren't speaking different languages at all. Different dialects maybe; the conversation still lost me sometimes. But relaxing, I heard his slow-and-steady.

After the excitement of the Memphis midnight show, we paid the price in Little Rock. A rider fell during the Cossack act, getting a concussion hitting his head on the ring curb. The Alley lost three to injuries, including Gumby smacking his crotch on the vaulting box in Charivari. He

came backstage limping and—pure Gumby—laughing. Billy was also out. He claimed a doctor's appointment back home but rumor said high school reunion. Dolly was gone too. Apparently their pretend kissing in performance hadn't been pretend. Smitty joined the casualty list when he dislocated his shoulder. He never did anything more physical than his "gear shift"—simulating changing a car's gears as an excuse to do a pelvic thrust—so how it happened was a mystery, and he wouldn't say why. Because he *was* the kind of guy who'd jump off a bridge if his friends did, maybe he'd tripped himself to join the parade of injuries. As he packed for an operation back home in California, he told us he hoped it wouldn't leave a "di-angle" scar. (Wait: who worries about a di-angle/diagonal scar? Were Smitty's verbal blunders planned? Was he secretly brilliant, preparing mangled words to amuse us the way Dorothy Parker prepared *bon mots* for the Algonquin Round Table?!)

On the run to Huntsville, Dean said it'd be Contracts for next year. That seemed unlikely; we were only halfway through the season. However, when Irvin Feld showed up, so many clowns clustered in front of his seat that I wondered if the von Braun Civic Centre would tilt. Still conflicted, I headed to the other side with my bread slices, while hoping that Feld noticed I wasn't trying to attract his notice. But no contracts. Cuz and Spike used Valley-Girl voices to mock us.

"Oh, gosh, is it, like, y'know, Contracts?"

"Like, yeah, like, I'm a dumb First-of-May, and like, I'll swallow anything!"

Biscuits and Jim invited me to lunch, thanks for helping them in Memphis. Tucking their black Scotty dog on the seat in the diner's booth, they announced we were celebrating. They'd just put money down on land in North Carolina. They'd chosen Charlotte, though Biscuits had suffered a heart attack there, and it's where Jim got tossed in jail on an ex-girlfriend's complaint. It'd taken years to save for it but for those "with it and for it," a place of their own to winter was key. As roly-poly Biscuits settled into her salad, and slim Jim chewed his cheeseburger, this reverse Jack-Sprat couple gave me an implicit tutorial on clowns. Jim spoke with near reverence about Otto Griebling. He repeated what Cuz had said, that Emmett Kelly was good but Otto was the best. Biscuits favored Lou Jacobs, speaking fondly of his motorized bathtub and his dress in drag while pushing a baby carriage. They liked Billy too.

"Billy's a good clown," said Jim. "Not like last year's."

In Clown College, it had been an article of faith that Blue Show clowns had been fired because they'd stuck up for their rights. Clinging to that

romantic vision, I said maybe they'd been fired partly for protesting abuse.

"No," said Biscuits, clinking the ice in her Dr. Pepper for emphasis, "screw-ups."

"Lazy," agreed Jim, "and not funny at all."

As Biscuits took two of Jim's fries, one for her, one for the dog, she said I was their favorite First-of-May. Their tribute floated me back to the arena.

The next city, Dallas, was shiny but empty during the day, when office workers huddled in their chilly glass caves. Tumbleweed could have rolled through the streets and hit no one but me. Big D gave me a review, sort of. Newspapers usually only mentioned the Alley in generic terms—enjoyed-the-antics-as-always—but the *Dallas Morning News* got specific. Applauding the clowns for being "inventive in their silliness," the writer gave the example of "two slices of giant 'bread' ready for filling." My bread! True, the original inventiveness had been Allan's, who'd given me the slices, but I'd enlarged the visual joke into an action prop, like picking a boy up with the slices and nibbling his baseball cap sticking out the top. When I asked one little girl if she wanted to be a sandwich, she said "Not now" in a deadpan delivery that cracked me up. Because I sometimes wrapped the slices around workingmen, they called me "Kanapka"—Polish for "sandwich."

One day a PR guy recruited volunteers to entertain big shots in a conference room, which included a popcorn machine! I *loved* popcorn as a prop. Though I wasn't big on props, this was perfect for me, light, so it can't hurt, and plentiful. In the seats I only took a few kernels because the patrons had paid for it. Still, Allan said he could always spot me up there by the shower of popcorn. Now with the stuff free, I threw caution—and popcorn—to the wind. I flicked it silently; I quipped as I flipped. A guy caught me putting a kernel on his head so I slunk away, apparently abashed, but snuck back to place it on him, unaware. Though apparently out of control, I assessed reactions. Who frowned, wanting none? Who might be delighted at double handfuls? By the time the clowns left, popcorn covered the floor. Take that, Orville Redenbacher.

We left Dallas for New Orleans, though we'd circle back to Houston. The clown wardrobe guy, Ross, explained the zigzag path. We'd be subject to livestock regulations if our animals stayed in Texas too long at a time.

* * * * * *

I woke wet with sweat. The air-conditioning had broken again, and the New Orleans sun beating on sealed windows turned the silver car into a giant baking pan. Giving up on sleep, I went outside. As I squinted in the glare, I saw a dome a few blocks away. It seemed too small to be wonder-of-the-world Superdome. Did New Orleans have some smaller dome I'd never heard of? Then I got closer. It *was* the Superdome, and the joint was giant. Every Opening number, I'd been determined to climb to the top row but that wouldn't be happening here. While the Superdome usually seats 70,000, big bleachers had been pulled halfway across; this "smaller" configuration was still our largest of the season, 25,000, while another full circus could have fit behind the bleachers. Because clowns had to be accessible to the floor for quick changes and emergencies, the Alley got set up off to the side, a blue-rimmed island in the sea of concrete. People in the highest seats could peep down on us, though at that distance we looked like figurines in a toy circus. Our usual two-a-day couldn't fill the place, giving us a virtual vacation, one show a day, and only two (!) on Saturday.

After opening night, people hit the French Quarter. Maybe it is a theme park for drunks, the exotic name "La Vieux Carré" wrapped around excessive drinking, but I didn't care. It was too much fun. In one club, the stripper looked matronly so I left, drifting on jazz floating out wide windows and doors that never closed. Watching the New York City blackout on TV in a dark bar, it felt as if we were in it too. Though I don't drink coffee, I moved on to Café du Monde for chicory coffee and beignets.

My ultimate goal was the Preservation Hall Jazz Band. It thrilled me just to be in line outside Preservation Hall, hearing music through the grimy windows. At the end of a set, the line moved up a side alley. Peeking in the door at the back, I couldn't see much except dirty walls and tired yellow lights but I heard better. As people left after that set, I got a seat in the back, and the next set, I moved to a front bench. Father Lewis, fat, with a large dark head, and wearing a lined denim jacket in the heat, passed out gum and balloons and jokes, then played his banjo in a fascinating mix of ease and concentration. The drummer wry and thin, leaning on his sticks, peered at us under his eyebrows as if he were about to wink, then mouthed the words to wordless somethings on his solos, the gentlest drum I've ever heard, until it erupted into thunder, like hunger finding a feast. It sunk in that these performers were doing with their music what I was learning as a clown, engaging the audience. Even the players more inside themselves remained connected to us somehow. Sweet Emma slumped at the piano in her red, round cap, red dress, and a lower lip that almost reached her chin, playing with her right hand, barely heard above the others until "A

Closer Walk with Thee," when she sang in her raspy voice as drums and bass answered. Percy Humphrey looked like an egg, a glum one, and then he played, gesturing with hands, wrists, trumpet, fingers. The white clarinet player looked like a befuddled storekeeper till he squirmed in his chair to get it out right.

I stayed late into the night, for the music, and the romance of my devotion, but also because I wanted to get tired enough to fall asleep in my oven of a room.

Shifting in my sheets at sunrise, trying to find a part not sweated through, I got an inspiration: the Superdome was air-conditioned! I swam through the humidity to the morning silence of the building, where I snuggled under my robe on a scrap of carpet by my trunk, with my clown shoe as a pillow, glad to be cold as I dozed off looking up at the vast space.

I'd been wondering how to reveal I was a lawyer. Despite the Judge's advice, I didn't want to make a big deal of it. That would defeat the purpose of the secret, to fit in without the lawyer thing clouding impressions of me. Ringling's sluggish mail service fixed my dilemma: the latest batch forwarded from DC months late included my California Bar card. Look, I said to Dean, casually, my Bar card arrived.

"Congratulations," he casually replied. Casual or not, he was a walking news service and word spread. Happily, it caused little stir. My secret had worked just as I hoped. People thought of me as a coworker by then. The most common response was the joke Hollywood hit first: "Aren't all lawyers clowns?" Later, some who knew I was a lawyer when they saw me clown decided I did it analytically, but that was the power of suggestion: those who knew me before the label of lawyer got applied never thought that. Clowning pushed me beyond analysis, beyond explaining, even beyond caution. A big part of that was movement. Clowning was dancing for me, moving in space and time. As John Mayall sang, "I can't give my best unless I've got room to move." Even standing still, movement's sly cousin, I was Jell-O, ready to wiggle. With instinct taking over, my body sometimes surprised me. Moves happened, and I didn't know where they came from. That didn't mean my legal education had no influence. Some fellow clowns performed with a virtual shrug, as if to signal adults, "I'm smarter than kid stuff." Though I had plenty of bad habits, that wasn't one of them. With law school behind me, I felt no need in my clowning to try to show intelligence. To the contrary, playing stupid was my ideal.

Thursday night, one of last year's clowns threw a party for the Alley. Listening to his grievances, I felt uncomfortable hearing my complaints in his, so I wandered outside and settled alone in a rusty lawn chair next

to the keg and its tumble of red plastic cups. Was I being independent or, leaving the women inside, faithful to Tracey? When I'd called the Carousel Queen after Hartford, a guy had answered, which convinced me he was why she hadn't invited me up. The next time I accumulated enough quarters for a pay phone at the end of the train, a gal had answered, so I was confused. Anyway, Tracey had written twice that she'd visit in the *next* town I played, and both times, she was a no-show. I wasn't surprised when she wrote that she'd absolutely come to New Orleans, and didn't.

A woman walked to the keg to fill her cup. With long dark hair draping her face, she looked like a cross between Gloria Steinem and Janis Joplin.

"Anti-social?"

Waiting for a good woman.

"I'm Cathy. You're a circus clown."

It was matter-of-fact. Usually people asked me about my exotic job but Cathy had her own adventures, in Peru, and as a New Orleans streetwalker, her joke about working on a city survey. When she told me that she came from a family of cops, she looked prepared to pounce on any sneer, but I was ex-MP, and my dad had been a highway patrolman. We talked into the muggy night about politics and Peruvian music and poetry. When she mentioned Herman Hesse, I repeated the only thing of his I remembered, about the lovely secret game of lips and legs. I said it in a fake-announcer voice so she wouldn't assume I was assuming anything.

She was busy Friday, so I returned to Preservation Hall. Saturday after the second show (only two!), she treated me to dinner at a local landmark, Messina's. Over muffuletta, I said I liked her—risky avowal—because she pushed back. We left, sparring our way out of the French Quarter, through her N'walns. I used another quotation, "bathe your silken limbs in wanton dalliance." Anyone, I said, be wantin' dalliance? She smiled, and we walked on, companionable in the dark.

Sunday night, we sat on a warehouse stoop, just beyond a cone of light from a street lamp, across from the train being loaded. In the fake-announcer voice, I tried another quotation.

Will your ambrosiac kisses bathe my lips?

It got a muted smile. After anguishing early in the season that I'd never meet a woman on the road, I'd learned that I had two advantages. In *Even Cowgirls Get the Blues*, Tom Robbins wrote, "There isn't but one aphrodisiac in the world. And that's strange stuff." A circus vagabond qualified as strange stuff. Second, what I'd considered a handicap, being here today,

gone tomorrow, could be an advantage. Keen to meet a stranger, women were also okay seeing the stranger gone. So I could be Cathy's walk on the wild side with no entanglement. Yet we stayed prickly with each other. I told myself it's because we were both being sophisticated but there was more to it. While a circus clown was a trump card for our generation, proof of dodging the sin of *normal*, Cathy was proud herself of not being normal. Did I threaten her status as the wildest one in the room? At three in the morning the train lurched. I leaned in for a quick kiss, then ran to hop on my vestibule. She got in her car with a good-bye smile that was... sad? polite? As she drove away, her brake lights popped red in the dark, then vanished around a corner.

With the train up to speed, I visited Dean, who had shortbread from home and his usual gossip. We wouldn't open Houston till Wednesday night, which gave us nearly three days off, so only half the Alley was on the run. Richard and Susu had flown to Florida, Dana traveled home to Tennessee, and Herb decamped—camped?—to California. Lynn, off to LA with Jeff, had been complaining that she had to pay for their flight, though he'd gotten them tickets to see Nureyev and Liza Minnelli.

That's it! Liza! That's what Dean's makeup reminded me of, Liza with a Z. The raccoon circles around his eyes echoed her rim of black eye-liner, his round cheeks were a clown version of her face, and except for his wig's neon yellow color, that bangs could have been hers. Of course all that made Dean's makeup effective, easily visible across a giant arena.

Not ready to sleep, I bumped through the quiet corridors, looking for an open door. Skip, the lighting guy, invited me for a nightcap. Then I visited the prim showgirl. When I pointed at a shooting star out her window, I elucidated: Look, a shooting star! She nodded, primly. Why do sober people think drunks don't notice being patronized? They—we—notice. It's just that we do not par-ti-cu-lar-ly care. As she humored my drunkenness, I humored her undrunkness.

Morning didn't like my head. After the hyper-literate flirtation with Cathy, another quotation hit me, Hemingway: "He was awake a long time before he remembered that his heart was broken." My heart wasn't broken, nor was Cathy's. But maybe heartbreak would have been better than clever and wry.

* * * * * *

Houston provided another mini-vacation. Because the Summit shared parking with office buildings, there was no room for customer cars on weekdays, so again we only had night shows. One morning, I hopped a bus to Galveston

but a gray sky made the beach dingy, there was no one to ogle, and I got hit by bird shit. Another day I snuck into the hotel pool next door. Henry, a teeterboard bottom-stander, had the same idea, and taught me a two-man high in the water, where falling wouldn't hurt. When he said to trade places, I thought he was nuts but I did it, hefting his 200 pounds on my shoulders. My ambition to roam succumbed to the heat and another downtown of blank-faced office buildings. I did go to a doctor. For my sore back? Aching ankle? Stiff knee? Bruised wrist? No, my throat again. One of the oldest circus tales, repeated about different clowns, tells of a sick man visiting a doctor, who advises him that he'd feel better if he went to see the famous clown then performing. The man replies, "Alas, doctor"—"alas" is apparently required in the tale—"I am that clown." Alas, I am that sicko. The doctor said that the processed air of arenas wasn't good for my throat. Circus made it worse: elephants spent most of their day eating hay so their manure was dry, creating more dust. Like the doctor in Atlanta, this one advised rest. Didn't medical school teach anything about *drugs*? Doc added that birth control pills could be an aggravating factor. Everyone's a comedian.

My new pal Doncho bought a bottle of Stolichnaya for our birthdays, a week apart. He was the Bulgarian wire walker I'd helped in Memphis, and friendship had grown in Huntsville, at a fourth of July party thrown by local fans. Grabbing burgers and beers, we sat on the grass, as local lovelies giggled near us. For some reason, they focused on my darkly handsome companion. Most Eastern Europeans came from their country's circus schools but Doncho had been studying to be a wrestling coach when little Bisi's dad, head of the high-wire troupe, recruited him. Athletic, Doncho had learned to walk the wire in a few weeks. He hadn't told his parents though, not wanting them to worry. As we drained the Stoli, he said the circus was the happiest he'd been in his life.

Backstage was a sleepy country village, with the musty aroma of hay poop overlaid by frying from Pie Car Jr. On the arena floor, all bustle and go; back here, cozy routine. One day, Carmelita helped me. When kids yelled "Mira! Mira!" as I approached, I assumed that was Spanish for "clown," and replied "Yo soy mira," what I thought was "I am a clown." But the puzzled looks brought me to Carmelita, who said that "mira" means "look," and "payaso" was clown. I'd been saying "I am look." Yo soy a foolish payaso. Someone ran past us for an entrance, then peace descended again. The music enhanced the calm, a steady signal of where we were in the show, Charly's tiger act.

Then word swept backstage: he was having a heart attack! Everyone rushed to a curtain or side door to watch. The audience, with the usual mix

Figure 7.1 The kismet of Charly Baumann and Kismet. RINGLING BROS. AND BARNUM & BAILEY and The Greatest Show on Earth are registered trademarks of and are owned by and used with permission of Ringling Bros.-Barnum & Bailey Combined Shows, Inc. All rights reserved.

of awe, boredom, and thrill, couldn't see the drama as Charly willed himself to continue. Initially I hadn't appreciated his act, seeing only sequins on his bolero jacket, black hair slicked back like Elvis, and minimal danger. Time had taught otherwise. The act was beautiful, and the risk real. Tigers are wild animals, always dangerous, especially if they sense weakness—like Charly's then. The key to the act wasn't flash but his rapport with his cats. I'd watched him train a tiger cub over weeks, with positive reinforcement and a patience that belied his fierce reputation. One trick especially impressed me, his favorite tiger Kismet grabbing his shoulder from behind and licking his head, something the tiger had originally done on her own out of affection. Where else could you see something so dangerous and sweet?

Charly kept going. Three tigers sat, paws up, on rotating mirrored balls and the band played "Shangri-La," as sweat covered his pale face. Taking

his bow, he didn't hurry but, a trouper, strode off as usual. Backstage, his wife Aricelli held his hand as he climbed in the ambulance that had backed inside. It was strange without him the next show, patrolling the floor in his tuxedo, joking backstage. Even after we heard he was fine, recuperating in Florida, it felt as if we'd taken a collective breath and couldn't exhale.

He'd have averted the flap over the Flying Farias. The Flying Gaonas featured Tito, a sex symbol with broad shoulders and a broad smile, while the Farias focused on the rising star, slim thirteen-year old Julio, his sister Carmelita, eight, and little Tata, six, with Papa as catcher. When the two trapeze acts finished, the troupes alternated flyers dropping to the net till only Tito was left. When he hit the net, he bounced back up to sit on the catcher's trapeze, a surprise that always got a big reaction. But in New Orleans, Julio did the bit first, leaving Tito to simply bounce to the net and lower himself to the ground. When Julio kept doing it, I assumed Tito was being gracious. That was naïve. It was his signature bit, and he didn't intend to give it up.

Irvin Feld, in Houston to check on the show with Charly gone, told Papa Farias that Julio had to stop. When Julio did it again, Feld was livid. As he waited, fuming, for the Farias to exit, nearly everyone on the show found some reason to be right there. Once the Farias got backstage, Irvin yelled, Papa yelled back, and Irvin fired them on the spot. That was stunning. Whatever Papa's fault pushing his son, the Farias were a featured act, and a family. *Our* family.

The next night they were back in the show, thanks to the face-saving story that Spanish-speaking Papa had not understood Irvin's order. Nobody believed the fiction, and everyone was grateful for it.

After buying Ringling in 1967, the Felds had sold it a few years later to Mattel for $50 million, making us corporate cousins of the Barbie doll. Circus fans said the costumes were the best they'd been in years, thanks to Mattel money. (In 1983 Mattel sold it back to the Felds.) With Mattel executives and their families in Houston, someone decided it would be a good idea to have clowns and showgirls stay in costume at the end of another infinite Saturday for a backstage tour. Being gawked at was demeaning. The joking bombast of our Clown College diplomas, finally delivered after months, fit the occasion: we were entitled "to all the honors and highest privileges thereunto appertaining, as well as the innumerable inconveniences, indignities..." Capping this inconvenient indignity, we had to change quickly and chase the bus as it chugged out of the parking lot. Clambering on, we bitched at the driver, who barked that he hadn't been told we'd be late. No one believed him. The little man relished his little power. The first night

in Dallas, he was driving behind Polish workers in their cheap wreck of a car when he flashed his turn signal to indicate they should turn at the next corner. Once they did, he laughed and drove straight on.

* * * * * *

One night, when Herb and his showgirl gal-pal visited Victor across the hall, his door and mine open, he shrieked that they were the only clowns who put effort into the dancing every show. Even as I bristled in my room, I had to admit that he *did* those high kicks every show—and that my enthusiasm had gotten wobbly. Clowning, like most jobs, has routine. Making children laugh is fun but it doesn't always work; some kids are squirmy or scared, weary or spoiled. So are adults. Now the daily slog of Texas was making things harder.

In a variation on the song, Abilene was the prettiest little town I've never seen. Our train sat out of Abilene in one direction and the arena was on the outskirts in another so all we saw as we bounced in the bus, windows open to swelter better, were buildings like a mirage in the distance. Those two days were meteorological barbells on the landscape: straight, hot roads between a globe of cool in the train's air-conditioning and another globe of cool at the Taylor County Expo Center. Meanwhile, what happened inside also shimmered like a mirage, apparently insubstantial. I was so discombobulated that one performance, after hundreds of shows and hundreds of thousands of people watching, I got nervous. The long run was getting to me.

Then I saw Prince Paul new. The Prince had to battle for respect. A clown, *and* old, *and* short, he faced overlapping condescensions, sometimes even on the Alley, as if, a child's size, he were a child. I enjoyed his random interjections. Returning from shaking an executive's hand in Houston, he'd muttered, "He handed me a handful of scallops." But I had to admit his clowning hadn't impressed me. That made me feel guilty, especially after we'd talked in Wheeling, but he seemed to do little more than smile and wave. Now, through my dry stretch, the Prince indirectly taught me better. He sat quietly at his trunk not because he was old and tired but because he was old and saving energy for work. The smiles that had seemed rote to me reflected his professionalism, as he smiled them every show, however he felt. Like Mark Anthony, the noble Prince worked at a high level, always in character, always alert. As I struggled to keep my spirit up, I was learning how hard that was, and how well they both did it. Whenever Mr. Feld came to town, the Prince got teased for sucking up to the boss. Prince didn't like the jab: "Suspenders you want, a belt I'll give you." Yet while he did play

to Feld when at the show, what the teasers missed is that Prince performed every show as if Feld were there. Regardless of town, crowd, or backstage drama, the old clown brought the same energy to each performance. It was the least dramatic lesson of the season, but maybe the most important: to the Army phrase, "same-old, same-old," the unhippie-like Prince had an implicit, hippie-like response: "Keep on keeping on."

* * * * * *

Lubbock was home to Texas Tech, eager crowds, and Gardski's Loft, a homey café where I returned so often that Saturday night they kept the kitchen open just for me. After flirting with the waitress, I walked quiet streets to the train. Passing a house bright through a big picture window, and another one lit only by the blue glow of a TV, I imagined myself over a lawn, through an open window, lying in bed in the dark, next to my own someone.

The show offered an attractive alternative to that domestic vision. Instead of a two-person cocoon away from the world, I could've been partying, maybe with drugs, probably with gals, certainly with booze and joking around. For some in the Alley, that camaraderie was key to the circus experience, with shows as pauses between parties. The clowning would always be key for me, but was I missing something crucial by not expanding socially?

Dean was playing his balalaika outside the train, chatting with Ned, who was leaving at the end of the season to finish high school. Someone had ignored the high school graduation requirement for Clown College. As Ned talked about vaudeville, that a revival was imminent and he'd be ready, I lay back on a weedy mound of dirt to look at the sky. The stars were big and bright, deep in the heart of Texas.

Sunday I got up early for the laundromat run. The bus pulled away from the Pie Car as I approached, so I chased it, my laundry bag flopping, till I gave up in the heat. Trudging back to the train, I ran into the driver's dad. I complained that his son had left early. He said Never mind, he knew a laundromat near the train. I told him that didn't help because I had to get clothes at the arena too. Maybe I didn't use my polite voice because he suggested I go fuck myself. I returned the compliment, and left. As I was climbing the steps of 140, I heard the bus coming back. I hustled over.

Why'd you leave early?

"I didn't!"

So why come back?!

"No one was on the bus, asshole!"

If so, why leave!?!

I gave up and started walking to the arena. A few blocks later, I heard the bus behind me. All week he had traveled the same route, a straight shot from the tracks of the Atchison, Topeka, & the Santa Fe—I loved the rhythm of that song—to the auditorium on the Texas Tech campus, but now he turned the corner before he got to me. Even as I swore, I knew this was about more than a ride. The driver and his dad were circus. Jerking me around was a reminder that they didn't consider me "with it and for it."

Earlier, I would have tortured myself over that judgment. Now, it stung but didn't really matter: I had a job to do, two more shows Sunday, then all out and over, and heading north.

Chapter 8 Spirit of St. Louis ❧

August and September: Tulsa, Assembly Center/Des Moines, Veterans Memorial Coliseum/Waterloo, McElroy Auditorium/ Omaha, Civic Auditorium/Sioux Falls Arena/ Madison, Dane County Exposition Center/ St. Louis Arena

Only connect.

E. M. Forster, *Howards End*

Whipcracker snapped.

The Sioux Falls Arena was another venue with no front aisle, the first row lapping against the track, so a program butcher had to pass Dean and me doing Whipcracker. A Bulgarian rider's wife, she knew she should go behind us but instead crossed in front. Worse, she stopped to wave a program. I was annoyed but Dean was furious, and grabbed it. She demanded the program back. He stage-whispered, "No." She said she was just doing her job. He said—no whisper—"Tough shit." If swearing in front of an audience weren't surreal enough, he tucked the program under his arm and resumed the gag, while continuing to argue with her. I could have walked away but I was as fascinated as the crowd by this theater of the absurd. When my pants dropped, Dean didn't chase me but strode away, followed by her, then me, pulling up my pants, a weird three-person parade. Surreal got surrealer when Dean halted, in full view of the crowd, and ripped the program, tossing the halves at her.

"That'll teach you to walk in front of my gag!"

His gag? What am I, chopped liver?

Dean smacked through the back curtain and into the Alley, leaving her outside, crying, saying he owed her $2. I told her I'd pay and went to my trunk to get a couple bucks, holding them up as I passed Dean. Back in the Alley, I stood over his chair while he pretended he didn't notice me. Two jerks can play that game: I pretended I didn't notice him not noticing me. When he finally looked up, I said he owed me two bucks.

"I'll pay you when I was going to pay her, at the end of the season!"

At intermission Dean slapped my trunk with a couple dollar bills. He'd torn them in half. That was funny. If I weren't being self-righteous, I'd have laughed. Ever since our slapstick shotgun wedding in Winter Quarters, Dean and I had squabbled over Whipcracker. About the pace. About how far apart to stand. I was surprised we hadn't argued how to spell the word. Once, in rare spontaneity, he'd chased me all the way around the track but otherwise he wanted to do it the same every time. Behind the arguments lay a fundamental conflict: Dean believed I was undisciplined, and I thought he had all the flexibility of a plank. It was like swing dancing with someone who didn't move her hips.

Still, we'd worked through a lot. And Dean and I had similar inclinations, as two of the few clowns—and only First-of-Mays—who regularly climbed into the stands during Come-in. While others did meet-&-greet from the track, I'd be way up in the cheap seats and, across the arena, there was Dean, also high up, his yellow wig like a beacon. Plus, we were pals away from the arena. On the run to South Dakota, he'd cooked us beef stew. When I mentioned it'd be my forty-eighth state, we yakked about places we'd been.

So it jolted me when he smacked the whip on my trunk and said he quit.

Maybe every human institution has a finite amount of goodwill, and clowns exhausted ours in performance. Gumby and Scotty had been our best duo till they argued and split. Dolly and Terry continued their polite feud. One afternoon, two of the most placid clowns, Flip and Mama, faced off, as if self-absorption and mildness could spark fire. A second-year, drunk, smacked his terrier, so it was good he gave him to Spike, but it wasn't good when Spike added the dog to Clown Band, stealing thunder from Mark's routine with Fanny right afterward. The rumor of a circus movie revived with word that the Felds had asked our union, AGVA, for permission to switch to the jurisdiction of SAG, the Screen Actors Guild, but it fizzled, along with visions of the Alley working as a team.

The first Come-in without Dean felt random, as if I were marking time till Clown Band. I asked Cuz if he wanted to do the gag with me. He

was a good clown, and that's meant as high praise. After the exuberance of "great" and "terrific" have burned away, what's left is solid and true and *good*. He also had a sweetness that his cynicism couldn't obscure. That's why I treasured his drunken praise back in Venice. Whether he really thought I was "one 'a tha' good ones" or was only boozily sentimental, he said it to be nice. But Cuz declined, telling me I should get back with Dean. Then I asked Scotty. My second-banana stupidity would play well against his snooty clown character but he said essentially the same, that Dean and I worked well together. Were they nuts?

* * * * *

The Rodeo Route traced a "K" on the map, the lower right of the K angling from our Florida start northwest to Cincinnati, the upper right stretching to Maine and back, and the stem in the rectangular stack of states through the middle of the country. On the run out of Texas, with the heat swept away by rain, and Buzzy smoking a joint, partly to block the stink of the backed-up toilet whenever the hall door opened, the arrow-straight rows of stalks of corn fields had me mesmerized as they flipped past, a visual version of a card in bicycle spokes. Most people see the plains as flat and empty. Where's the bustle that announces importance? I had internalized that attitude living on the East and West Coasts but ancient feelings tugged. No place was my place after all the places I'd lived, yet back in this landscape, boyhood memories shimmered to the horizon.

Expecting dry and dusty in Tulsa, I was tickled to walk under the emerald canopy of tree-lined streets. There I ran into Leo. An old, short Polish worker, with a face like a cherub, he always pulled a tiny bell from his pocket during Spec to ring along with the big handbells we rang atop our elephants. I often saw him in my rambles. He'd been an engineer in Poland, and signed on with Ringling to see America.

At a stoplight, I walked up next to a damsel in a summer yellow dress. Originally I'd worried that I couldn't meet women on the road, or meeting, wouldn't know what to say. It turned out to be easy: simply say *something*. Has anyone else discovered this technique? I asked for directions to the arena. Earlier I'd looked at a map to orient myself and knew exactly where it was but asking was *something*. I could have also told her I was a clown but that would have begged a response. Then I'd never know if she liked—or lusted—me for myself. Asking directions allowed her to decide the next step: she could answer and walk away or continue the conversation. It was

like dealing with an audience: approach, then let response shape what came next. When she asked why I wanted to go to the arena, *then* I told her I was a clown. She said she'd been thinking about taking her nieces and nephews to the circus. If you do, said the gallant clown, exchanging names, ask for me. Joyce did, and fantasies blossomed until our date turned out to be with her family. The next day, the second of the two-day stand, she picked me up between shows for dinner. Again, family. Lovely people but, in my opinion, too many in the situation.

I got another date in Des Moines. I wondered if having no close pals on the show increased my inclination to flirt. Or did I miss the interaction of Whipcracker? (!) Doing a PR gig downtown—with Dean: we remained pals beyond Whipcracker—I paid jokey attention to a young woman wrangling children from a summer camp. I got her name from the kids, who thought that was hilarious, and when I jokingly asked Corky out, she recognized it wasn't a joke. That night we joined her friends for pizza near Drake University. She invited me to the Hot Air Balloon Championships the next morning. The ascension would be at dawn but I'd sacrifice sleep in hopes of early AM canoodlin'—then Corky drove up with her parents. Lovely people, with a lovely, protected daughter. When they came to the show that night, I told them to focus on the start of Menage. The entrance to the Des Moines arena had a low ceiling so elephant riders had to lay flat, and all the others leaned forward but I lay back, to pop up like a jack-in-the-box once we hit the light.

Waterloo—no dating—had the feel of a show under canvas. Trees framed the train across a green field from the small arena, and inside it looked temporary as a tent, with concrete blocks anchoring the rigging, and windows lighting the performance. Approaching our 300th show, clowns were in a barn again, with a dirt floor. The elephants were in another barn, so we mounted outside. I loved being on Leutze under sun or stars. It was on her that I heard Elvis had died. It was also in Waterloo that I learned of another death, when I was cleaning out old newspapers intended for Whipcracker, and saw an obit for a favorite writer, the Penn naturalist and fellow Nebraskan, Loren Eiseley. His words spoke to me: "Each of us is a statistical impossibility around which hover a million other lives that were never destined to be born."

Omaha brought an indirect flirtation with Judy Collins. She was performing in town, and when I saw her in a hotel lobby, I thought it might intrigue her to be invited to the circus by a clown. Which surely would lead to a date. Which could lead to her whispering, "I've looked at clowns from both sides now." By the time my fantasy had us juggling her tour and mine, she'd left the lobby. Her manager was still there so I asked him to

pass along my invitation. Judy Blue Eyes didn't show up. Must not have gotten the message.

I was in the lobby for breakfast with family. Grandma and Grandpa had driven from Lincoln, my other grandma came from the very southeastern tip of Nebraska, sister Suzie was in from California, and an aunt, uncle, and cousins arrived from Denver. Later, friends of Grandma came straight from their flight from Europe, to wave a sign in the seats, "Hi, Dave. We're from Falls City." When any of these wonderful people introduced me to others, it irked me, as if they were treating me like a relative rather than a professional. More experience would make me a better professional who could handle it, weaving it into my clowning. Some of my personal cheering section was sitting directly behind Irvin Feld. After months of avoiding his seat when he showed up so it wouldn't seem I was trying to impress the boss, it now looked exactly like that.

After Sioux Falls came Madison, Wisconsin, and another stop on my nearly-Romeo tour. After the mayor loaned the circus a city truck to put up high rigging, the clowns were told to give him special attention Saturday night. While the others spritzed him with water, mussed his hair, and smacked a shaving-cream pie in his face, I focused on his companion.

Since the demise of Whipcracker, I'd come to the realization that my true partner was the audience. Flirting with women was only part of that larger invitation to interaction. It wasn't exactly arena clowning, but—the second lesson offered by Dean's quitting—I'd begun to recognize how much this individual stuff in the seats influenced what I did on the floor. That seemed counterintuitive. Clowning in the seats required finding a rhythm with individuals and small groups I encountered, adjusting to match their specific responses. Some 50 or 100 might watch me up in the seats dancing an impromptu waltz with a four year old in a tutu, while thousands saw me on the floor with my giant bread. Still, more and more of me emerged in the arena gags and even in the tightly timed production numbers. I no longer felt awash in this massive enterprise. Even in Menage, in the middle of the ring on a huge elephant, I increasingly found ways to reach individuals.

If the rehearsed routines were fundamental to the circus, the seats were fundamental to my education. Up there I did and said what I wanted. That's why I'd stopped worrying about pandering. I did nothing to get any particular response, either by directive or my own sense of what "should" be happening, I simply lobbed a joke or a gesture, ready to deal with whatever happened. And that interaction had improved my timing in clown routines. The process reminded me of the old vaudeville comics. Buster Keaton, Bert Lahr, Red Skelton, all those comedians spent years performing for live audiences, and in effect carried

Figure 8.1 Down in Ring 1, I point into the stands at someone, surprised to be singled out at that distance. RINGLING BROS. AND BARNUM & BAILEY and The Greatest Show on Earth are registered trademarks of and are owned by and used with permission of Ringling Bros.-Barnum & Bailey Combined Shows, Inc. All rights reserved.

those audiences with them into movies and TV. That was the reason the Marx Brothers took plays on the road before turning them into movies. Even when the old baggy-pants guys no longer faced live audiences at all, they still felt in their bodies the timing, rhythms, and reactions of audiences. So Dean had done me a favor by quitting Whipcracker. No longer front and center at the start of Come-in, I could go into the seats earlier. Stretching my personal pre-preshow as much as 60 minutes before the main show started, it was just me and a section, or me and a row, or a family, or a person. And for that momentary partnership to work, it had to be based on whatever came up.

Now I swerved to the mayor's girlfriend each number. (One guy said it was his wife but I decided to believe the ones who said girlfriend.) With my giant wrench in Clown Car, I asked solemnly if she needed adjustment.

I stopped in Spec, pretending not to see her wave at me. In Walkaround, when I held up my slices and inquired politely if she wanted to be in a clown sandwich, she didn't say no. I still couldn't tell which seemed weirder, that I didn't meet women more often on the tour or that a woman might get interested in a touring stranger in full makeup.

After the show, the mayor invited the clowns to a party but I didn't go. Flirting with his date would be different outside performance. Walking to Lake Mendota under a black sky, I rued the separation of true love. The next morning, guys told me I'd blown it, that she'd been asking for me. She was not the mayor's wife *or* girlfriend, and she'd been *really* hoping to meet me. Stupid sky. Stupid ruing. Stupid me.

<p align="center">* * * * *</p>

Summer heat returned full blast in St. Louis. Dragging through the thick air or thin water of muggy Missouri, in an arena with no air-conditioning, I was reminded what Prince had told me, that he'd liked the shorter tent seasons— about six months—but preferred buildings with heat on cold days and cooled on hot ones. Bad as this soupy air was, I felt worse for the audience. Our work at least kept us focused, while they had nothing to do but swelter and watch. It was strange looking at sweaty people looking at us sweat. Between shows, the Alley camped out in the chilly bowling alley next door.

One show, after pulling on my pants, very carefully because sweat made the lining easy to rip, I entered for Come-in. The bottom section by the back curtain was empty. Normally I'd have climbed to the seats a level up but in this furnace of an arena, I decided to stay on the floor and play parade-clown, waving and making faces. Any more movement seemed to violate some basic law of nature. Then a boy, leaning on the railing in the cross-aisle above the empty section, waved at me and yelled down, "Hi, Mr. Clown!"

The greeting made the heat matter less so I climbed up.

The next show another boy at the railing above the empty section waved and yelled the same "Hi, Mr. Clown!" That gave me another boost of energy in the barely bearable heat. It happened the next show too, another boy by himself, with the same lean and wave and "Hi, Mr. Clown!" I climbed up again.

It was coincidence. Kids regularly wave, often yelling "Hi, Mr. Clown!" Yet the next show, a kid stood in the same spot, with the same wave, same yell, same boost...

Catching up on books I'd skipped in college because they seemed obligatory, I'd been reading *Journey to Ixtlan*. In it, Carlos Castaneda

wrote, "Yesterday you believed the coyote talked to you...to believe that is to be pinned down in the world of the sorcerers. By the same token, not to believe that coyotes talk is to be pinned down in the realm of ordinary man." Whatever this spirit of St. Louis was, eager children or talking coyote, something beyond myself lifted me up those stairs show after steamy show.

Chapter 9 Live ✎

September: Fort Wayne, Memorial Coliseum/ Toledo, Sports Arena/Detroit, Olympia Stadium/ Nashville, Municipal Auditorium

> *The theater gains its natural—and unique—effect not from the mere presence of live actors, or the happy accident of an occasional lively audience, but from the existence of a live relationship between these two indispensable conspirators, signaling to one another through space.*
>
> Walter Kerr, *The Theater in Spite of Itself*

ort Wayne should have been a good stand. Biscuits had warned that circus didn't do well in Indiana but our crowds were lively, backstage was spacious, and the clowns had a genuine dressing room, with makeup mirrors bordered in lights. (Habit is strong. I looked up from the 4" x 3" shard of a mirror in my hand and noticed most of the Alley ignoring the fixed mirrors to bend over *their* mirrors in hand or propped on trunks.) We also had a break in the routine, a soccer game. A *match*, Doncho corrected. After a season of yapping about who was better, the Bulgarians and Poles finally played. Being on the show had cleared up a question about soccer that had confounded me for years. How did a species that evolved thanks to the use of hands (and humor) not only favor an activity that prohibits use of hands, but make it the world's most popular sport? The clue came watching four Bulgarians kicking a Coke can backstage. Baseball needs space, football needs space and an inflated ball, and basketball needs space, a ball, and a hoop, but soccer can be played anywhere, with anything to kick. It's perfect for a world of limited resources. The Poles won. Drunk, Monastyruk climbed to his monkey-man rigging back at the arena to celebrate, bellowing the Polish national anthem. He refused to come down and, with the audience entering,

someone got Charly. He and Aricelli had been outside having a picnic on a blanket with his new tiger cub. Imports of tigers had been banned, making Charly's breeding efforts important. He couldn't yell at Monastyruk with people watching but he did stare *fiercely*. Fortunately the Pole was a happy drunk and came down, still singing.

So what was my problem with Fort Wayne? Shakespeare said it in *Midsummer Night's Dream*: "Wall, that vile Wall which did these lovers sunder." The Memorial Coliseum had a high wall that separated the arena floor from the seats, except for a few on front track and back track, and that wall kept my audience and me sundered. The problem wasn't the physical distance. Far rows here were no further than in other arenas of course. But my emotional connection rippled from the close rows, as I ran out of my place in Opening to shake hands or hid from the Clown Car behind someone, and this arena had few seats close. The problem was both psychological and practical. My Walkaround bread was dead without people to grab, leaving me little but walking around. Most clowns didn't mind the separation. Some even preferred it. Like many acts, they felt it framed them better, the way actors are set off by a proscenium arch. But it cut me off from my audience. Whether brief or profound, whether it was like the bond felt with a mainstream comic movie or a favorite indie band, it's still connection, human spirits joining in mutual recognition. Here, disconnected, I felt as if I were faking it.

Disconnected, and nearly deceased. It was move-out night. We were doing the Michu Presentation again, once His Low Highness's broken arm had healed, and it was my turn to pack the presentation box. As I fit the pieces into the prop box in the wide hall, the grooms brought the liberty horses to line up, side by side, tails to me. We'd been warned the horses kicked so I should have moved out of the way but I almost had the box in place. Then, done, I should have slid out between two horses to reach their heads, away from the hind legs. But the door to the Alley was only a few steps—

The horse kicked so fast that I didn't see the hooves coming, only the recoil past my eyes.

"Get outta there!" Camel John yanked the horse away. "You idiot! *Never* stand behind them!"

In the Alley, I felt calm, joking to myself, You could put out your eye with that hoof! Then I noticed my hands shaking. A few inches closer, at my temple, I'd be dead. Not dorm-room musing about death but dead. Be in the moment? Just *be* is good, thankyouverymuch.

* * * *

Figure 9.1 Richard Fick, a First-of-May marvel. Author's collection.

I got a great idea for a walkaround in Toledo. With a borrowed broom and the scrap of rug from my trunk, I lay the scrap on the track, pretended to sweep dirt under it, and picked it up to move on. I could see the humor in my head—sweeping dirt under a rug—but that's where it stayed, in my head. For a dozen shows, a dozen crowds showed indifference. Either there wasn't a joke or I played it wrong a dozen ways. Maybe I'd try it again but Toledo's verdict was clear. This failure didn't crush me though, the way earlier failures had, because I'd learned that little was real failure. With so many performances, there was always the next one for trying a bit again, doing it the same to see it would land better with different people, or tweaking the bit a bit, or altering it drastically. What had felt like a crushing schedule blossomed into an open-ended experiment, with no blunder final, and "failure" a launching pad to the next step.

On Saturday, the Prince fell unconscious in the Alley, toppling like a short pillar. Richard, who'd gradually become the Prince's semiofficial caregiver, went with him to the hospital. When I got there later and a nurse asked who I wanted to see, I drew a blank. The clown Prince had been so singularly "Prince Paul" that I didn't know his last name. Fortunately the hospital had admitted only one little person in clown makeup that weekend: Paul Alpert. He joked he had his epitaph ready: "I hope I don't come up short."

* * * *

Detroit's bleak reputation seemed confirmed when our bus passed boarded-up buildings jagged with graffiti, before stopping at the parking lot's locked gate, topped by razor wire. The paper blowing over straggly weeds on the cracked asphalt made it look like a crime scene, which it had been, with a killing scaring audiences away. Olympia Stadium looked no better inside. Cracks and stains slashed the dimly lit walls, as if the hard checks of Red Wings hockey had smashed the building itself.

But Olympia was great. Alive with sound, the place mixed Gucci and Carhart, black, white, brown, young, old, city and suburbs, all eager and enthusiastic, no sitting on hands. People chattered, pointed, leaned in. After 350 shows I'd learned that some audiences preferred their comedy on the quiet side. Not Dee-troit. When I mentioned the lively sound to Ronnie, he gave a bandleader's response, that it was the acoustics. The old wooden arenas literally resonated, vibrating like the inside of a cello. Olympia was, in musician's jargon, "live." A week-long personal cheering section enhanced the effect. Mom and Dad drove down from Bay City to attend nearly every performance, joined Saturday by a busload from Delta College, where my dad was president. Walt, the old guy at my summer job in the meat-packing plant, who'd introduced me to Bernard Malamud's books, drove down with his German hausfrau Mabel. My high school council president campaign manager came from the 'burbs. A fellow ex-MP arrived from Jackson to reveal the conspiracy that ran the country. Another visitor was a lesbian I'd dated. A high school buddy showed up at the back door, though he didn't stay for the performance. (Probably still jealous I was a better basketball player.)

With the joint jumpin', the Motor City's mixed crowds embraced my implicit bargain: we'd work with whatever came up between us. Crucially, that meant me not trying to control what happened. That's why I didn't whisper instructions when I did a bit with someone in the audience. Plowing ahead with what I'd planned deadened the moment, turning both of us into stereotypes, the clown doing "antics," the "volunteer" as a prop, and the audience a generalized clump watching in "enjoyment" or "appreciation." (It must be a pain to be a performer who's "appreciated.") Though control had been my original goal—that does make a clown's life easier—it felt better, livelier, more *human*, to simply approach, which started the party, and then use the response, any response, for our next step. As those steps proceeded, we joined, creating the moment together. During Clown College, Bill had quoted the brilliant Otto Griebling, "To make people laugh is God's gift." Early on, beguiled by the easy laughs, I thought I was passing on the gift to others. Audiences taught me different. Making people laugh was a gift

shared between us, the willing and the eager. This was more than interaction, it was exchange of energy. I started the ball rolling; I was the clown, after all. But I couldn't have sustained my excited enthusiasm from the first weeks, and eventually, I fed off the energy that audiences brought. I'd heard about using audience energy but dismissed it as show-biz flummery. Now I'd learned that, for me, it was literally true.

Yet even as I dug into this improvisational impulse, I violated the rules of improv. In improv, you're supposed to say Yes-And, because denying what the partner says can sap the comic impulse. Me? I denied all over the place.

I'm not a clown, I said.

Polar bear? It's not bare, it's wearing a fur coat.

A circus! Where?

No, that's not a tiger, it's a horny toad. Oh, wait, it's a horny frog. (Kids missed the double entendre, and surprised adults chuckled. I loved that surprise.)

Clowns don't talk? You're right, I'd say somberly, in full makeup and costume.

All that chatter meant I broke improv rules. So improv-sue me. But my No didn't stop things, it propelled the comic impulse. Saying No tugged people out of the expectation that I'd do vaguely amusing things and that they'd vaguely laugh. I'd discovered that no one older than seven expects clowns to be actually funny. But my contradictions got them wondering, opening the possibility of genuine comedy. It cracked the carapace of clowning. Say Yes to No.

Contradiction worried some parents. When they said "Look at the clown!" and I replied that I wasn't a clown, a few of them got protective, trying to prevent what seemed to be imminent disclosure of something inappropriate. A mom or dad would rush to explain to their little one that maybe I wasn't like the *real* clowns down on the floor. Meanwhile, kids got the joke, as parents caught up. Again, my No pulled us together into the state of grace that actors call "being in the moment."

Omigosh, did that make me a trickster? The truth-to-power trickster notion had appealed to me in college but lost its charm as I noticed the implied boast. In this intellectual version of the action hero, the trickster always bests villain-like authority, while those who tout the trickster see themselves beyond his challenge, making it not much of a challenge. So, disenchanted with the notion, and no longer seeing myself as a rebel, especially after the Army had posed its own challenge to my rebel pose, I dismissed the idea that I could be tricksterish. Yet I'd stumbled into the role. I'd

change no oppressive society but I challenged expectations all over the place. Parents, expecting to mentally doze through the circus, woke to attention. Snarky teens, expecting to faze the clowns, encountered one who, unfazed, slid in his own snark. Children, expecting arm-waving antics, had to deal with me dealing genuinely with them. They became my co-conspirators in nonsense. Individuals in the audience were my material and my partners, creating together on the fly. My approach pushed us to the edge, often close to discomfort, in that uncertain but creative border between uneasiness and fun.

That's how my horn bit developed, collaboratively. Originally I'd carried my cornet in the seats only so I wouldn't have to go back to get it for Clown Band. But remembering, again, that a clown carrying something makes it a prop, I pulled out a feather duster and played it like a violin.

"It's a trumpet!"

Oh, it's a banjo, I'd say, lowering it to strum. (To point out it was actually a cornet would detour from the joke.)

"No, it's a trumpet!!" They loved my stupidity, and jumped at the chance to correct me.

Not a banjo?

"No! No! No!"

Oh. Oh. Oh. Then it must be a gee-tar.

"It's a trumpet! A trumpet!"

A strumpet? Ya sure it isn't a ukulele? A lute? A galoot? A balloon! A baboon.

"It's a TRUMPET!"

Oh, a *trumpet*, why didn't you say so?

I held it to my face but with the bell on my mouth and the mouthpiece pointing away.

"NO! The other way!"

Keeping the bell end on my mouth, I'd face the other way.

"No, the trumpet! *You* stay!"

But if I stay like this, I can't see you.

"*You* turn this way, and turn the *trumpet* around!"

After I rotated to them, they yelled more corrections. Some would slowly enunciate each word, with the didactic patience that impatient adults use. "Now—hold—it—with—that—end—sticking—out," they'd say, pointing at the bell end, and of course I just *had* to put the mouthpiece against the back of my head, bell end out. So it went, scheme-and-variation. The value didn't lie in the jokes, good, bad, or indifferent, it lived in interaction. The kids in effect told me whether to do a quick bit or pile on more, whether

to be loud—You are ALL being OUTRAGEOUS!—or underplay—I'm so corn-fused. Kids are not idiots. They recognized that I knew how to hold a horn. But me playing idiot gave them a chance to correct a grown-up. I set up the joke and they made it work.

This was different than traditional improv, which starts with audience suggestions, then settles into the usual performance pattern, in which one side leads and has a voice, while the other side watches and listens. My audience and I both had a voice. I went where we implicitly decided together to go. To the romantic part of my soul, it felt like democracy.

One afternoon, I entered for Come-in in the corner opposite the back curtain, when a kid waved me over. Holding his hand flat, he said "Gimme five." I swung my hand down but he pulled his hand away and laughed. I pretended to be vexed. Making a determined face when he held out his hand again, I tried again, and he pulled away again. I had to leave but in Opening I ran over to him. Would he recognize the running gag? He did. Again he pulled away at the last minute. Great: he wanted to play.

I headed to the same corner for Walkaround. While most of the guys delayed till the last minute and ran to the back curtain just in time, I usually went to the other end early. Dean did too. Entering the number there gave us that end of the arena before the clump of clowns coming from the back curtain got that far.

We were doing Whipcracker again, by backstage popular demand. When our gag broke up, I assumed it only mattered to us. But Doncho had asked about it, and so did Biscuits. Michael, the assistant with Ursula Bottcher's polar bears, said in broken English, "Why you not do that?" Every Come-in, he'd been behind us at the polar bear cage in Ring 2, which I'd assumed was to prepare. He and Ursula took such good care of the bears that they could have been parents. In fact, Ursula had raised them, and though part of the act's appeal was the contrast of her tiny size and their towering height, she had baby pictures of each one. But Michael said he came out early to watch our gag. Even Camel John mentioned in his don't-give-a-shit way that he hadn't seen it lately. Dean had been hearing the same thing from others. For me, Bisi clinched it. One day, he toddled up, held up a newspaper paper in his tiny fists, and, scrunching his face into mock-seriousness the way I did, ripped it. A clown gag is exaggeration of a human situation. If Dean and I hadn't been equally stubborn, we might have seen how comically exaggerated our squabbles had been.

When I got to the kid with my bread, he put down his flashing red light, and handed his cotton candy to his dad. Clearing the decks for action. He held out his hand, I swung, and he pulled away, laughing, and I acted consternated.

People were watching now. When Dean arrived, I motioned him over to show him. Again, the kid held out his hand, again I swung and he pulled away. Then he held out his palm for Dean. This was an important moment. If the kid pulled his hand away from Dean, it'd be cute but ordinary, another youngster turning a joke on clowns. And Dean might pull his own hand away, a cheesy thing for a clown to do, but it worked for him. Moment of truth: the kid kept his hand there while Dean smacked him five, and the kid smacked back. Together, they made *me* the butt of the joke. Great! Then the kid turned back to me and held out his hand. He *felt* the timing of joke, as if he and I were a comic team improvising our rhythm together. (See, Dean.) I peered at him with suspicion, then at Dean, then back at the kid. I raised my hand, letting it hover there as I considered the situation. The kid, a picture of innocence, kept his hand steady. I swung, he pulled away, and laughed and laughed. Tricking the trickster. Frowning, I laughed on the inside. One of the skills I'd been learning was to make the other person the star. Part of my fun was doing it so those watching didn't realize I'd framed it, thinking instead that I was surprised or baffled, or happened to reach the shy child by accident. People worry about being mocked by the clown, a not unreasonable worry with insensitive clowns, but clowns I admired made others looked good, joined in the comic moment.

Throughout the show, the kid and I repeated our routine, me pretending increasing frustration and more people watching. I even ran over in Menage, though I usually didn't venture so far in the few moments off Leutze.

What would the kid do in Finale? By now the whole section anticipated my arrival. He held out his hand. I held up mine, then hesitated. Would he pull away again or recognize we'd been building a routine that needed a conclusion, a blow-off? He waited. I swung down, he kept his hand there. Slap! Then he slapped my hand back. Perfect! I loved that kid. I loved these crowds. I loved Detroit.

* * * *

Move-out night in Nashville, Dean and I were strolling to the train from bluegrass music at the Station Inn. Kenny had introduced us to the place. He was a pal from my Philly days who'd kept my VW tuned up when I was in the Army. A great mechanic, he was also a great musician, a guitar player who'd made his own banjo. I didn't know he'd moved to Nashville so it surprised me when he blew into the Alley, bushy beard rampant, eyes shining behind dark-framed glasses that looked both nerdy and cool somehow. Seeing Dean's banjo, Kenny invited him along. He was like that, always friendly and convivial. At the Station Inn, Kenny knew half the folks there and met the rest.

Dean and I had returned on our own, and now walked to the old station downtown, where the train was parked. Usually a talker, I was content to let Dean chatter, happy to be in harmony again. A bag of ginger snaps and *The Great Gatsby* waited in my room.

Reaching the bridge over the tracks, we looked down and the train was moving! We took off running. We had to cover three sides of the block, to the corner, a turn and run to the next corner, and a block-long sprint back to the tracks. There the train sat, not moving, mocking our worry as we caught our breath. Cars were simply being linked. The old station platform looked like a step into the past, with a film-noir pool of light around each pole in the dark. When Dean climbed up to his car, I moseyed toward my vestibule by the next light.

"Hands up!"

I turned casually, nonchalant with the prank. But it wasn't anyone I knew, it was a stranger, his face shadowed, a gun pointed at me.

"I said Hands up!"

Even as I stared at that pistol, this didn't seem real.

"C'mere!"

I had an impulse to scoot over to the train, as if that would make me safe, like touching base in tag. An incredibly stupid impulse. I put up my hands and that didn't feel real either, as if I were part of a game.

He said something about two guys running. That told me this wasn't a mugging. I sensed him deciding he needed to look for someone else and was explaining to justify the stop. Still, he didn't lower the gun. A few things can happen with a pointed gun, most of them bad. As a military policemen, I'd halted a guy running in the dark by pulling my .45 and yelling "Freeze!" He'd stopped, clearly nervous, but I'd been nervous too. What if he'd kept running? Or moved toward me? Or scooted to touch something, as if playing tag? What if my finger slipped?

What if this guy's finger slipped?

"Why're ya runnin'? Got a report of a break-in."

He wasn't a cop or he would have said so. Must be a railroad dick.

" . . . and two black guys runnin' away."

I saw him hearing his words. Looking for two black guys, he was facing one white guy. If this were a movie, I'd say something funny to defuse the situation, but the hole in the end of that gun barrel scared funny out of me. Adrenaline racing, I was both in the situation *and* thinking about it, and thinking *about* thinking about it. As calmly as I could, I said we were with the circus and running to catch the train before it left—

"We?"

Shit. He's looking for a two guys and I just told him I wasn't alone.

"Anyway," he said suspiciously, "the train's not moving."

Damn its stubborn immobility. I wished it would start then to prove my point, even though I'd have to find my own way to Indianapolis. My words came in a rush, about Station Inn, the indeterminate departure of the circus train, the hassle if I—emphasis on the singular—missed it. I smothered him in details, and though I disliked the stereotype of clown-as-innocent, I pushed that angle hard.

"Yeah, well, we're looking for black guys."

He was seeking a way out. It was bad police work, and probably racist, but if he didn't want to take time checking my story, that was okay with me.

When he *finally* lowered his gun, another guy puffed around the corner, waving *his* gun. Young, fat, with a flat top, this one was itching for action: slam me against a wall, throw me to the ground, shoot me. I'd known MPs like that. The first guy stayed in charge but just barely. I nodded earnestly as he warned against running in train yards, and a bunch of other stuff I wasn't hearing as I watched Flattop. I didn't make eye contact though: no challenge, mister.

The first guy said I could go. With their guns still out and their stares on my back as I walked to the train, I felt awkward, as if I were *acting* the task of walking, and doing it badly. I stepped up to my car *very* carefully. In movies, if one guy stumbles, the guy with the gun shoots.

Chapter 10 Stop Giggling ❧

October: Indianapolis, Market Square Arena/Carbondale, SIU Arena/Champaign, Assembly Hall

We are still being born, and have as yet but a dim vision.

Henry David Thoreau, *A Week on the Concord and Merrimack Rivers*

It was finally Contracts in Indianapolis, where a few of us were summoned to Market Square Arena one morning. Every stand for months had spawned rumors that the *next* stand would be Contracts. It had seemed legit in Sioux Falls when Steve scribbled reports on us. Then Detroit was *definitely* contracts, especially once Irvin showed up. But that was only a visit, punctuated by a publicity shot of him surrounded by clowns. I wished I had shoved into the shot but I was content just out of the picture a couple feet away holding the baby of a visiting ex-showgirl.

Babies were a great perk of my clown career. I'd be running through the seats, skid to a stop, ask, May I? and mom or dad would hand over their bundle of joy. Though clown-with-child is standard stuff, I don't know that I'd have said yes if I were a parent. How did they know I wouldn't use the kid as a prop? Yet every time I asked, the parent trusted me, so I got hundreds of babies to hold, cooing them to a smile, and talking to them about their big eyes and the circus and the state of the world. Too young to notice that makeup was unusual, a baby would focus on my eyes and the sound. Babies would blink and I'd blink back, signaling that they had a say in the way their world worked. It was like the improv I used with everyone older than babies. Obviously there was no exchange of words with the littlest ones, no meaning to be parsed by the conscious brain, but the *message* was the same: what you do affects what I do, which affects what you do,

back and forth. Occasionally one would cry, and a mom would apologize, but I'd point out that crying is a baby's job, and I'd continue cooing. And the giggle: there are few sounds as glorious as a baby giggling. I never stopped marveling at the gift parents gave me.

In Indy, showgirls had been called in first. All but two got renewed. One wasn't asked back because she only went through the motions in performance. The showgirl walk-and-wave is easy to mock but parading hundreds of shows in a row with grace, smiles, and apparent enthusiasm is not easy to do. Showgirls didn't even get to vary what they did. Their only variety came when a clown, who did have freedom to vary, goofed with them. We were *their* comic relief. Lynn finally got that. She now smiled when I altered my steps around her. Still, she'd have blamed me if she hadn't gotten a contract.

Then came the clowns' turn, starting with Richard, me, and a few others. My admiration for Richard had grown through the season. He was wonderful at elegant presentation yet, a rare combination, he was also terrific playing broadly.

A different job offer had come my way in Des Moines. On move-out night, wagons get loaded at the arena, then pulled to the train, to be run up a ramp and along the flats, linked by crossover plates. The story goes that, before World War I, circus had become so efficient loading trains that the German High Command came to observe. But this silver box of a wagon canted on the side of the street, like a cow with a broken leg culled from the herd. The front axle attachment had snapped, and the wagon had to be emptied to get at it. I helped unload, as Camel John wrestled with the problem. With no time for a permanent repair, something had to be done right away to get it onto the train. I thought of a solution but hesitated. If my idea failed, I'd hit a lower circle of disregard than John usually assigned clowns. When I'd performed at the University of Michigan, the techies had created the "Golden Screw Award" just for me, because I helped in the shop and moved sets during performances, but John wouldn't have cared. I screwed up my courage and climbed in.

"What?!"

I suggested sticking a screwdriver through the housing as it came up through the wagon floor, precarious but maybe enough to get the wagon up the ramp. John scowled, but tried it, and it worked. As we all reloaded the wagon, he said, "Quit that clown shit and I'll hire you." He was joking. Probably. Still, it was a proud moment in my circus career.

Buzzy wasn't being asked back. He and Richard were the best First-of-Mays but Buzz was also an angry guy. Ironically, he was peaceful on

the Alley but that was because no one risked arguing with him. Unlike the rest of us, he wouldn't bluster, he'd act. When Lynn pushed him out of the way before Opening once, Buzz didn't yell, he simply told her, firmly, to never do it again. Though *she* shoved *him*, his intensity made him the bad guy. Something similar happened in Indy. The car of Clown Car had the front seat taken out so more clowns could fit inside, and Mama drove sitting on a low stool. One afternoon a clown snuck the stool out, and another hid it, giggling like rascals who'd taken the schoolmarm's ruler. Mama yelped when he saw it missing but, with our music cue starting, he had to go, driving on one knee, making for a rough ride around the track, jerking the car, then turning hard into the ring, banging everyone inside. Each time the door opened to let out a clown, that clown yelled at Mama, who yelled back. Buzzy played a baby in the number, with bib, diaper, and huge bonnet, plus a giant "baby bottle" that he'd used all season to spritz water randomly. Now, he leaned back in to empty his bottle at Mama. When we got back to the Alley, Mama stormed up from parking the car, madder than a wet mama hen, blaming Buzzy for the water and for stealing the stool. Buzz fiercely denied the stool. An angry man dressed in diaper and bonnet looks funny but no one was laughing. Sensing the truth in Buzzy's denial, Mama switched gears.

"Anyway, spraying that water pushed my contact lens back into my eye! It was dangerous!"

Of course the real danger was pushing Buzz too far, and Mama stomped away. So far it was business as usual, Alley squabble as spectator sport. But Mama upped the ante, skipping Steve to complain to Charly, who came to yell at Buzzy for stealing the stool and spraying the water. The first part wasn't true, which even Mama knew by then, and the water was innocuous. But before the real culprits could confess to a harmless prank, Charly expanded the indictment, accusing Buzz of bullying the Alley. Ironically, Mama was the bully in this situation. Though a gentle soul who'd have been astounded to be called that, he'd done what bullies do, exert power—here, management clout—over someone weaker, a guy in disfavor. He at least looked uncomfortable when Buzzy got kicked out for the day, his pay docked.

Despite being summoned early, Richard and I were kept waiting. A year ago I'd anguished about a contract. This time my anguishing had extended half the season. After the First-of-May urge to quit had faded, my old concern about the straight-and-narrow revived. Shouldn't I return to the law? What about loneliness? And despite growing proficiency, doubts

about my talent nibbled like tiny fish. Plus, I wouldn't ride elephants next year. Bigfoot had told me the show would get a new trainer next season, Buckles Woodcock, the one Bill Ballantine had praised at Circus World, and he wouldn't use clown riders. If I returned, no Leutze. Bummer.

After waiting an hour, my turn came. It wasn't Irvin but Kenny. Ken? Kenneth? Mr. Feld? Your Exalted Majesty? He never said what to call him and I didn't ask.

He started by talking about uncertainty in the Teamsters contract. That confused me. What'd that have to do with clowns? As he talked, it sunk in that he wasn't offering clown contracts yet. Rumors, correct or not, later filled in the gaps. The Teamsters were threatening to go on strike, and apparently the Felds used the pending clown contracts as a negotiating tactic. With no clowns signed, they could say they were ready to shut the show down. Squinting just right, it was possible to see management claiming that clowns were important. Another rumor said that Ringling would use the Poles and Bulgarians as strike-breakers. So much for solidarity from Communist paradises; Workers of the World didn't always Unite. (Once their contract was settled, a pal on ring crew quit his $140 a week job, yelling about a payoff.)

Kenneth asked if I'd take a contract if offered. He wanted me to agree *before* an offer? He also asked if I had anything to add. I had lots I wanted to say. Had they learned about my Pied Piper routine in DC? Did they know I was doing a *pre*-preshow, my personal Come-in a half-hour *before* the scheduled 20 minutes? Had they seen me growing beyond flailing energy into greater skill with audiences? But to ask embarrassed me, as if I were seeking praise. Maybe I *was* seeking praise. Still, it bugged me that I had to ask. Other than the warning against screwing around or being late, no one said anything about anything to any of us. Sink or swim.

Walking to the train that night, I caught up with JC of King Charles. As the last cars made their way out of the parking lot, the red dots and bars of tail lights glowing in the night, I groused about the contract fake-out. Tall, dignified, ex-Marine as Nubian prince, JC let me vent. Then in silence, like the people in those cars, we went home.

* * *

While studying for the Bar Exam, I saw Jim Dale, a great clown and actor in *Scapino*, his Broadway hit on tour in San Francisco. Now in Carbondale, I saw a college production at Southern Illinois University, of the same show, and it was a revelation.

Watching Dale a year ago, I'd felt a kinship with him. In movements big and small, it was clean and clear physical comedy, and I thought I did the same. I even imagined myself on stage with him, a fellowship of funny. (Later as an actor in New York, I did *Scapino* off-off-Broadway.) But watching this production at Southern Illinois University, I realized three things. First, I'd been like these students, eager but antic, *signaling* comedy as much as being funny, the laughs mostly from fellow students enjoying their friends being silly on stage. Second, I had improved. If not yet at Jim Dale's level, I had learned enough to recognize spaghetti and avoid it. Third, despite one and two, those laughs shouldn't be denied. Laughs from friends are important too. "You had to be there" is not just a shrugging way to excuse a joke that flopped, it's also a statement of fact, testimony to the foundation of live comedy, that for it to work *requires* you to share the moment. To get *this* joke, you had to have participated. You literally had to be there. Spaghetti or not, and home-field laughs notwithstanding, this SIU troupe had created a moment with their audience. So too, I wasn't entertaining others; I was joining them.

Now I did it with props. Other than the bread slices in Walkaround, and maybe the giant wrench in Clown Car, I'd seen myself as an ascetic clown, relying on nothing but me, baggy pants, and an audience. That was until our clown wardrobe man Ross appointed himself my personal producing clown. A producing clown is the clown on the Alley who thinks up gags and props, and Ross appointed himself my personal, civilian version. Tall, bespectacled, and stiff, with a William Powell mustache, Ross was also, as he might have put it, formal of speech. He reminded me of P. G. Wodehouse's fictional butler, Jeeves. Just as the gentleman's gentleman Jeeves always helped his gentleman Bertie Wooster, Ross helped me, by suggesting props. Earlier I'd have rejected his suggestions. I thought creativity meant originality, that I had to come up with ideas myself. It didn't help that Ross treated me as if he really were Jeeves and I was a dim-Bertie clown. He especially tried to persuade me to stay out of the seats. Fussing about what could go wrong, he counseled me to stick to the safe stuff, shaking hands and waving from the track. What he couldn't see was that the risk of failing was what made the work special.

Still, I shrugged off Ross's condescension because his ideas were so good. One day he returned from antique shopping with a silver lamé pith helmet and two 40"-wide, hard plastic double wings. Following his plan, I cut the wings in half, 20", bolted one on each side of the pith helmet, and sewed the other pair to gold lamé spats scavenged from men's wardrobe. Then I bought plastic daisies at a dime store, to dangle out of a white florist's

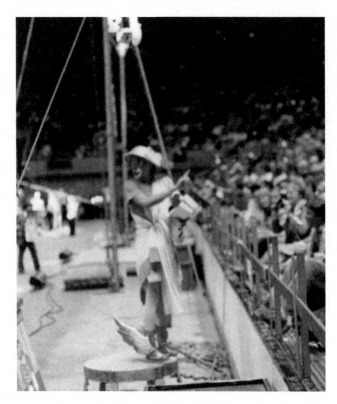

Figure 10.1 Mythic in fake flowers, plastic winged ankles, and a silver lamé pith helmet with its own pair of wings. Author's collection.

delivery box. With winged helmet and winged feet, pink tights, and a thrift-store pink-&-white striped sheet for a toga, I was the FTD logo. Or, for the classically minded: Hermes, aka Mercury. The next Walkaround, I tried to deliver my fake flowers. I'd stop on the track, look at a woman, decide with a regretful shake of the head that she wasn't interested, and after posing with a leg and an arm up like the FTD logo, I'd move on to repeat it down the track. A fun bit, it was homage to/echo of a classic routine by the great Otto Griebling, who tried to deliver a beat-up package.

Or, another Ross inspiration, take a toy helicopter attached by a stiff wire to a handset holding batteries that spin the rotors, break off the rotors *and* the helicopter, thread the cable through the bald spot on a clown wig, attach a patch of the same orange "hair" to the spinning end of the cable,

stick the handset in your pocket, push the button and—voila!—a spinning wig. At least a spinning toupee.

Then there's the squirting flower, as obvious as a joke can get. In the dim mists of the comic past, the very first victim of some early vaudeville comic *might* have been surprised when prompted to smell the flower on a lapel and getting squirted instead, but surprise had long curdled into cliché. Now anyone who sees a plastic flower on a lapel knows what's coming, a second-rate joke that's sunk to the *symbol* of a second-rate joke. That's why my squirting flower was so fun, the surprise. Ross bought fire-engine red fabric patterned with big white daisies, and suggested that I carve foam rubber into big bow-tie shape—I made it 18" wide—and hand-sew the fabric to fit it. I then got a plastic jump rope and cut off the handles, turning the length into a narrow tube, with one end attached to a bulb syringe and the other end squeezed through the middle of the tie, the end poking out disguised by a plastic daisy that blended with the daisies on the fabric. So instead of the obviously fake flower on a lapel, the giant tie with a large plastic flower in the middle looked *interesting*. Something that people wanted to see closer. Approaching Leo, my Polish fellow-traveler, I was maneuvering to squirt him when, curious, he leaned in himself to look. Spritzed, he giggled. Next, Tim, resplendent in his assistant performance director's tux, leaned in too, got sprayed and grinned. It was the plastic flower that attracted attention, that odd note poking through the fabric drawing my victims. I only had to put my tie in line of sight and curiosity did the rest. Everyone enjoyed being spritzed because it was so unusual.

Everyone but one showgirl. "That's really *ignorant*, David!"

As she stormed away to fix makeup that didn't need fixing, I felt bad till I decided, either trickster-like or rationalizing, that showgirl haughtiness *required* squirting. Seeing Buzzy's baby bonnet as the car was loading for Clown Car, I angled toward him. All season he'd been squirting us. Now he leaned in to look and got his own faceful. Blinking the water away, he guffawed, literally throwing his arms up in delight.

* * *

The University of Illinois arena was tough on clowns. Though the arena itself had been designed with circus space and rigging in mind, the Alley was a long hallway away from the back curtain, and we were crowded in a small room, so tiny that side-opening trunks had to be stacked two-high. The cramped quarters didn't help the coughing: every time we got back from a number, the Alley sounded like a TB ward. With the rest of the cast

scattered in distant dressing rooms, I missed the casual camaraderie, saying Chaisch to the Poles, clucking over gossip, squirting people with my tie. Also that long entrance had a ceiling barely high enough for elephants so clowns didn't ride. Missing the cast and not riding Leutze made it feel as if I were barely doing the show. By Finale, I had no favorite faces in the stands, and little overall sense of the crowd. Whether people enjoyed themselves seemed to have little to do with me. As if I were a chorus boy in sequins.

That increased the importance of the connection in Come-in for me. One afternoon I stopped to pretend-flirt with a co-ed—pretending to flirt is a great way to flirt—and she giggled.

Excuse me, ma'am, I said, would you please stop giggling?

She giggled more.

Sometimes I dropped a bit after a single attempt, despite laughs. If something didn't tickle my funny bone, I had no impulse to do it again. That's what happened with the liberty pig Dean suggested. A liberty horse is one "at liberty," that is, without reins attached and following voice commands, so I'd do that in Walkaround, using the pig Dean carried in Clown Car. Setting it on the track, I gestured grandly for it to play dead, then "secretly" tipped it over with my toe. Though I liked Dean's idea, and it got a reaction, Liberty Pig did little for me, and I only tried it that once.

On the other hand, I used Stop-Giggling nearly every show, because it felt new every show. What kept it fresh was the challenge of finding the balance. Any painted face can say "Stop giggling," but to play it right took experience and finesse. The person had to be laughing but not too much, or the bit would kill the laugh. Then I had to figure out how intensely to play it, and how far to take it. Sometimes one "Please stop giggling" was enough, and I'd move on. Other times I'd stretch the bit, snapping off a "shh" like a curve ball, and letting the person's energy push us further. On a few delicious occasions, I had to leave because the person was out of breath from laughing. But short or long, it only worked if it was mutual, the person knowing the joke and laughing *because* of that knowledge. That's why Michael, Ursula's helper, laughed every time I did it with him. It had gotten to the point that I only had to look at him sternly, and he'd break up. This woman seemed similarly responsive.

Please, I said, this flagrant display of gigglishness is *inappropriate*.

She could barely contain herself. When things hit just right, it felt great.

Then her date interrupted. "He's just going to tell you to stop laughing again."

The risk of trying to bond with audiences is that someone rejects the invitation. Did relying so much on the mere prospect of connection show

me shallow, seeking favor in a way that allowed others to determine my
work and my worth? Or was it bravery, like the freelancer getting a "No"
more often than "Yes," yet still proceeding to the next audition or book
proposal?

"He'll keep saying stop laughing, and you'll keep laughing, and so on."

Where was my squirting flower when I needed it? *Of course* that's how it
works, you soul-sucking, sophomoric sap. That's the joke, you jealous jerk,
that it's *obvious*. The youngest *child* who's ever laughed at this bit knows
that, you college cretin, which is *why* they laugh. Not only that, your date
was *enjoying* herself, which is more than she'll ultimately do with a pea-
brained paternalistic prig of a pig like you.

That's what I wanted to say. But unable to come up with a comic trans-
lation in the moment, I slunk away, defeated.

More to learn.

Chapter 11 Clown Mask ❦

October: Boston Garden

Send in the clowns.

Stephen Sondheim, *A Little Night Music.*

Stephen Sondheim apparently regrets that "Send in the Clowns" has become a sappy clown anthem, because it's not about clowns. The song, from his musical *A Little Night Music,* uses regret at lost love to hint at a renewed affair, and doesn't particularly apply to clowns, but clowns are people too, and know loss, so in that roundabout way, it *is* about clowns. Anyway, Sondheim can't complain about clichéd use because he built his song on a cliché, the happy clown melodramatically contrasted with sadness.

The season had smacked cotton-candy clichés out of me. Though they'd been a big part of what drew me to circus, I'd learned how treacherous they are. Whether it was this happy clown, the hackneyed sad clown, or the hippie romance of a truth-to-power trickster, they buried what a working circus clown does in a swamp of stereotype. To truly engage an audience, I had to wade through that swamp, diverting people from the image they expected and draw them to what I was really doing, while making sure they recognized it was based on what *they* were really doing. When someone said, by rote, "Look at the clown, isn't he funny," my reply—"I haven't done anything funny yet"—was simultaneously a joke and an invitation to engage. Work matters, clichés lie.

So I should have recognized as we left Illinois that my worry about hyper-literate Boston was its own cliché. I had lots of time to worry, out of Illinois over the ICG line, then the N&W to Buffalo, the D&H, and the B&M. On the way, our car lost heat. I usually hurried through my root beer before the cans lost their chill, but that was barely necessary in this rolling refrigerator. Seeing my breath when I woke in the morning, I went

to the vestibule. I usually moseyed out because I only saw half the country out by my window, and wanted to see the other half, but this time I hoped for warmth. When the thin sun didn't help, I drifted to the heat in other cars, unfreezing my fingers. Back in my room at the end of the day, I held my left hand over the steam of my hotpot soup and wrote letters with the right till, passing North Adams, I opened *Great Expectations*. I'd avoided Dickens, thinking he was corny, but I read through the night, my toes thawing under the blankets.

I worried about Boston because, after my experience with that Champaign jerk, I thought I'd be facing more snarky students, plus persnickety professors and extravagantly educated citizenry, all sniffing over folded arms at what they deemed crass or corny. Or, maybe worse, laughing immoderately to establish their free-spirit credentials. I'd done both in college, and now knew that either muffled the event, like holding a struck bell. I kept imagining dead bells thudding in Boston.

But I was wrong. Boston was great. The Garden was another live building acoustically, like Detroit's Olympia, and the crowds were lively too, with the same rollicking mix as Detroit—and no erudite scorn. Instead it felt as if every show was a welcoming. Hyper-literacy did pop up in one way: More kids asked for my autograph in Boston than in all the other stands combined. Every few steps in the Garden, I got paper and pen thrust at me. When a boy asked for my John Hancock, I wrote "John Hancock."

We hit our 400th show the first weekend in Boston. After the initial shock of three-show Saturdays, I'd settled into the 14-hour rhythm. Originally I'd slept as long as I could, squeezing in a last few moments in bed before rushing to the arena, groggy. Lately I'd changed tactics, getting up early, which, counterintuitively, made me more alert as I applied my makeup. It had improved by fits and starts, sometimes with deliberate changes, like smoothing those cheek circles to shading, and sometimes by happy accident, like eliminating white under my eyes in the hurry before our midnight show in Memphis. (A few years later, after performing on a telethon, I was still in clown face and leaving down a long hall when the fabulous singer Dionne Warwick approached from the other direction, trailed by her entourage. I was trying to think of something to say to her when she stopped and said, "Ooh, I love your makeup.")

Though I could apply my makeup faster now, I still took my time. It was like meditation, or an actor preparing for a play. Holding my shard of a mirror, I looked at the same dark eyes and eyebrows, same nose, its length unseen straight on, and the same full lips. Finally, less a decision than some internal cranking of the wheel, my forefinger touched the white

greasepaint and I stroked white over the right eyebrow. I always started on the right. When I tried starting over the left, it felt weird. After white around my mouth, I used my finger to apply black to make the exclamation mark across my eyebrow, with black on the lower lip and corners to make the mouth. I only used a brush, a tiny one, to outline the white in black, thin lines barely visible at a distance but enough to make the white "pop." Like an idiot-joke in action, I held the brush still and moved my head.

Makeup on, nose on, shirt and pants on, tie on, waiting to put the wig on, I sat at my trunk, quiet. Next to me sat the Prince, quiet. He broke our reverie to poke at the floor. "Dammit, somebody spit like a dime."

That Saturday morning's show, I worked up the nerve to put my bread around Charly. He was about the only one on the floor I hadn't sandwiched. As I neared him, I pretended not to notice where I was going until he was between my slices. He said he'd like mustard.

Between first and second shows Saturdays, I always napped. Long before ever thinking about clowning, I'd read a *National Geographic* article about a mud show, and I'd been envious that circus folks could sleep at the drop of a hat. Now I could too. Recently I'd switched from a rug on the floor, my clown shoe's padded toe as pillow, to the clown wardrobe boxes. The bottoms were comfy, carpeted to protect the hats between towns, while the hanging costumes, like fabric stalactites, kept the heat in. That day I fell asleep to Smitty confiding to the world that he may have picked up an "aerial disease" while gone. Having him back told me how much we'd missed his jabber.

The last Finale of the day, Dawnita stopped on the front track for her pose, arm gracefully raised. Though she had long ago declined, as Prince's line put it, to be a gambler and take a chance on a blanket, she seemed to enjoy my flirting. Now I took off my yellow glove and placed it on her head, telling her over the music that yellow was her color. Smiling her audience smile, she whispered, "You monster." But she didn't remove it, not even tilting her head so it would fall to the track. She wore that glove on her head as if it were the height of fashion, all the way down the track and out the curtain. What a classy woman.

Saturday's pillar of three shows pivoted into Sunday's two, then a day off.

Boston harbored a cornucopia for wanderers. I walked to the Museum of Science near the train, and to Faneuil Hall. One day I took the Blue Line to Revere Beach, watched a woman wading in the cold water naked—a local custom?—then roamed an Italian neighborhood in the rain. Monday

off, I caught a bus to Falmouth, and the ferry to Martha's Vineyard, where the autumn colors made the hills glow golden. Hiking the island, I reveled in the muscles of my legs moving and the sun on my face. Back at the ferry early, I strolled on the beach, when a dog trotted up and dropped a stick at my feet. I threw it and the dog brought it back. Instant buddies, we kept it up, her bringing the stick and barking, me throwing and clapping. Then the ferry docked. Love 'em & leave 'em. As the boat pulled away, she was still on the beach, so I clapped. She barked, and we kept it up, call-and-response across the growing gap of water, till she was a speck on shore.

* *

On the Alley, clowns routinely said "comedy is hard" as an in-joke, an ironic jab at use of that cliché by clowns and fawning newspaper articles. The arrival of a reporter from the *Boston Phoenix* promised relief from journalistic clichés, as that underground newspaper positioned itself as a truer voice than co-opted mainstream papers. That flattered our self-image as rebels, and we became chums, even though he introduced himself with a cliché, about seeing what's really behind scenes. We answered every question, and when he left that night, it felt like the end of summer camp, with hugs and vows to stay in touch. The next day, he returned, asking to be made up as a clown for a Halloween party, and I obliged. Anything for a pal. So his article was a slap in the face. He depicted us as sour and cynical, fatigued in a dying institution. Mindlessly repeating the seedy-behind-the-scenes cliché, he did exactly what mainstream accounts usually did, ignoring the effort and talent. You don't have to be a heartless corporate enterprise to exploit people, bub. By coincidence, Jeff and I ran into Mr. Crusading Journalist on our run to flirt with the cookie clerk at Faneuil Hall. Flustered at seeing us, he pulled out the reporter-presents-truth-he-sees cliché, then tried some speaking-truth-to-power but it was bullshit and he knew it. Finally, he confessed he had to write the article that way because *Phoenix* readers would only accept the opposite of standard publicity.

But he was a blip in the bracing Garden variety, with its exhilarating mix of vox populi, vox middli, and vox eliti. That exhilaration made me reconsider something I'd thought of as my private joke. Entering a ring, I'd step over the empty space of the opening, where the ring curb sections had been pulled to the side. I didn't gesture or make a face to signal the joke, I simply stepped over nothing as if the ring curb were still in place and continued on my way. Assuming it was too small to register, especially in the middle of big production numbers, I did it for my own enjoyment. But in

the fertile Garden, I realized that some people among the thousands must notice my step over nothing, and that a few—2 or 20 or 200—would get the joke. Then once I began to *feel* them noticing, as if those random few and I were connected by an invisible string, taut between us, it led to another realization. Those random people, getting that I did it on purpose, would realize that *their* getting it was part of the moment. At a distance and anonymous, realizations met, vibrating the string between us.

* *

Despite the contract tease in Indy and the imminent end of the season, Contracts snuck up on me. It was Mr. Feld the Younger. It had been hard to get a sense of him. He was my age, and had only become coproducer recently, so I didn't know how much he ran things. More important to me, did he love circus? I yearned for the feeling that we were circus together. That afternoon, it wasn't any easier getting a read on him. When I officially told him I was a lawyer, Kenneth said he hadn't known. Maybe he didn't want to seem surprised but my unusual background had gotten Ringling publicity in Detroit. I probably should have read this contract before signing. I was a lawyer, after all. I did notice the leap in salary, from the paltry $155 up to a bountiful $165 a week. In Clown College I'd been desperate to get on the Red Unit to play the coasts, where friends lived, but now that the second half of the two-year tour was in sight, I couldn't imagine it being better than the Rodeo Route.

I asked if the clowns could get more reaction to our work. Kenneth said there were so many performers in the show that offering comments would only cause problems. Surely there's a difference between comparing star acts and telling a clown what management expected. But Cuz's lesson, that what mattered was the opportunity to clown, implied a second part: the Felds could make the decisions they wanted because they were the ones who had provided hundreds of us the opportunity.

Passing Charly on his way into the arena, I told him he was stuck with me another year, and he shook my hand, his wink as close as he'd get to praise. The King Charles guys slapped me five as they waited for their cue, and Jerome bumped my back. On the floor, Ronnie nodded at me with his own wink, and Dawnita said she was happy for me. When I passed Camel John, his grunt might have meant "good."

Dean, Richard, and Hollywood would return, along with Terry and Steve. The Prince would too, though he'd been telling me since Wheeling that he wouldn't be asked back because he was too independent. That didn't make him paranoid; all but one of the older clowns he'd worked

Figure 11.1 Next year: pas de duh. Author's collection.

with had been replaced by Clown College youngsters. Dana would be gone, for missing shows. The Felds may not have commented on our work but one standard was clear: show up. Though Lenny regularly bowed out of gags for various ailments, he got a contract because he usually was at the show. They made Herb wait till the last day, out of alphabetical order. He'd missed a bunch of shows so they wanted him to sweat. Smitty had to wait till the next day, when he was warned about "bad influences." They meant our best clowns Billy and Cuz. Maybe it'd been a mistake for them to return to circus. Blinded by fond memories or accustomed to independence that circus doesn't allow, they didn't find whatever they were seeking. As the usual indignities piled up through the season, they'd soured, and skipped shows. Dolly would be gone too, with her sweetheart Billy.

To me, the biggest loss was Buzzy. While Billy and Cuz were better clowns, experience enhancing their talent, their hearts were no longer in it. But Buzzy loved this, with no hesitation, no jealousy, no self-regard. He simply wanted to clown. Of course love for clowning doesn't guarantee quality, and often has the opposite effect, sentiment squashing comic

impulses. But Buzzy's devotion fed his talent. He was funny, quick, and expansive. Henry James wrote in *The Americans* about someone "not economizing his consciousness. He was not living in a corner of it to spare the furniture of the rest. He was squarely encamped in the center and he was keeping open house." That was Buzzy. While clowns like seeing themselves as rebels bucking authority, he was the real deal, and that edge made his work stronger. Still, trouble found him again in Boston. When one of the clowns reported Michu for drinking, the little man badgered him. Then Michu squeaked that he'd been shoved, and Buzzy jumped to protect him, causing the other clown to flee, claiming that Buzzy had threatened him with brass knuckles. That was ludicrous. Still, the tempest provided an excuse to fire him then, before the end of the season. I'd miss our ritual before Opening: "Have a good one, Buzz"/"Have a *great* one, David." I'd miss the times that, despite different tastes, we found ourselves flirting with the same woman. I'd miss his flair for clowning, and his respect for it. Though we didn't hang out in towns, I'd miss watching the world go by with him on the vestibule. Though not necessarily friends, I loved him.

Have a great one, Buzzy.

* *

As I turned off Boylston Street, a clown mask in a store's Halloween display caught my eye. Conventional wisdom says clown makeup is a mask to hide behind, and that's not completely wrong. I found myself taking charge in the seats in a way I didn't normally do. Of course I tended to take charge in other public roles like teaching, leaping past my habitual reserve. Anyway, it seemed to me that the makeup has less effect on the wearer, who is behind it, than on those who see it, in their response to the *idea* of clown makeup. People project what they think about "the clown" onto what is in effect the abstract canvas of a face. More importantly, a good clown reveals self. Working in the moment, not acting clowny but truthfully, can include emotional vulnerability. However, I didn't buy this mask to make a point, I bought it to make a joke. Writing "Trick or Treat" on a grocery sack, I had a Halloween walkaround. I was a clown disguised as a clown.

From the first time I held the clown mask in front of my face in the arena, and then pulled it away to reveal my "real" clown face, it got a good reaction. A bonus, it invited interaction: half the time I stopped, someone waved me over to drop candy or popcorn in my sack. Showfolks joined in. Ronnie paused directing the band to pull out a breath mint for me. Charly beckoned me and flipped a penny in my sack. Between shows, Skip bought

a bag of candy and gave me a piece every Walkaround as I passed his lighting control console. Then Danusha borrowed the mask for teeterboard, and so did one of the "Russian" Cossacks for their riding. Charly turned a blind eye at first. A single mask-wearer in a large troupe was Halloween fun. But he decided things had gone too far when Monastyruk wore the mask instead of his gorilla head in his monkey-man act.

Second show Sunday, I pulled out the sack and picked up the mask, to walk to the back curtain, early as usual, to get a feel for the pulse of the show.

Kimberly's parents were waiting. She had died.

I heard them say they'd come to tell me because I had been so important to her but their words blurred. I blurred. As they talked, I puzzled over how they had gotten backstage. I heard the band playing. They said they'd driven to Portland last May because she wasn't expected to live till fall when Ringling got to Boston. The Cossack act was half done, halfway to my cue. She had chattered about me all the way home from Portland. They said that the Jimmy Fund had paid their way to Disney World but I was the happiest thing in her life. The band segued to the Walkaround music. She died on July 25. The day after my birthday. I wondered what I'd been doing. Carlos Castaneda wrote in *The Journey to Ixtlan*, "Death cannot overtake the warrior who is recounting the toil of his life for the last time until he has finished his dance." She danced to the end.

Music played. My skin was jangling, as if an arm had fallen asleep, only my whole body felt pins and needles. Charly came over, telling me that Walkaround had started. Her mom said they thought I'd want to know, though it might be hard. How hard for them? They said she'd talked about her special clown to friends, to family, to nurses. How hard for her?

Charly came over again and growled, "Get out there."

Her parents said they didn't want to get me in trouble, and left with a "God bless you."

I pushed through the curtain. I tried the mask bit once, pulling it away from my face, but I was crying, so I put it back and kept it there as I walked around the track. Sensing more than seeing the other clowns, I was simultaneously part of what was going on and not there.

Yet another cliché: clichés hold a germ of truth. Clown with dying little girl. Tears of the clown. Hiding behind the mask. Maybe my sentimentality was sloppy but I know one thing: Kimberly and I got it right in the time we had together.

Chapter 12 So Far, So Good ❧

November: Pittsburgh, Civic Arena/Cleveland, Richfield Coliseum

Hey, kid, when's the first time you thought you were funny?

Paul "Prince Paul" Alpert

When in doubt, keep moving.

Mark "Mark Anthony" Galkowski

So far, so good.

Lou "Lou" Jacobs

Mark put our trunks together in Pittsburgh. He was temporary boss clown while Steve and Terry were off teaching at Clown College, and one of his jobs was arranging the Alley. Months ago, I didn't recognize that sharing crackers and beer in his trailer had been an overture by Mark, and I didn't follow up. But here in the pipe-lined underbelly of the Civic Arena, I got a second chance, to ask questions, to listen. Mark talked about being in the Merchant Marines during World War II, and visiting Paris, where his search for circuses had come up empty, one closed for the season, the other with no show that day. In Ireland he did find a circus though he was only following a hunch. It was like my impulsive trip to Venice on that weekend pass. He also brought up his muddy contract status. He'd told Kenneth in Boston that he had more to talk about, but he was vague now about whether he'd asked for a second meeting. It wasn't even clear that he knew what he wanted to discuss. I guessed it was his frustration with the Alley bedlam, or maybe a need for clarity about his role. He shouldn't have other gags undercutting his impact, the way adding a dog to Clown Band stole the thunder of his act that followed with Fanny. But whatever he'd said to Feld, he worried that he'd left the impression that he

didn't want to return next season. Assuring him that wasn't likely, I worried that it *was* and urged him to ask for another meeting.

He deputized me to refurbish the inner-tube size dentures he'd carved from foam rubber. A season of being knocked around in the Tooth Chase, one clown wearing the big teeth over his head and chasing a clown dentist around the track, had worn the paint, making the thing look shabby, but he hadn't been able to persuade Steve to fix it. Now, even with season's end near, Mark gave me his own money to get paint. I bought white for the teeth, and a perfect color for the gums, "Pink Elephant."

Mark gave me another assignment. I'd talked with him about the base-ball gag I'd had in mind since Hartford, when *Flintstones* cartoonist and circus fan Ray Dirgo had told me about Slivers Oakley. (Later, Dirgo sketched me.) Slivers was an early twentieth-century clown who, before he went insane, reputedly from lead-based greasepaint, became famous for his one-man baseball gag. As he talked about Slivers, Dirgo got me thinking about my own version. Now Mark said I should try it, though as a duo. I hesitated, wanting to do the solo act I'd envisioned. After all, there's a tra-dition that you should stay true to your artistic vision. But there's another tradition: master-apprentice. The lesson with Lou Jacobs in Clown College recurred: I needed to heed what veterans said. So if Mark, a master, said I should expand to a two-person gag, two it would be. I asked Mama to join me, and when we showed our progress to Mark, he suggested adding another. Okay, three it would be, and we worked Smitty in—on the "sperm of the moment"? When Mark gave us a slot on the track, Smitty as umpire forgot to call "Strike One" and, while yukking about that mistake, missed "Strike Two." But show by show, the gag took shape, with the audience unknowingly telling us what we had.

*

On the run to Cleveland, munching and slurping through root beer, gin-ger snaps, and a big bag of salted peanuts, I calculated we'd traveled 15,000 miles, and performed 450 shows in 46 towns in 27 states, including the six-pack in Portland, the virtual vacation of one a day in New Orleans and Houston, and a midnight performance in Memphis. We played arenas civic, convention, exposition, assembly, and capitol; coliseums; auditori-ums; a field house; an omni; an armory; a summit; a superdome; a sta-dium; and a garden. We started in the south, headed north, returned south over the Allegheny Mountains, pulled by four engines, and southwest, north again, then east, and now back to the winter Midwest.

Mark and I had a second week side by side as Steve and Terry were still gone. A season on the road had flipped my perspective on Clown College. That hallowed hall of learning hadn't taught—couldn't teach—clowning. It was good preparation, introducing skills that might be useful, especially a clean makeup, plus it laid groundwork to learn in the arena, which was the crucial step. For anyone who'd be more than the funny guy he'd been when he started, the arena was *required*. Though I hadn't always recognized mentors, audiences, and mistakes, I now saw that they taught, just as Mark was teaching with my baseball gag. None of his comments were major—pause here, look there—but between the audience and his tweaks, it became a solid gag. Then Mark put it in Ring One. A First-of-May, I had produced a ring gag. Though a function of circumstances, it still felt significant to be tabbed by a veteran.

Richfield Coliseum had something new in arenas, enormous video screens in both ends showing close-ups of the action, shot by cameramen roving the floor. Seeing the camera pointed at them, *everyone* looked up at themselves on the screen. That struck me as funny, especially when the line of showgirls looked up in profile, in unison. So for Walkaround, I grabbed the prop movie camera from Clown Car, and when I saw which clown was on the screen, I sprinted to aim *my* camera at that clown, as if I were the seriously important cameraman filming my next seriously important task. I ran all over the arena floor chasing down my shot. And whenever a cameraman zoomed in on me, I looked up at the screen for my next "assignment," saw my face, did a double-take, shrugged—sometimes a shrug can be a good comic move—and turned my camera around to point at myself, looking seriously important.

Cleveland also featured the return of what I assumed was the *real* Whipcracker, from Clown College. Saturday, Dean would be taking photos of other gags, and Terry was still away teaching, leaving both Richard and me free during Come-in. Now we'd return to former glory, the two of us effortlessly joined, a true comedy duo doing Whipcracker again. Our first attempt sputtered, not bad, not good, but no problem: we were rusty, or maybe overeager. We'd do better. The second time *was* better, though only a little. Again, no need to fret, we'd get in sync. But the third time didn't shine either. Memory had elevated Whipcracker with Richard to cosmic comic brilliance but we had had been beginners in Clown College. Richard was one of our best but then we'd been above average for amateurs, little more.

And Dean and me? Sparring and squabbling, repeatedly violating the Yes-and of improv, instead exchanging volleys of No-You-Idiot—all that kept us *focused* on each other. Two lovers couldn't have concentrated on each

other more. Engaged in a struggle *over* Whipcracker, we had inadvertently made Whipcracker *about* that struggle, creating a core of reality that pushed things deeper than jokey trills. Crowds saw an un-expert whip expert trying to control his bumbling assistant, but more than that, they could sense one person struggling for control, the other dodging it. Consciously or not, they witnessed a genuine battle of wills. Doing Whipcracker with Richard, I missed the sharp snap between Dean and me. Despite ourselves, Dean and I had crafted a strong, tight gag, and—omigod!—become partners.

Sunday night, I didn't take time to wash my makeup off, so I could catch the first bus back to Akron, and make it to a concert of the Rotterdam Philharmonic. I had to argue with the driver to let me off near the concert hall at the University of Akron, then rush through a lobby of people, startled at my clown face, and scrub off the greasepaint in a restroom—bulk soap and cheap paper towels made it more scraping than washing—before buying the last available ticket. It was a delicious way to end the week.

<p style="text-align:center">*</p>

The next morning sat cold and gray as I headed from the train parked in Akron to catch a bus to Cleveland 40 miles away—the coliseum was halfway between, in the middle of nowhere—but my nose and toes froze walking to the bus station, so I turned around. Seeing a place that personalized t-shirts, I got Mark one with the Superman logo, customized with his name. That sparked an end-of-season shopping spree. I bought Ross a toy circus train. I considered lavender soap for Dawnita—and wished I'd had the nerve to get it. I bought an expensive bottle of Scotch for Camel John, partly as a thank you: he'd snuck me a pair of Ringling coveralls the workers wore. I next hit the local library, where its "Suggested Books" included Charly Baumann's autobiography, *Tiger, Tiger*. Reading his as-told-to-tale was a revelation. The season had shown he wasn't a Prussian horror story, and even that he had a sense of humor. I grinned recalling his quiet "Boo" at the announcement that it would be Burger Chef Night at the circus. But it wasn't till reading his book that a broader picture emerged. He enforced discipline in performance to sustain quality, not out of Germanic rigidity. Like Mark, he was concerned about circus *and* its people. When our young flyer Julio went through a stretch of missing the triple somersault, and Charly couldn't be on the floor to watch, he always asked, "Did he make it?"—both a performance director keeping tabs on his show and a kind of second father. I got to know him more personally when he approached me about a will. That included telling me how much money he made, which I'd never share with anyone because of lawyer-client

confidentiality—and because I forgot what he said. After a visit to the university's law library, I advised him as his (temporary) lawyer to get a (good) lawyer once he got back to Florida. Perhaps I lacked lawyerly ambition.

As dusk fell, I shivered my way to the train. Car 140 was usually quiet on days off but bustled now as everyone was cleaning out a year's accumulation. Tossing my own stuff, I pulled an interview of Lou Jacobs out of the trash. Like a cross between Satchel Paige and Yogi Berra, Lou said he didn't want "to slacken up too fast." Though one of America's great clowns, he expressed no ambition for greatness. Instead, he wanted people to know "That I'm here. That I'm happy they accept me as a clown. That I do a good job." Modesty like that would never boost his salary or make him famous, and it would garner no foundation grants. But it anchored his work. He showed up every day and did his work (very well). So did Prince. So did Mark. No whining, no self-granted days off, no screwing around in private jokes that left the audience mystified, no treating routines as routine. As Lou put it, "So far, so good."

In Clown College, the high turnover in clowns had seemed a fine thing, giving many of us jobs. Now I recognized the cost. It wasn't just the clowns fired, it was the turnover itself, half the Alley last year, nearly that many again this year. That hurt the Alley. It hurt clowning. The turnover on the Blue Unit Alley was unusually high but continuity wobbled on Red too. Clowning thrives in apprenticeship, the way Mark helped me. However, as experienced ones left, experience itself was downgraded, and rookies heeded less.

Was the turnover partly my fault? There were lots of good reasons for clowns to leave: little respect or support; low pay; tough conditions; running in and out throughout a three-and-a-half hour show 10–13 times a week. Then there were the unreasonable expectations people brought to Clown College; uncertainty about how to train clowns; unreasonable expectations we lucky few brought on the road; routine that killed the romance. Of course, I caused none of that, plus, I was a quiet presence in the Alley, except for my occasional tiffs with Dean. Circus folks—Camel John, Biscuits, Jim, Doncho—thought well of me too. The King Charles guys and I had gotten so chummy that I couldn't imagine moving off 140 now, though rooms would be available on the clown train car with so many clowns leaving. (I did trade up on 140, getting a room with a door that closed all the way!) Tim, the ex-clown/assistant performance director, had even taken me aside in Pittsburgh, telling me that my experience and attitude positioned me to mentor the new clowns next season. Yet for all that, I saw my own failed responsibility. Not negative isn't the same as positive. When someone stomped into the Alley to bitch, or stomped out snarling—opera buffo

among the buffoons—I'd done nothing to calm things. I could have hung
out more, adding to the social glue holding us together. I could have asked
Smitty about his favorite movies, or checked in with Terry. I told Mark I
was sorry he'd had to give his Weimaraners away but had missed the chance
to talk to him most of the season. I had tumbled into a job that suited me
to the ground, allowing my solo impulses to flourish in performance, but
maybe I soloed too much beyond it, not going out nights—telling myself
I couldn't afford the bar tab—and roaming days alone. Phyllis had said in
Clown College that the clown is always an outsider: I felt like an outsider
to these clown-outsiders.

Another cliché says that performers do this unusual work to fill an emo-
tional gap, seeking love we missed. That discounts the work involved, shrink-
ing talent and craft to a narrow stereotype. It also ignores the same lust for
affirmation I'd seen in other pursuits, in law professors, cops, and teachers,
business leaders and reformers. Yet my quest for kinship with the audience had
more intensity than can be explained by my growing belief that performance
was best that connected best. I don't know if I sought love in the audience but
I couldn't ignore that I was seeking more than improved clowning.

*

I tried to savor each show but the last week had no slow in it.

Lucy wowed Clyde, my Leutze astonishing the former NY Knicks star
Walt "Clyde" Frazier. Elephants are astonishing creatures. Clyde now played
for the Cleveland Cavaliers, who used the same arena we were—my size 20
Converse basketball sneakers would have been perfect in a cross-promo-
tion—and I was on Leutze when Frazier, his usual snappy dresser in vest
and fancy hat, eyed her and me on his way from practice.

Mama won the end-of-season poker game. Fifty-two shows earlier,
clowns had each put $10 in the pot, with one card dealt a show, yielding
Mama a full house and a nice chunk of change to take to Florida. His wife
had not gotten into Clown College—Mama was told the Felds confused
her with someone else—so they were leaving to work at Circus World in
Orlando. He asked if he could use my baseball gag. Of course. It wasn't
mine, it was ours, extending a string from Slivers Oakley. As Mark put it,
"Never old, never new, adding your own touch."

Prince Paul volunteered for the first time to make up a Guest Clown.
That was another way of getting the show publicity, by putting clown
makeup on a contest winner or local media star. Usually we applied the
makeups quickly but Prince gave one little boy the full treatment, copying

his own makeup on the kid. A six-year old replica of ancient Prince Paul looked bizarre.

Wandering the seats one Come-in, I heard my own voice. My real voice. Like most First-of-Mays, I'd probably emitted a weird 'clown' voice and waved antic limbs early on, but if I had done that nonsense, sweet oblivion erased it from memory. Regardless, now I recognized it was my voice and my moves, exaggerated but never 'clowny,' no random smiles for no reason, never more or less than me. That's not a humble-brag about being 'truthful,' but practical: that First-of-May baloney gets few genuine laughs.

Billy, Jeff, Dean, and I played Scrabble between acts, cozy together, as if we'd been doing it all season.

Bisi's father was converting inches to centimeters for a box to ship their gear back to Bulgaria, and I helped him. After months of wondering how to spend the $5 Kimberly had given me, something worthy of her gesture, I'd bought purple and green fabric to sew a miniature version of my tie to give little Bisi. I gave Doncho a University of Michigan t-shirt, and he invited me to the troupe's last party, guests including the Metropolitan, head of the Bulgarian Orthodox Church in America.

During one of the fights that popped up in the end-of-season tension, Siegy decked a ring worker but hurt his ankle. I'd been worried about friction between the clowns leaving and those staying, but the Alley, still contrary to ordinary—the title of Billy's song—turned tranquil.

Tracey wrote that she'd swing by Cleveland on Wednesday. The Carousel Queen had told me in the spring that she'd visit when she got back from Ireland but she didn't. Later she wrote promising a few other places, but didn't come then either. So, Cleveland? The first show came and went. No Tracey. Second show. Same nothing. On the bus that night, a new butcher patted the seat next to her, and slid closer when I sat. Oh, my, thigh to thigh. Still, out of fidelity or hope, I resisted Sweet Young Thing, even when she whispered it would be *very* interesting to see a clown's room. Thursday, I kicked myself for stupid fidelity when Tracey didn't arrive. By Friday's first show, I finally and fully abandoned hope. And then, there she was, by the back curtain as I approached for Walkaround. Disappointment disappeared in her smile. Tracey said that when she hadn't been able to make it Wednesday, she didn't send a message because she guessed I wouldn't believe her. Good guess. Mark invited us to his trailer after the show, when he gave her a foam-rubber seal he'd carved, pointing out that the anatomy was just right. He had a gift for me too. When he'd thrown away a section of foam-rubber spine from a skeleton that hadn't worked, I said it looked like a Christmas tree. So later he dug it out of the trash, reshaped it, and colored it green for me. As Tracey and

Mark compared notes on Ireland, she leaned against me. Ours was no grand romance. We were what we'd been that intense day in Hartford, footloose comrades sharing curiosity about the world. Then she was gone.

*

Since my implicit truce with the roaches in Venice, them not bothering me, me not squashing them, my room had been a live-and-let-live roach motel. But with the season virtually done, one crawled on my face, and I jumped awake, the creepy feeling augmented by an odor wafting through my door that proved to be brown slime oozing out of the toilet into the hall. Ah, the romance of circus.

We were, in Army slang, "short." Our last Saturday morning show was missing people because the bus got stuck on its last run on a snowy hill, leaving a dozen performers stranded in the wilds of Ohio.

Now a solo for the fanfare that opened Come-in, I'd been playing the Michigan fight song all week, with the Michigan-Ohio State football game approaching. The Ohioan running the sound board cut the microphone but I played on, loud enough to reach every OSU ear in the arena. However, after Michigan beat Ohio State, I refrained. No need to rub it in. Then I heard the band's sax player in a jazzy version. I figured him for a Michigan fan but he told me he was an OSU grad playing out of frustration. Go Blue.

Jeff and I stumbled onto a joint improvisation, because of a promoter. Promoters were ambitious young guys, usually just out of college, who preceded the show by months to prepare a town's advertising, marketing, publicity, elephant-poop giveaway for fertilizer, anything that might boost ticket sales. This one was a jerk. Earlier he'd promised the Alley $10 and a meal for a promotion, then denied it, and seemed to think he'd fooled us. Now Promoter-Jerk rushed into the Alley in panic. He'd scheduled a TV interview between shows but had messed up arranging for someone, and acted as if we *owed* it to him to volunteer. It would have been gratifying to let him stew, but that would make Ringling look bad so Jeff and I saved his sorry butt. As the TV camera rolled, a strange and wonderful thing happened. Jeff and I both started goofing on the interview. We alternated pretend ignorance and fake concern for the interviewer, and grabbed the microphone to ask each other questions. With much of my clowning underplaying, and Jeff underplaying more, I'd have guessed that our humor would be so dry together that we'd parch the air, but it was great, as if we'd been partners forever.

Third-show Finale, I pointed Dawnita out of the ring to the track. Knowing every step of her choreography by now, I pretended to be directing each move:

turn, get in line, style. Then saying "We've got to stop meeting like this," I demonstrated an exaggerated hip-swing. For a few delicious steps, she swung her hips, before resuming her dignified way down the track. What a woman.

*

We got paid Sunday, first show. Typically, management waits till the very end to distribute that last paycheck to make sure no one skips out early but maybe this time they were more worried about pranks.

Billy and Cuz left. Striking a rare balance as clowns, savvy enough to work large arenas while staying subtle, they had a right to be disappointed that others didn't follow their lead. So why was I angry? Trying to sort out my feelings, I saw self-interest. If two I admired couldn't fit Ringling, how could I? Later I looked deeper. Breakups made me anxious. Even friends splitting up agitated me: only connect, not disconnect. Now, feeling abandoned, I retreated into the consoling certainty of anger. That response blocked a glimmering awareness, that Cuz had been helping me. I hadn't recognized it during the season because he'd been subtle about it. But he'd drop a hint, and a few days later I'd adopt it as if it'd been my idea all along. Once he'd called me a stupid First-of-May, and First-of-Mays *are* stupid, almost by definition. But I was stupider, not realizing I'd had a mentor.

Mark leaving simply made me sad. He was the Alley's last active link to the old days. That's no disrespect to Prince Paul, who would soldier on, a pro doing his best every day for a few more seasons, but he passed along little other than his vaudeville jokes. ("How do you get rid of crabs? Hold a mirror down there, and they'll jump off, looking for fresh territory.") Mark's departure, along with Clown College grads like Cuz and Billy who'd learned from the old timers, banged another nail in the coffin of apprenticeship. For two centuries in American circus, performance wisdom had passed from clown to clown. Even as circus changed after the Civil War from rowdy adult fare to family amusement, with the clown reconfigured as a children's favorite, clowns learned from veterans to engage audiences, meeting minds, hearts, and souls over the ring curb. Apprenticeship kicked the "clowny" out of a clown. But next year would be rookies guiding rookies, those of us barely more than First-of-Mays trying to pass on what we were still learning. (Following Tim's advice to mentor the next First-of-Mays, I'd get frustrated when they ignored suggestions—as I'd ignored some of Cuz's—so I tried harder, which increased their resistance.) Future turnovers would make it worse, inexperience pontificating to inexperience, and grabbing at stereotype—big

arenas *require* big gestures—in the name of "tradition" and "rules," an unconscious but desperate attempt to grasp what had been lost.

Mark spent his last day back and forth, loading his motor home. If he did talk to the Felds, it hadn't worked. Now he said, "Well, Fanny Cakes, it's a new order. Things are changing. Yep, it's a new order, girl. I guess we'll be on our way." Then it was a handshake and goodbye. In most buildings, the arena is level with the ground, or a little higher, with a ramp down. At Richfield Coliseum, we were below ground level, with a long ramp up. Early for Walkaround, I saw Mark walking up the last time, still in his raggedy blue costume, alone except for Fanny Cakes, a bundle of curly white jittering around him, the two of them framed in the giant door as they went up and out into the twilight.

*

Last time on Leutze. To note the moment wasn't simply sentimental reverie. With no clown riders next year, I wouldn't ride an elephant again. This concluding time so high was heightened by being the only clown in Ring One, because Charly kept the others out for altering their costumes. Many performers were doing the same. Ursula wore a short black wig over her silver hair to work her polar bears; one of the "Cossack" riders dressed like an "Indian"; Maria wore a clown costume for her single-trap act. I enjoyed their end-of-season mischief but didn't think it worked for clowns. When one person in an act dresses differently than others, the audience recognizes it as a joke, but clowns already do things abnormally, so piling unusual on top of abnormal is confusing. Trying to be "zany" just looks bad. Our merry band of nonconformists even turned conformist, making this mini-rebellion seem obligatory. Hollywood told Ned that he didn't have the guts to wear a different hat in Spec. Dean succumbed too, switching his Menage costume for a weird concoction. I didn't resist the pressure for any noble reason, I just wasn't going to jeopardize my last time on Leutze. Because Siegy had hurt his ankle, he couldn't lead the Ring One elephants in, leaving it to Bigfoot, who ran us *fast*, a thrilling gallop. The absence of other clowns made the act feel new, as if the elephants, Bigfoot, and I were collaborating as a team. Sometimes work becomes seamless.

I wondered if my sentimentality reflected deep feeling or shallowness. Maybe I lacked a strong sense of self. Or self in a place. On the vestibule during the run west, Fitzgerald's words from *The Great Gatsby* sang to me: "When we pulled out into the winter night and the real snow, our snow, began to stretch out beside us and twinkle against the windows, and the dim lights of small Wisconsin stations moved by, a sharp wild brace came

suddenly into the air. We drew in deep breaths of it as we walked back from dinner through the cold vestibules, unutterably aware of our identity with this country for one strange hour, before we melted indistinguishably into it again." That's what I wanted: my place. I'd lived in eight homes before high school, my fifth school in five years. Though I loved the Midwest and New York City, the former made me yearn for big-city energy and a broader emotional horizon, while Manhattan scraped my skin with the shoving to speak first and get first. Where did that leave me? For all the pleasure in the places I'd lived, none fit just right.

Till circus.

I sensed I wouldn't be a lifer, that next season or maybe the season after would be my last. Still, circus gave me a place to be here, wherever *here* was this week, stepping one day to the next, using me fully, brain, body, and heart. "This shaking keeps me steady. I should know." That's what my favorite poet Roethke wrote in "The Waking," and I knew it in me. And in my bones, the ending: "I learn by going/where I have to go." Maybe *that's* why I became a clown. Not simply another 1960s adventure, going to clowning taught me where I had to go, letting me explore what shook me, what rolled between me and others. Here, I had a place to puzzle out the world from a comic slant. Here, I didn't apologize for my silliness to prove

Figure 12.1 Lucy will always be Leutze to me. Author's collection.

my sophistication. Here, I got the daily opportunity to connect. Clowning would not be something I'd done, it was me, with others. Whatever else I'd ever do, I would always be a circus clown.

Galloping in on Leutze, I didn't hold the harness because I'd figured out months earlier that my legs were just long enough to tuck my toes under the buckles below Leutze's ears. Look, ma, no hands! Even when Leutze stood on her hind legs, with my literal toehold, I could flop upside down to her back as if falling, arms flying.

This time, as my sweet pachyderm plopped down to four legs and I popped up, I noticed a woman 20 rows up, tapping her boyfriend's arm and pointing at my apparent fall. People in a circus audience assume they're invisible, like a theater crowd in the dark, so when I mimed tapping and pointed too, her mouth opened in surprise and she poked him with her elbow about what she clearly thought was a coincidence. Then I opened *my* mouth and poked with my elbow. She paused, mid-gesture. I elbowed again, hard, then shook my finger at her in mock sternness, as if admonishing her for being rough. Awareness hit: the clown way down in the ring was mimicking her. She cracked up.

Cuz was right. You can clown. Near and far, on an elephant or around Clown Car, up and down, you can clown.

As the woman buried her head in her guy's shoulder, then peeked through her fingers, I turned my head and peeked through *my* fingers. Usually I couldn't help grinning to beat the band on Leutze but in the middle of a clown routine with this woman, I turned earnest and intent. For the rest of the number, in the ring, then as the elephants ran out of the ring and around the end track to the front, we kept going, me, officially a clown making a joke, but really the two of us goofing with each other. During the cross mount, I looked to the right and, grinning, spread my arms to the crowd along the front track. Then I turned slowly, looking left and up toward the woman in the seats, before a quick double-take, eying her as if I'd caught her up to no good.

Across the arena and halfway up she laughed.

So far, so good.

Appendix A: 1976 Clown College and 1977 Blue Unit Route ✑

There's nothing so dangerous as sitting still. You've only got one life, one youth, and you can let it slip through your fingers; nothing easier.

Willa Cather, *The Bohemian Girl*

CHAPTER 1 • ROMANCE OF THE RED NOSE

Clown College, Ringling Arena, Venice, Sep.–Nov. 1976

CHAPTER 2 • BOWL OF CHERRIES

Rehearsals and first performances, Ringling Arena, Venice, Jan. 10–Feb. 2

CHAPTER 3 • RUBBER (NOSE) MEETS THE ROAD

Lakeland Civic Center, Feb. 4–6
Atlanta Omni, Feb. 9–20
Savannah Civic Center, Feb. 22–23
Asheville Civic Center, Feb. 25–27
Raleigh, Dorton Arena, Mar. 1–6
Fayetteville, Cumberland County Memorial Arena, Mar. 8–9
Columbia, Carolina Coliseum, Mar. 11–13
Charlotte Coliseum, Mar. 15–20

CHAPTER 4 • THE SHOW BUSINESS

Knoxville, Civic Coliseum, Mar. 22–27
Cincinnati, Riverfront Coliseum, Mar. 30–Apr. 3

Washington, DC, Armory, Apr. 6–17
Largo, Capital Centre, Apr. 20-May 1

CHAPTER 5 • LOVE 'EM & LEAVE 'EM

Binghamton, Broome County Veterans Memorial Arena, May 4–8
Hartford, Civic Center, May 10–15
Portland, Cumberland County Civic Center, May 17–22

CHAPTER 6 • GOOD OL' DAYS?

Troy, RPI Field House, May 25–30
Providence Civic Center, June 1–5
Niagara Falls, International Convention Center, June 8–12
Wheeling Civic Center, June 15–19
Charleston Civic Center, June 21–22
Memphis, Mid-South Coliseum, June 24–26

CHAPTER 7 • RODEO ROUTE

Little Rock, T.H. Barton Coliseum, June 28–29
Huntsville, von Braun Civic Center, July 1–4
Dallas, Convention Center, July 6–11
New Orleans, Superdome, July 14–17
Houston, Summit, July 20–31
Abilene, Taylor County Expo Center, August 2–3
Lubbock, Civic Center, August 5–7

CHAPTER 8 • SPIRIT OF ST. LOUIS

Tulsa, Assembly Center, Aug. 9–10
Des Moines, Veterans Memorial Coliseum, Aug. 12–14
Waterloo, McElroy Auditorium, Aug. 16–17
Omaha, Civic Auditorium, Aug. 19–21
Sioux Falls Arena, Aug. 23–24
Madison, Dane County Exposition Center, Aug. 26–28
St. Louis Arena, Aug. 31–Sep. 5

CHAPTER 9 • LIVE

Fort Wayne, Memorial Coliseum, Sep. 8–11
Toledo, Sports Arena, Sep. 13–18
Detroit, Olympia Stadium, Sep. 20–25
Nashville, Municipal Auditorium, Sep. 28–Oct. 2

CHAPTER 10 • STOP GIGGLING

Indianapolis, Market Square Arena, Oct. 4–9
Carbondale, SIU Arena, Oct. 11–12
Champaign, Assembly Hall, Oct. 14–16

CHAPTER 11 • CLOWN MASK

Boston Garden, Oct. 19–31

CHAPTER 12 • SO FAR, SO GOOD

Pittsburgh, Civic Arena, Nov. 3–6
Cleveland, Richfield Coliseum, Nov. 8–20

"All out and over"

Appendix B: A Brief Cultural and Idiosyncratic (Mostly Circus, Mainly American) Clowning History, as a Means of Providing Context for the Preceding Individual and Idiosyncratic (Mostly Circus, Mainly Evolving) Clown's History ❧

I do now remember a saying: "The fool doth think he is wise, but the wise man knows himself to be a fool."

William Shakespeare, *As You Like It*, 5.1 (Touchstone)

NOTE

After finishing the first draft of this history, I gave Pat Cashin permission to post it on his blog, ClownAlley.net. Now I'm happy to thank Pat for regifting, allowing me to use that earlier version as the basis for this one.

I wrote that earlier version years ago for myself, out of frustration with clown histories. Even the good ones, the histories I admire, full of interesting stories and appealing writing, neglected what I'd learned as a working professional in a large, traditional circus. That frustration doubled after I became a scholar and realized how most clown histories simply echo other clown histories, and performance histories either ignore this significant element of our cultural past or repeat the lore as if factual. The same tales and clichés rattle from book to book, as if repetition equaled

accuracy. Because this appendix reflects decades of scholarly research and writing, it has a different tone than the rest of the book, though still eschewing traditional scholarly apparatus, earnest theorizing, and, for the most part, words like "eschewing." (While the title reflects this appendix's focus on the United States, it includes trans-Atlantic trends.)

"CLOWN"

"Clown" applies to many things but, without claiming a fully definitive interpretation, it simultaneously refers to (a) a performer acting comically for other people, often in self-deprecation; (b) a figure of legends and lore; and (c) a vessel for clichés. References in daily life to a "clown" as someone acting goofy or, alternatively, a denigrated person, echo (a) but lie beyond the scope of this essay. Meanwhile, the working clown is the historical and psychological foundation for the (b) legends and (c) clichés, but those other meanings have their own influence and must also be taken into account. Even people who've barely seen a working clown routinely encounter the ideas that clowns bring joy to the world, that the clown mask hides pain, and that trickster-clowns speak truth to power.

Of course, each cliché holds a germ of truth. When the culture deems a clown gentle, it makes approaching a sick child easier. Clowns are not easily controlled, so the clown can present a challenge to authority. A crying funnyman makes a dramatic contrast. But germs of truth get ground to mush by the weight of clichés. Those clichés are so culturally embedded that merely starting a tale about a clown spawns nodding agreement, as listeners prepare for an ending already known. Nor can the problem be solved by aiming to move past clichés: that aim is another cliché.

This is a cultural history, exploring the interaction of what clowns do (and don't do), how legends both incorporate the work of clowns and encourage clichés, and how those clichés work. In this history, I treat both the work of clowns and stories about them as artifacts that reflect cultural assumptions and desires. For instance, the clown-with-dying-child didn't become a routinely told tale until the late 1800s generated new sentimentality about childhood. Before that period, the once great American clown Dan Rice generated a tentful of tales, repeated well into the twentieth century, though many of them were fiction. This history features Dan Rice because I wrote a book about him, because he was the nineteenth-century's best clown and most famous circus performer, and because he was, as other historians have noted, a representative American figure. Moving forward in time, the 1960s wanted to see the clown as a truth-telling trickster, and

American culture still hasn't let go of the idea. To take a more recent example, a particular clown in a particular performance may frighten a particular child but the new "scary clown" notion reflects something at work in the broader culture.

COME-IN (CLOWNING BEFORE CIRCUS, AND BEFORE THE WORD "CLOWN")

Ever since a caveman bumped into a mastodon and got a laugh, comic figures have been important to human society. Status has varied from era to era, and individual to individual, but early figures were random. Like the class clown making his buddies laugh, most comic individuals of the past were known only to their tribe and time. Some did develop into cultural icons, like the nineteenth-century German character Pickelherring, or Native American spirit figures such as "contraries" and the koshare. Outsiders became unwilling clowns. mocked by the majority. That historical process thrived in the immigrant-based United States, as earlier immigrants, now "Americans," laughed at later arrivals, leading to "Dutch" (German) clowns, "Hebrew" clowns, etc. The same process works geographically: Outside the South, using an exaggerated "Southern" accent draws grins. So does what I call the New Jersey joke; Broadway shows getting laughs simply by referring to New Jersey.

Theater comic characters have their own lineage. Ancient Greece featured bawdy performers. Classical Rome applauded its "mimes," rowdy physical performers in farces, with little connection to current silent mimes. Into the Middle Ages, comic characters popped up in local festivals and church holidays. Medieval religious plays had a comic figure beating the devil. Some performance-like events included a character called the "Lord of Misrule," upending traditional rituals in the "Feast of Fools."

Note that none of these figures were called "clown." That label has been applied retroactively, but originally referred to the country bumpkin. This "clown," in life and in performance, is a risible rube with clownish attributes, ill-fitting clothes, big shoes that make him stumble, and a lack of sophistication that causes him to say stupid things. While no definitive origin of the word has been found, this rural influence suggests that "clod," as in a clod of dirt, morphed into "clown."

Court jesters repeatedly appear in histories, but the ubiquity is less about significance than association, as they are included in histories of kings and courts that they served. Some of the jesters were physically or mentally challenged people kept at court to be mocked themselves.

Other jesters led the mirth, yet mostly as royal mascots helping pass the time. The court jester would later be celebrated as a daring political figure, speaking truth to power, but comic subversion was rare—if it actually occurred at all. After all, ancient tyrants were no more likely than modern tyrants to tolerate defiance, and the instances mentioned in histories don't bear close scrutiny. It is fiction that has driven this romance of the truth-telling jester. Shakespeare crafted the perfect literary specimen—and a powerful influence on later examples—in *King Lear*, as the Fool said to Lear what no one else dared say. Historically however, court jesters got laughs the way comedians usually do, by making jokes a particular audience approves. Rather than mocking power in the king, jesters reinforced a traditional perk of power, mocking the king's foes or courtiers out of favor.

Around 1600 Shakespeare placed the jester and the rube side by side in *As You Like It*. While Touchstone is identified as a court fool and listed in the cast of characters as "Clowne," he greets a shepherd by derisively calling him "clown." This meeting of rustic clown and court clown suggests the historical transition of "clown" from the hayseed butt of jokes to the comic performer making jokes. (Shakespeare's comic actors, William Kemp and Robert Armin, neatly symbolize the physical/verbal range of clowning, with Kemp more physical and buffoonish, like Dogberry in *Much Ado about Nothing*, and the more verbal Armin replacing him, including playing Touchstone.)

Commedia dell'arte, an earlier development out of Italy, would strongly influence clowning. "Dell'arte" meant "of the profession," referring to the craft of professionals doing improvisations based on rough outlines of earthy material, presented on makeshift, outdoor stages. The label was a contrast to commedia erudita, with scholars using classically inflected scripts and adhering to what were deemed classical rules. (In a twist of history, college classes teach commedia dell'arte that often comes closer to the rules and structured approach of commedia erudita.) Commedia dell'arte influenced clowning with its spontaneity; its "lazzi," or comics bits; and its servant characters, called "zanni." Arlecchino was originally a minor character with patched clothes (like a twentieth-century tramp clown's) until becoming prominent as his costume settled into the bright diamond-shaped pattern associated with the Harlequin's costume, an elegant look (like a twentieth-century whiteface clown). Arlecchino sported another influence on comedy, his "slapstick," a narrow board with a hinged piece that made a loud noise, while softening the blow when used to strike someone. Thus, slapstick comedy—which is better than its reputation.

THE CELEBRITY CLOWN (1780s–1870s)

Character, label, and venue joined around 1800 in the circus clown—
though precision is elusive. Circus wasn't called "circus" yet, and its clowns
began in ambiguity.

Originally, circuses barely had clowns. Acrobats and riders provided
the comedy in the first circus, Phillip Astley's in London around 1770,
and in the first American circus, John Bill Ricketts's in 1793 Philadelphia.
A major comic act, "Billy Buttons, or the Tailor's Ride to Brentford," was
a riding, not clown, act; relying on the popular assumption of tailors as
physically inept or cowardly, the performer was costumed as a tailor. The
clown began primarily as an assistant to riding acts. The main feature of
early circus, these acts lasted as long as 20 minutes, and required a "clown
to the ring" or "clown to the horse" to handle props and hold "balloons"—
paper-covered hoops—for the rider to jump through. The "clown to the
rope" assisted tightrope walkers. The early clown's comedy came mostly
during the other performers' moments of rest. Circuses did not perform
in tents yet, but behind canvas sidewalls or in theaters, which included
"clown to the stage."

Ambiguity about the clown reflected uncertainty about circus itself.
Struggling during its first two decades in America, this odd hybrid of
horsemanship and comedy was still not called "circus." The "Royal
Circus" referred to the arena used by Astley's rival, Charles Hughes, but
not to either troupe. In the United States, Ricketts advertised his show as
an "Equestrian Exhibition," reflecting the origin of circus in the horse–
human partnership. It took three decades before a troupe and its show
were called "circus," the touring "New York Circus" of 1824. That struck
a chord: Within a year, use became standard, as if the nascent form had
been waiting for the perfect label. (Writers, perhaps in an effort to make
their subject seem classier, usually invoke the ancient Roman circus as a
precursor to modern circus, with generalized reference to unspecified or
unrelated acts; meanwhile, the primary similarity is the word's indication
of a circular space. Note that "circus" was applied to this new amusement
about the time that the word was first used for England's traffic round-
abouts, like Piccadilly Circus in 1819.) Through this period, urban refer-
ences to "circus" usually meant circuses in theaters that also featured plays.
Philadelphia's Walnut Street Theatre, which originally offered both plays
and circuses, is still in operation.

Joseph Grimaldi, the most famous clown in these early years of circus
never appeared in one, but only on stage. Though his whiteface makeup,

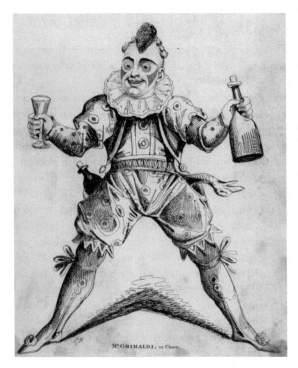

Figure A.1 Joseph Grimaldi, in his character named "Clown." Author's collection.

physicality, and stylized costume with geometric shapes would cast a strong influence, he was neither like earlier stage clowns, a single comic figure in a large cast, nor like early circus clowns with their brief comic routines. In his character, called "Clown," Grimaldi took the major role in a performance of knockabout comedy. Popular lore says that clowns are called "Joeys" in his honor, though it is not clear if the nickname was routinely used then. More likely, it's a later application/affectation by writers.

Clowns did not figure in early circus symbolism. The two original circus symbols were Circus Day, a vacation sparked by the arrival of a show in a small town, and invocation of "the good, old days" of circus. That nostalgia began early, when circus was barely a half century old, reflecting the appeal of this peripatetic institution in a peripatetic country. Meanwhile clowns had little symbolic function; people cared about what these circus workers did rather than what they might represent. (Compare current baseball players, who attract interest because of what they do on the

field, not because of any widespread cultural symbolism. No one speaks of the First Baseman of Industry, or the Pitcher of Politics.) Charles Dickens reflected that clown-free symbolism in 1853, in *Hard Times*. While contrasting the circus in that novel to the rigidities and injustices of industrialism, Dickens included no clowns. The rare times the clown did appear as a literary symbol, he represented rowdy good nature boosting adults' spirit. Another work from 1853, Herman Melville's story, "The Fiddler," relies on that symbolic use. Here, a world-weary man recovers his appreciation of life once he discovers that a world-renowned violinist gets pleasure simply from watching a circus clown. A variation on this theme appears in a clown tale, apparently first told about Grimaldi and repeated often, including in chapter 7: A sick man visits a doctor, who tells the man that he'll feel better if he goes to watch a famous clown, at which point the man says, "Alas, doctor"—again, "alas"—"I am that clown." The early clown stories, though shy of details like dates or places, nevertheless show the stirrings of romantic notions about clowns.

Writers played a role in another significant aspect of circus, publicity. With the emergence of the penny press, advertising became a key to circus success—and to how clowns were perceived. Widely read newspapers greatly expanded advertising, augmenting the bills posted around town (hence their later label, "posters"), and they increased the buzz of comments after the fact. P. T. Barnum was not involved with circus till late in life, after first retiring, and his role in management remains unclear, but his mastery of publicity, a key element of circus success, rightly includes him in circus history.

Through all this, circus and its clowns aimed at an adult audience. Footloose urban urchins might attend circus (or theater or minstrelsy), and country kids would join most of the population when a circus came to town. Juveniles's interest can be seen in warnings *against* the circus in reformers' pamphlets. Nevertheless, the focus—and symbolism—of mid-nineteenth-century circus remained resolutely adult.

As circus dominated American amusements in the middle of the nineteenth century, clowns and riders dominated circus. In the 1830s most American circuses offered two kinds of clowns, whiteface and blackface. The whiteface focused on knockabout comedy; the blackface clown combined physical and verbal comedy, in a thorny but popular exploitation of stereotypes about African Americans. The whiteface–blackface pairing in circus faded once a quartet of blackface circus clowns formed the Virginia Minstrels in 1843, sparking the century-long craze of a new form, minstrelsy. (Histories of minstrelsy barely note its origin in circus clowning.)

Still, blackface continued in many amusements, including circus, into the next century. A 1923 book, *How to Put on an Amateur Circus*, included tips on blacking up, and into the 1940s, Marx Brothers movies and Bing Crosby in the movie *Holiday Inn* used blackface—though those scenes are now usually cut for broadcast.

The talking clown emerged in circus in the 1840s, perhaps because the verbal comedy of the blackface clown had migrated into minstrelsy. The talking clown included two sub-specialties, the singing clown and the Shakespearean clown.

The talking—and singing and "Shaksperian"—clown Dan Rice was the best of the century, as well as one of the best-known people in any field in America. He started in whiteface and occasional blackface, including a stint with Dan Emmett, author of "Dixie." (The lingering blackface helps explain why Dan Rice is still confused with the earlier blackface stage comedian, T.D. "Jump Jim Crow" Rice, less renowned then but more heavily studied now.) Dan Rice's fame grew as he trouped in large tents every summer and performed in major city theaters over the winter, with his "Riceana" known throughout the country. Between his large venues, sparkling wit, unusually wide geographic range, and vast popularity, he was likely seen by more people than any other American of his age. He appealed to the emerging middle class as "The Great American Humorist," occasionally performing, without makeup, in a gentleman's tie and tails. He expanded his "hits on the times" into political commentary, then ran for political office from the ring. Though his campaigns would be retroactively dismissed as jokes, Rice ran in earnest as a Peace Democrat, on the ballot for the Pennsylvania legislature in 1864 (running ahead of the ticket of the party's presidential candidate, George McClellan), vying for a congressional nomination in 1866, and campaigning—briefly but legitimately—for president of the United States.

Rice's eminence spawned many fictions still repeated as fact. He did not campaign for Zachary Taylor in 1848, nor did he have anything to do with the phrase "on the bandwagon," which didn't become political slang until the 1880s. Rice was not Abraham Lincoln's bosom buddy, a still popular tale, and he did not give a "great Union speech" early in the Civil War, as he'd later claim. To the contrary, for most of the war, Rice was a Southern sympathizer, a Copperhead who fiercely criticized Republicans from the circus ring. However, Lincoln and Rice *were* paired in the public mind as similar jokesters out of the West, to their respective critics, uncouth jokesters. (Though born in Manhattan, Rice was considered a Westerner because he reached manhood in what was then the West, i.e., Pittsburgh.)

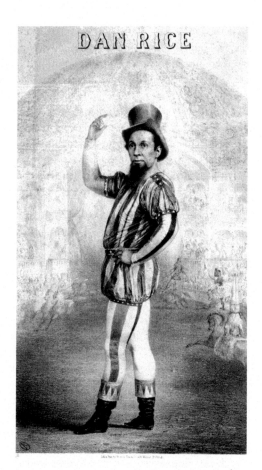

Figure A.2 Dan Rice, nineteenth-century America's illustrious circus clown (and politician). Author's collection, from Maria Ward Brown, *The Life of Dan Rice* (1901, p. 54).

Another popular tale that comes closer to the truth says that Dan Rice was the model for Uncle Sam. Much evidence suggests otherwise. The cultural icon of Uncle Sam began developing *before* Rice's fame, as companion to the earlier, rustic icon, Brother Jonathan. And it wasn't till *after* Rice's

greatest fame that the Uncle Sam figure we recognize today coalesced in an 1869 cartoon by Thomas Nast, an ardent Republican who would not have deliberately used a prominent Democrat as a model. Nonetheless, a case can be made for unconscious influence. Nast's Uncle Sam image combines key parts of Rice's nationally renowned image: the stars and stripes of his clown costume, the top hat and tailcoat of his "Great American Humorist" character, and his famous goatee. The top hat and tailcoat are telling. Those refined elements would seem odd for a national symbol in a country that favors the Common Man over the Gent—unless they derived from a well-known figure like Dan Rice, popular among all classes and regions. While he cannot be definitively claimed as the model, if America produced any original for Uncle Sam, it was Dan Rice.

CLOWN ALLEY (1880s–1970s)

Circus grew in the late nineteenth century, and became redefined as family entertainment. Large size was not new. While some mid-century shows fit the nostalgic view of small-town, small-tent affairs, others toured in tents seating thousands, experimented with moving by trains, and presented winter seasons in large city theaters. Nevertheless, growth accelerated in the 1880s. The biggest shows expanded to three-rings, hired hundreds, took to the rails full time, and replaced solo clowns with clusters of knockabout clowns. Histories usually claim that talking clowns disappeared because they couldn't be heard in the larger tents. An equally important reason was cultural change: audiences increasingly preferred their amusements to be more polite than rowdy, especially in this new guise of family entertainment. So talking clowns came to seem old-fashioned, and Rice's brand of political commentary would be forgotten. People now expected, as circus ballyhoo put it, clowns in a clattering cacophony to amuse the kiddies.

The large groups of funnymen led to the phrase "Clown Alley." That refers both to the clowns' dressing area and to a group of clowns. One origin story for the phrase claims that clowns were told in French to "allez"—go—into the tent, but American circus had little French connection. The likelier origin was the dressing area these clowns required, an alley-like space near the big top for their many entrances during a performance. The early twentieth-century emergence of "alley" as a collective reference, like "Tin Pan Alley" for songwriters and "Gasoline Alley" for filling stations, hints that "Clown Alley" started then. With the kind of extension common in slang, the label "Clown Alley" would be applied to clowns using that space.

In the masses of clowns, a few stood out. Slivers Oakley was probably the best of the early 1900s, and Spader Johnson was another noted one. Later, Otto Griebling was considered by many circus people to be the best twentieth-century clown. Other notables included Emmett Kelly, easily the most famous, thanks to movies and TV appearances; Felix Adler, known for his trained pigs; Paul Jung (the J as in "jungle"), a remarkable producing clown, or creator of gags; and Lou Jacobs, his giant red nose, big scoop of white makeup framing his mouth, and tiny hat on high domed head known to generations from prominence on Ringling posters.

Clowns emerged in other venues. Most common were the baggy-pants clowns of vaudeville, music hall, and burlesque, sometimes joined by circus clowns between summer seasons. The few who became stars when they moved into movies—Buster Keaton, the Marx Brothers, Charlie Chaplin, Bert Lahr—came to dominate ideas of clowning in the early decades of the twentieth century. Rodeo clowns, in makeup and patched clothes, can be considered performing kin of the rube clown of circus. (Rodeo clowns began calling themselves bullfighters, either to emphasize their dangerous

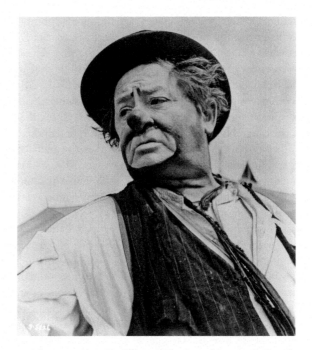

Figure A.3 The great Otto Griebling. Collection of Don B. Wilmeth.

function of distracting bulls from fallen riders or to distinguish themselves from circus clowns.) To refer to a "baseball clown" usually means Max Patkin, who made a half-century career out of clowning at games.

As circus morphed into family entertainment, children joined its symbolic universe. Childhood became sentimentalized in the 1880s, and clowns got the same sentimental treatment, recast as the children's special friend. One of the first depictions of clown-and-innocent-child appeared in the circus episode in *Huckleberry Finn*. Mark Twain had relished the rowdy, adult circus before the Civil War, and probably based Huck's description of a clown "quick as a wink with the funniest things a body ever said" on Dan Rice, who played Hannibal when Twain was a boy. However Huck's gushing innocence at the circus was a double anomaly, neither true to the raucous circus Twain had enjoyed, nor to how he depicted Huck elsewhere in his book. Twain used that 1884 masterpiece to satirize American society, but dropped the satire for the circus episode to give the Gilded Age the circus image it favored, an innocent child in awe of a clown. (Twain expressed interest in being a clown himself, while Rice joked that Twain had stolen his material.)

The popular and literary images that shape how people now understand clowns mostly emerged in the late nineteenth century, as clichés began to overwhelm what a clown actually said or did in the ring. The dominant cliché for a century remained clown-as-children's-friend, as if it were an ancient and inevitable bond, rather than the result of a specific historical process. Another newly popular tale told of the clown's sadness at unrequited love for an equestrienne, highlighting those two new symbols: the tears of a clown and the clown hiding pain behind the mask. Though there is nothing inherently sad about this particular circus worker, the dramatic contrast of laughter and sadness became irresistible to writers. The children's-friend trope eventually merged with the sad clown, as the source of sadness shifted from lost love to dramatically sick child. Another new symbol was the angry clown, only able to engage people in performance.

The clichés cannot be dismissed as mass-market banalities. In 1892 the opera *Pagliacci* presented another in the long line of sad clowns, hiding tears behind the mask. (Curiously, the trope's supposedly hidden tears can be seen by everyone.) Meanwhile theater directors sometimes turn Shakespeare's clowns into the happy clown or sad clown of stereotype. Painters found allure in clowns too, with makeup highlighting the face in intriguing ways, and colorful costumes and unusual scenes appealing as background. Pablo Picasso and Georges Rouault are two of the many artists who have gravitated to the clown, as have innumerable writers, especially

for the dramatic contrast of laughing clown/sad clown. Magazine and newspaper writers, aiming to dig behind the happy-face cliché, routinely fall into the behind-the-happy-face cliché. More renowned writers followed suit. In 1948 Henry Miller wrote a romantic tale about a clown, *The Smile at the Foot of the Ladder.* In 1963 the Nobel Prize winner Heinrich Boll used the title character in *The Clown* to explore German guilt over World War II.

BE A CLOWN (THE SIXTIES AND SINCE)

In the late 1800s, clowns entered the ring with the cry, "Here we are again!" A century later, in the 1960s and beyond, that cry implicitly rang in the wider world, as clowning became participatory. Previously clowns had been the ultimate outsiders. That was a key to fascination with circus, its separate world. It was also the allure for those who "joined out": circus accepted those who didn't fit normal life. As the phrase puts it, you had to "run away and join the circus." Not surprisingly, many clowns began as circus hands who stayed "with it and for it." Otto Griebling began as a rider, Swede Johnson was a lion trainer, and Lou Jacobs embarked on his circus career as a contortionist and acrobat. (Though Jacobs was German, European clowns tend to be better known as musical clowns playing instruments.) Meanwhile the training was a craft apprenticeship.

But the 1960s proclaimed "do your own thing." Now anyone could make a costume, throw on makeup, and declare "I'm a clown!" Hippies seemed halfway there already, with long hair, outlandish clothes, and rainbow suspenders. Meanwhile Shrine clowns, originally amateurs with a minor role next to the professionals in Shrine-sponsored circuses, increasingly became a Shrine show's only clowns. While the craft of circus clowning was as difficult to master as ever, and "clown" remained a symbol of the outsider, the working clown no longer stood outside society. Unusual, yes; outsider, no. It wasn't simply the counterculture. Many forces were dismantling old notions of behavior and career. While joining the circus could be depicted as a bold rejection of "The Establishment," other pursuits scratched the same itch. Some became clowns, some climbed the Himalayas.

These changes included women's roles. Historically, women clowns were rare, for a range of reasons beyond the scope of this survey. Commedia dell'arte did include women performers, including Isabella Andreini, also a writer and intellectual, but commedia was an exception. Few women became clowns for the first two centuries of circus. Even as late as the 1970s, the idea of a woman clown still seemed outlandish to many people.

The benign interpretation says that a clown's loss of dignity is beneath women; the more restrictive view questioned whether women could actually be funny. Examples like Fanny Brice and Lucille Ball render both views silly, as do many women clowns since the 1970s.

The Clown College of Ringling Brothers and Barnum & Bailey Circus emerged from and helped propel these changes. Started in 1968, it was held for eight to eleven weeks every fall at Ringling's winter quarters in Venice, Florida. The teachers—specialists in circus-related fields and Ringling clowns from the tour—offered a wide array of subjects, from performance-oriented classes including clown gags, mime, dancing, juggling, gymnastics, and stilt-walking, to clown-helpful crafts such as sewing, magic, wig-making, and nose-making. Other courses, like history and movies, broadened the neophyte's perspective. While few students became expert at anything, the schedule introduced what might be useful to a clown, with improvement depending on individual aptitude and practice. The two months concluded in a graduation performance that was also an audition for a job. The school moved to Baraboo, Wisconsin, then Sarasota, Florida, and closed in 1997.

Old-timers insisted that Clown College didn't teach clowning, but only spit out "cookie cutter clowns." There's truth there. Primary hiring criteria were clean makeups, professional-looking costumes, and circus skills like juggling. Meanwhile, Clown College graduates did not necessarily become stellar clowns. George Burns said, "The circus is the only place left to fail," and First-of-Mays—rookie clowns—seemed determined to prove him right. The criticism also points to a larger issue, whether any school can teach clowning. While Clown College offered a significant foundation, the lessons of professional clowning are still learned best as they have been historically, in performance. Despite all that, Clown College produced more than a few good clowns. In fact, the proportion between duds and good ones among Clown College graduates is probably the same as the proportion in every era. So though some were what the critics sneered, painted chorus boys, the range was wide, from bad clowns and mere chorus boys to graduates who learned, made mistakes, learned more, and became good clowns.

The free-spirit impulse that created hippies and influenced Clown College combined in the counterculture clown of the New Circus era. It is no accident that new clowning particularly developed in New York City and San Francisco, strongly identified with the counterculture movement. Just as hippies scorned The Establishment, so did these new clowns scorn established circuses and their clowns. Akin to the talking clowns of the mid-1800s, these new clowns made words an important part of their comedy.

A key element was irony, calling attention to their own performance and mocking traditional clowns. (Ironically, a few of the new "traditional" circus clowns also used irony, that standard comedy technique of the 1960s.) Talking also led to renewed partnership with the audience. The late nineteenth century had decided that "art" should ignore audience response, while "entertainment" amused a passive crowd—another historical development now regarded as ancient and inevitable—but 1960s clowns revived the ancient performer-audience connection. This path has generated some of the best clowning around.

European circuses influenced many Americans. First, Europe provided a venue for Americans to work, as has been the case with jazz musicians and dancers. Second, Americans studied mime in Europe, busked on the streets, and joined European circuses. One of the most notable teachers of physical theater and movement was Jacques Lecoq in France. Two performers who brought lessons home from Europe, Paul Binder and Michael Christensen, used the one-ring shows they had seen and worked in as inspiration for Big Apple Circus, which they built into a Manhattan institution, featuring the ex-Ringling clown Barry "Grandma" Lubin. A notable American influence was Hovey Burgess, a skills-based godfather of new circus in the United States. The San Francisco area spawned the Pickle Family Circus, with two of its clowns, Bill Irwin and Geoff Hoyle, spinning off into notable solo careers. The same impulse produced the juggling Flying Karamazov Brothers and Avner the Eccentric. These clowns of the New Circus era, sometimes called "neo-vaudevillians," were predominantly college educated, and savvy about appealing to middle- and upper-class audiences. That includes discomfort with the label "clown," and a search for upscale alternatives: "eccentric," "fool," "buffoon," and, with a French flair, "buffon." The new clowns and new impulses have forged important paths.

This New Age approach incorporated political and social impulses. The Bread and Puppet Theater, spawned on New York City's Lower East Side and moved to "The Northeast Kingdom of Vermont," exemplifies this tendency. A theater based on puppets, it has a clown-like anarchic spirit and outsized characters. Their slogan, "Cheap Art and Political Theater," suggests the new scorn of polished presentations. Many of the new breed of clowns, while positioning their work as higher than mere amusement, take pride in being haphazard, rough, and improvisatory, rather than being smooth like mainstream fare.

Overlapping this political and social bent is a search for the inner self/inner clown. That urge to personal discovery, authenticity, and fulfillment

finds encouragement in the proliferation of clown teachers and classes. Its strength, however, can also be a weakness: the focus on self often devalues audiences. Talking in a workshop about the importance of audiences doesn't put them in the room, to speak and react for themselves. It's like men discussing what women want: a crucial element is missing. That's not to dismiss the urge to personal discovery. It's important in itself, and to clowning historically. The best clowns offer—or seem to offer—their genuine selves to the audience. (Old show-biz joke: "Sincerity—if you can fake that, you've got it made.")

Though clowns of the New Circus era register significantly in Europe as a new hipster-ish counterculture subculture, that's not the case so far in the early twenty-first century in American culture, where clowns remains known mostly to other clowns, to a small coterie of fans and critics in major cities, to the universities, conferences, and workshops where they teach, and to grant-giving foundations. Though that list covers many people, none of the American clowns of the New Circus era have made the leap that the old vaudeville clowns did, via television and movies, into broad cultural recognition.

One group did make that leap, a Canadian outfit that grew into Cirque du Soleil. Though its narrative focus, lack of animals, and dark moods convince some circus fans that it's not really a circus, it's the largest circus organization in the world, with multiple touring troupes and other theater-based circuses in Las Vegas. Sometimes it seems as if Cirque du Soleil is determined to singlehandedly revive circus as a culturally relevant amusement. Though its clowns, often a shabby Everyman, can suggest the tramp clown of traditional circus, its tightly controlled programs make them more like characters in a play. The loosely structured standalone gags of traditional clowns are rare, and rarer still is room to improvise, with whispered instructions to audience volunteers and planted props apparently "found." Similarly, these clowns' cultural recognition remains low, as they're seen as other figures in the extravaganza of any particular Cirque du Soleil show.

This new influence generated new symbols. The most obvious one claimed the clown as the ultimate free-spirit. As the age celebrated being weird or innocently childlike, the clown became a hippie dream in baggy clothes and wild hair, symbolically beyond disdained normality. The other new clown symbol was the truth-telling trickster. The influence of the age's political activism is obvious, framing any contrary statement or cheeky attitude as a challenge to power, with academics enlarging culturally specific Native American "contraries" and generic court jesters into

daring political jokers. However, this impulse has holes. The supposed challenges turn out to be fiction or symbolic, enacting no change. The medieval "Feast of Fools" has been framed as carnivalesque inversion of society but documentable instances show little threat to power, and only a momentarily sanctioned easing of hierarchy. Anyway, the "carnivalesque" is not historical analysis but a literary theory by the Russian Mikhail Bakhtin, yet it routinely finds its way into scholarly essays about performance. Though evidence of genuine trickster challenge is rare, cultural fondness for the symbol thrives.

The participatory urge had another effect, in the explosion of clowning outside traditional venues. It might be called amateur clowning, and the majority do make little or no money, doing it instead for enjoyment. Another category is hospital clowning: clowns visiting sick children in hospital wards. This admirable work reinforces the human urge to comfort and, despite its use for publicity, hospital clowning has done great good. Other clowns perform at birthday parties, and some make a living that way. Many clowns outside circus find comradeship and training in clown organizations, like the Clowns of America International and the World Clown Association.

The corporate world took notice of the popular symbol of clown, and have long used it to sell things. Ronald McDonald, the emblem of the McDonalds hamburger empire, is the most visible of many clown icons and figureheads peddling stuff.

"THREE TYPES OF CLOWNS"?

The commonly repeated categorization of three types of clowns, whiteface, Auguste, and character clown, is too categorical, turning comic impulses and makeup tendencies into rules. For nearly two centuries, a circus clown was simply the costumed comic figure in a circus, with no defining required. But because the 1960s encouraged the idea that a "clown" might be anyone who threw on makeup, it could be reassuring to have rules to follow, a way to prove that one was "officially" a clown. That urge to authenticity might explain the resurgence of older slang, such as "Joey," "Clown Alley," and "First-of-May." So it is not surprising that this three-part division was influenced, if not invented, by Ringling's Clown College, in particular a pamphlet illustrated by the school's second "dean," Bill Ballantine. (Having clowned for a year, Ballantine used his own makeup as the main illustration for the whiteface.) Nevertheless, the division does have value, helping new clowns sort through a confusing array of options.

Meanwhile, the categories have their own validity: the whiteface and Auguste fit the straight man/stooge comedy pair, common in vaudeville and movie comedy teams, while the character clown, especially the tramp clown, represents the solo comic figure.

Here are the types, as now typically regarded, as they developed, and as symbols:

The whiteface wears white makeup all over the face and neck, with accents of other colors. (European whitefaces—and Americans seeking exotic authenticity—apply red makeup to the ears.) The whiteface functions either as the straight man in a comedy pair or as a presenter, often elegant in costume and movement. The whiteface began as a knockabout stage clown like Grimaldi, with a side influence from commedia dell'arte. In the nineteenth-century circus, whiteface clowns were both knockabout and talking clowns. Though now regarded as an authority figure and not especially physical, the whiteface clown follows the needs of a gag for the show, including boisterous physical comedy. This type may be fading. Few whiteface clowns populate American circuses now.

The Auguste (capitalized, pronounced aw-GOOST) wears baggy clothes and typically uses skin-tone makeup, a red nose, and white around the mouth and eyes. This is typically what people think of as a "circus clown." Some, called "neat" Augustes, wear elegant costumes and resemble the whiteface. Otherwise the Auguste is the stooge, or second banana, in a comedy pair. One origin story says that an American performer named Tom Belling was kicked out of his circus tent in Germany in the late 1800s and got laughs when he snuck back in disguised in oversized clothes, fell, and bloodied his nose, with the resulting baggy pants, red nose and blundering establishing the type. The label "Auguste" probably began as an ironic flip of "august" (aw-GUST), the word for dignified.

The character clown is not really a type, even in this three-part division, but a category encompassing many types. Anything that can be identified as a character, such as a policeman or a professor, can be turned into a character clown. An early character clown remains popular, the rube clown of circuses and stages. The rodeo clown is essentially a rube clown. Other character types were "ethnic" clowns, based on immigrant groups, such as the "Dutch" (German), Irish, Italian, and "Hebrew" (Jews). (The Jewish comedian Chico Marx played an "Italian" clown.) Because blackface became identified with minstrelsy, circus has been able to ignore the embarrassment that the "Negro," perhaps the first "character" clown, remained a circus character into the twentieth century. Currently, the most common character clown is the tramp clown, evolved from unemployed tramps caused

by the Industrial Revolution in the late 1800s, and boosted to prominence during the Great Depression. Ironically, as the original tramp/homeless person became more scorned, the tramp clown became more lovable.

Some historians see a class division in these three types, the whiteface as elite, the Auguste symbolizing the smug, rising or struggling middle class, and the tramp clown representing the lower class.

"HERE WE ARE AGAIN" (NOW)

As the late 1900s turned to the twenty-first century, the 1960s growth of clowning became an explosion, multiplying clown types, venues, and impulses. However, that multiplication can't hide the fade of three-ring clowning. Ringling shut down its Clown College and now hires fewer clowns, focusing on headliners like the puckish David Larible and the acrobatic Bello Nock. Other traditional circuses often now have only a clown or two. Or none, except for circus workers at the entrance who wear clown makeup to advertise that they'll put makeup on kids. Meanwhile clowns have increasingly altered the ancient craft of spontaneous improvisation with the audience into semi-scripted interaction, with whispered instructions to audience volunteers.

This resurgent interest has produced solid histories that combine primary evidence, related scholarship, and original thought. However the resurgence has also expanded the traditional tendency of circus books and, now, websites to treat clown tales, legends, and clichés as fact. Unless the field engages the newer studies that dig into primary research, and instead continues to rely on secondary sources that in turn rely on secondary sources, circus and clown history will be like the old joke about the foundation of the world: it's turtles all the way down.

As three-ring clowning decreases, the clown-as-symbol increases. Television, movies, and advertisements employ the clown to represent hilarity or an ultimate children's pleasure. That insistence on hilarity calls the actual encounters into question, because few live moments can match the perfect glee of a staged, fictional encounter. Every TV show or movie that shows a mildly amusing routine paired with an audience roaring in laughter increases the sense that actual clowns are inane, as no one is continuously hilarious in every moment in every performance. Year by year this repeated use of clichés weakens the link to genuine clowning, the symbols less and less reflective of what real clowns do. Cirque du Soleil may contribute to this inflationary humor spiral. Though its shows seem dark and hard-edged, it sentimentalizes its outsider comic figure, a stranger-in-a-strange-land as lovable as the tramp clown.

The scary clown is a curious addition to clown symbolism. Children have periodically been afraid of clowns, as they get frightened of many things— thunder, Santa, the first day of kindergarten—all of which they get over. Meanwhile, adults who adamantly insist on their fear of clowns in makeup blithely accept other full makeups, like kabuki's. Ironically, the "scary clown" may have started as a joke, a comic flip of the clichéd happy clown. On the January 19, 1991 episode of television's *Saturday Night Live*, in the first of what would become writer Jack Handey's recurring segment, "Deep Thoughts," he said that he was afraid of clowns, "and I think it goes back to the time when I went to the circus and a clown killed my dad." Whatever the origin, the Scary Clown cliché only became popularly but falsely regarded as a genuine phobia after the turn into the twenty-first century. Four reasons suggest themselves. First, the increase in amateur clowns and young performers out of Clown College meant a lack of experience dealing with children, leading to awkward encounters. Second, movies began to exploit the dramatic contrast of happy face and menacing figure. Third, the Internet accelerated the scary-clown image, with repetition making the vague notion seem legitimate, encouraging otherwise capable journalists to routinely insert this web-propelled inanity into articles about clowns. Finally, just as the happy-clown cliché spawned the sad-clown cliché, the vapid notion that clowns represent perfect hilarity generated its own backlash, the vapid notion that clowns must be creepy. Though clowns are no more or less likable than any other performer, to claim a dislike of clowns became an implicit boast of independent thinking, albeit dependent on conformity to this new cultural fashion.

Another, novel angle on reaction to the clown can be gleaned from *Understanding Comics*, by Scott McCloud. In his comic-book history of comics, he discusses how readers' perceptions of the blank slate that is a cartoon face help inform the material they're reading. Similarly, audience reaction to the clown's makeup, another abstract version of a face, helps create the comic event.

FUTURE? (NEXT?)

Though bold predictions are a fool's errand beyond the ken of this fool, a few observations may be worthwhile. Because talking clowns faded, Dan Rice seemed a dead end, but his brand of verbal clowning continued onto the vaudeville stage, into movies, and then into television. The Marx Brothers, Danny Kaye, Red Skelton, Bob Hope, Bert Lahr, and many other verbal comedians carried the DNA of Dan Rice's comedy. It would take over a century though before cable television and the Internet created the

true successors of the politician-clown Rice, in politically charged comic entertainers. Meanwhile, performers of various kinds have discovered and rediscovered the extreme value and immense fun in physical comedy.

Here is one bold prediction: people still want to laugh, providing audiences, material, and encouragement to plenty of clowns, physical and verbal, bad, indifferent, good or great.

Bibliography ❧

He words me, girls, he words me.

William Shakespeare, *Anthony and Cleopatra*, 5.2 (Cleopatra)

TOURING LIFE

Antekeier, Kristopher, and Greg Annapu. *Ringmaster: My Year on the Road with "The Greatest Show on Earth."* New York: E.F. Dutton, 1985.

Baumann, Charly, with Leonard A. Stevens. *Tiger, Tiger.* New York: Playboy Press, 1975. Master tiger trainer and efficient, caring performance director.

Binder, Paul. *Never Quote the Weather to a Sea Lion (and other Uncommon Tales from the Founder of the Big Apple Circus).* Bloomington, IN: AuthorHouse, 2013. Major figure in New Circus.

Clausen, Connie. *I Love You Honey, but the Season's Over.* New York: Holt, Rinehart and Winston, 1961. Entertaining account of World War II circus life, with one of the greatest titles ever.

Feiler, Bruce. *Under the Big Top: A Season with the Circus.* New York: Scribner, 1995. A writer takes the role of a clown for a story.

Kelly, Emmett, with F. Beverly Kelley. *Clown: My Life in Tatters and Smiles.* New York: Prentice Hall, 1954. Reminiscences of rising to fame.

Kline, Tiny. *Circus Queen and Tinker Bell: The Memoir of Tiny Kline.* Ed. Janet Davis. Urbana and Chicago, IL: University of Illinois Press, 2008. Pre–World War II circus life.

Lubin, Barry. *Tall Tales of a Short Clown.* Waltham, MA: AuthorMike Ink, 2014. A fellow Ringling clown in 1978, then Big Apple Circus's clown, "Grandma."

Marangon, Barbara File. *Detour on an Elephant: A Year Dancing with the Greatest Show on Earth.* Port Charlotte, FL: Ogham Books, 2014. Showgirl on Ringling's Blue Unit, 1978.

Wise, Mary R. *Girl Clown.* Lulu.com, 2004. Clown College graduate who worked on a tent show.

Wood, Joe. *Funnyman: Life and Times on the Greatest Show on Earth.* Pittsburgh, PA: RoseDog Books, 2010. Fellow Ringling clown.

ONLINE

All Fall Down: The Craft & Art of Physical Comedy. John Towsen. http://physicalcomedy.blogspot.com. Wide-ranging look at physical comedy.

BucklesBlog. Buckles Woodcock. http://bucklesw.blogspot.com. Daily display of circus pictures, spiced with circus veterans' comments.

Clown History. http://www.charliethejugglingclown.com/clown_history.htm. History and lore.

Circus Now. http://circusnow.org/circommons. Contemporary circus and training.

ClownAlley.net, Pat Cashin. http://clownalley.blogspot.com. Traditional clowns and physical comedy.

Specatcle. Ernest Albrecht. http://spectaclemagazine.com/. Reviews, pictures, and essays on contemporary circus and its trends.

Travalanche. Travis D. Stewart. https://travsd.wordpress.com. Old-time performers, including comedians.

CLOWNS IN PRINT

Ballantine, Bill. *Clown Alley*. Boston and Toronto: Little, Brown, 1982. An insider's perspective by the second "dean" of Clown College.

Boll, Heinrich. *The Clown*. New York: McGraw Hill, 1965[1963]. Nobel Prize winner used a clown character to challenge post–World War II Germany.

Bratton, Jacky, and Ann Featherstone. *The Victorian Clown*. Cambridge: Cambridge University Press, 2006. Early clowning in England: 1840s overview; 1850s memoir; 1870s clown sketches.

Carlyon, David. *Dan Rice: The Most Famous Man You've Never Heard Of*. New York: Public Affairs, 2001. Biography-cultural history interrogating how Rice's clowning fit, reflected, and influenced nineteenth-century American culture.

———. "The Trickster as Academic Comfort Food," *Journal of American Culture*, 25.1–2 (Spring/Summer 2002): 15–19. A historian's challenge to trickster "challenge."

Davis, Andrew. *Baggy Pants Comedy: Burlesque and the Oral Tradition*. New York: Palgrave Macmillan, 2013. Circus clowning's comic cousins.

Davison, Jon. *Clown*. New York: Palgrave Macmillan, 2013. Clown history, theory, and practice from secondary sources, with many block quotations.

Dickens, Charles. Ed. Richard Findlater. *Memoirs of Joseph Grimaldi*. New York: Stein and Day, 1968[1838]. More Dickens version than Grimaldi's.

Disher, M. Willson. *Clowns and Pantomimes*. London: Constable, 1925. An early, important scholarly approach to clown history.

Gordon, Mel. *Lazzi: The Comic Routines of the Commedia dell'Arte*. New York: Performing Arts Journal Publication, 1983. Avoids the commedia pontificating that kills the comic impulse in its crib.

Green, Stanley. *The Great Clowns of Broadway.* New York: Oxford University Press, 1984. Cousins of the circus clown, their craft, and their audiences.

Huey, Rodney A. "Social Construction of the American Circus Clown: Production of Clowning in the United States from 1968 to 1997." Dissertation. George Mason University, 2005. Though offering insight into the demise of apprenticeship, it dismisses Clown College graduates as "commodified," not doing "real" comedy like New Age-subversive-trickster-art clowns.

Jenkins, Ron. *Acrobats of the Soul: Comedy & Virtuosity in Contemporary American Theatre.* New York: Theatre Communications Group, 1988. Though heavy on 1960s truth-tellers fighting conformity, a good overview of New Circus–era clowns.

LeBank, Ezra, and David Bridel. *Clowns: In Conversation with Modern Masters.* London and New York: Routledge, 2015. Clowns of the New Circus era and older European clowns.

Lee, Joe. *The History of Clowns for Beginners.* New York: Writers and Readers, 1995. Graphic novel mixing actual, possible, and fanciful predecessors of clowns, plus shamanism, existentialism, etc.

Martin, Steve. *Born Standing Up: A Comic's Life.* New York: Scribner, 2007. Martin details the same learning process explored in this book.

Miller, Henry. *Smile at the Foot of the Ladder.* New York: New Directions, 1974[1959]. Unlike other romantic views of clowns, this one appeals to me.

Otis, James. *The Clown's Protégé: A Story of Circus.* New York: A.L. Burt Company, 1883. One of the early books sentimentally linking children and circus.

Remy, Tristan. Trans. Bernard Sahlins. *Clown Scenes.* Chicago, IL: Ivan R. Dee, 1997[1962]. Classic routines explicated by a French circus historian.

Rogers, Phyllis Ashbridge. "The American Circus Clown." Dissertation. Princeton University, 1979. Though reducing Ringling clowns' "main function" to chorus boy, Rogers's perspective bears consideration.

Schecter, Joel. *Durov's Pig: Clowns, Politics and Theatre.* New York: Theatre Communications Group, 1985. Bakhtin, Boal, Brecht pose tricksterish challenge.

Severini, Ron. *Otto Griebling: "The Greatest American Circus Clown."* Windermere, FL: Castle Talent, 2012. A biography in photographs.

Sherwood, Robert E. *Here We Are Again: Recollections of an Old Circus Clown.* Indianapolis, IN: Bobbs-Merrill, 1926. Whiff of the nineteenth century.

Spangenberg, Kristen L., and Deborah W. Walk, eds. *The Amazing American Circus Poster: The Strobridge Lithographing Company.* Cincinnati Art Museum and The John and Mable Ringling Museum of Art, Sarasota, FL, 2011. Clowns among images and essays, including mine.

Speaight, George. *The Book of Clowns.* New York: Macmillan, 1980. Noted British historian provided color pictures and a European perspective.

Stewart, D. Travis. [Trav S.D.]. *Chain of Fools: Silent Comedy and Its Legacies from Nickelodeons to YouTube.* Duncan, OK: BearManor Media, 2013. Early comedy cousins of circus clowns.

———. [Trav S.D.]. *No Applause, Just Throw Money: The Book that Made Vaudeville Famous*. New York: Faber and Faber, 2005. Earlier comedy cousins of circus clowns.

Stott, Andrew McConnell. *The Pantomime Life of Joseph Grimaldi: Laughter, Madness and the Story of Britain's Greatest Comedian*. Edinburgh: Canongate, 2009. Clearer history than Dickens's.

Towsen, John. *Clowns*. New York: Hawthorne, 1976. One of the first of the new generation of serious looks at clown history.

Wall, Duncan. *The Ordinary Acrobat: A Journey into the Wondrous World of the Circus, Past and Present*. New York: Knopf, 2013. Based on the author's path in New Circus, positing modern European circus as art, while respecting traditional clowns and their craft.

Ward, Steve. *Beneath the Big Top: A Social History of the Circus in Britain*. South Yorkshire, England: Pen & Sword History, 2014.

Welsford, Enid. *The Fool: His Social and Literary History*. London: Faber and Faber, 1935. Noting the difference between professional and mythical buffoons.

Willeford, William. *The Fool and His Sceptre*. Evanston, IL: Northwestern University Press, 1969.

CLOWN RELATED

Albrecht, Ernest. *The New American Circus*. Gainesville, FL: University Press of Florida, 1995. Experienced observer.

Alger, Horatio, Jr. *The Young Circus Rider, or, The Mystery of Robert Rudd*. Philadelphia, PA: Henry T. Coates, 1883. Circus tale reflects the era's shift of focus to children.

Bradley, Patricia L. *Robert Penn Warren's Circus Aesthetic and the Southern Renaissance*. Knoxville: University of Tennessee Press, 2004. A rare use of trickster, neither Bakhtin's "carnivalesque" nor the 1960s anti-Establishment icon, but Ralph Ellison's self-effacing American "eiron."

Burgess, Hovey. *Circus Techniques*. New York: Drama Book Specialist, 1976. The godfather of New Circus in America.

Carlyon, David. "'Soft and Silky Around Her Hips': Nineteenth-Century Circus and Sex," *Journal of American Drama and Theatre*, 22.2 (Spring 2010): 25–47. Dirty jokes and revealing costumes, with sexual allure a key component of early circus.

———. "Twain's 'Stretcher': The Circus Shapes *Huckleberry Finn*," *South Atlantic Review* 72.4 (Fall 2007): 1–36. Previously unnoticed circus influence on this great American novel.

Coxe, Anthony Hippesley. *A Seat at the Circus*. 1951. Hamden, CT: Archon Books, 1980.

Culhane, John. *The American Circus: An Illustrated History*. New York: Henry Holt, 1990. Wonderful pictures and extensive coverage, though the Dan Rice tales mix facts and the usual fictions.

Dahlinger, Fred. Jr., and Stuart Thayer. *Badger State Showmen: A History of Wisconsin's Circus Heritage.* Madison, WI: Grote; Circus World Museum, 1998. A cradle of American circus.

Davis, Janet. *Circus Age: Culture and Society Under the Big Top.* University of North Carolina Press, 2002. A rare cultural history of late nineteenth-century circus.

Fox, Charles Philip "Chappie." *A Ticket to the Circus: A Pictorial History of the Incredible Ringlings.* New York: Bramhall, 1959. A close look at the Ringling show by one of America's first circus historians.

Hammarstrom, David L. *Inside the Changing Circus: A Critic's Guide.* Duncan, OK: BearManor Media, 2012. Experienced observer.

Hoh, LaVahn G. and William H. Rough. *Step Right Up!: The Adventure of Circus in America.* White Hall, VA: Betterway Publications, 1990. A "book for circus lovers, by circus lovers."

Kerr, Walter. *The Silent Clowns.* New York: Knopf, 1975. Master silent film clowns illuminated by a master writer.

Martin, Reed, and Austin Tichenor. *Reduced Shakespeare: The Complete Guide for the Attention-Impaired [abridged].* New York: Hyperion, 2006. Shakespeareanish version of the clowning discussed here.

McCloud, Scott. *Understanding Comics: The Invisible Art.* New York: Harper Perennial, 1994. Comic book history of comics, and of the blank slate that is a cartoon face, with intriguing implications about audience reactions to the clown's abstract version of a face.

McPherson, Douglas. *Circus Mania.* London: Peter Owen Publisher, 2011. Contemporary English circus.

Renoff, Gregory J. *The Big Tent: The Traveling Circus in Georgia, 1820–1930.* Athens and London: University of Georgia Press, 2008. Indepth focus on a region.

Saxon, A. H. *Enter Foot and Horse: A History of Hippodrama in England and France.* New Haven and London: Yale University Press, 1968. A theatrical cousin of circus.

Simon, Linda. *The Greatest Shows on Earth: A History of the Circus.* London: Reaktion Books, 2014. Circus seen through art, literature, and theory.

Slout, William L. *Olympians of the Sawdust Circle: A Biographical Dictionary of the Nineteenth Century American Circus.* San Bernardino, CA: Borgo Press, 1998. A leader in the historiographical shift to use primary evidence to write circus history.

Speaight, George. *A History of the Circus.* London: Tantivy Press, 1980. Brief discussion of European clowns in a broader history.

Stoddart, Helen. *Rings of Desire: Circus History and Representation.* Manchester and New York: Manchester University Press, 2000. Cultural history.

Thayer, Stuart. *Annals of the American Circus 1793–1860.* 1976. Seattle, WA: Dauven and Thayer, 2000. A rigorous look at early circus, by the dean of American circus history.

Weber, Susan, Kenneth Ames, and Matthew Wittman. *The American Circus*. New Haven, CT: Yale University Press, 2012. Wide-ranging collection of essays.

Wilmeth, Don B. *The Language of American Popular Entertainment: A Glossary of Argot, Slang, and Terminology*. Westport, CT: Greenwood Press, 1981. Intriguing guide with fascinating explanations.

———. *Mud Show: American Tent Circus Life*. Photographs by Edwin Martin. Albuquerque: University of New Mexico Press, 1988. Tent shows as a foundation of American circus.

EPIGRAPHS

Adams, Henry. *The Education of Henry Adams*. Boston, MA: Houghton Mifflin Co., 1918.

Cather, Willa. "The Bohemian Girl." *McClure's Magazine*, 39 (August 1912): 420–443.

Chekhov, Anton. "The Student," from *The Witch and Other Stories*, trans. Constance Garnett. New York: Macmillan, 1918.

Dickens, Charles. *Little Dorrit*. London: Bradbury and Evans, 1857. Book II, Ch. 12.

Forster, E. M. *Howards End*. London: Edward Arnold, 1910. Ch. 22.

Frost, Robert. "It Takes All Sorts," *The Poetry of Robert Frost*, ed. Edward Connery Lathem. New York: Henry Holt, 1969[1962]. See Acknowledgments.

Henry, O. (William Sidney Porter). "The Green Door," *The Complete Works of O. Henry*. Garden City, NY: Doubleday, Page and Co., 1926. 50.

Homer. *The Iliad*. Book 17.

Kerr, Walter. *The Theater in Spite of Itself*. New York: Simon and Schuster, 1963. 68. See Acknowledgments.

Shakespeare, William. *Anthony and Cleopatra*.

———. *As You Like It*.

———. *A Midsummer Night's Dream*.

Sondheim, Stephen. "Send in the Clowns," song title, musical, *A Little Night Music*, 1973.

Thoreau, Henry David. *A Week on the Concord and Merrimack Rivers*. Boston, MA: James R. Osgood and Co., 1849. Rev. Ed., 1873, copyright, 1867, p. 406.

Whitman, Walt. "Song of Myself" and "Infinity," *Leaves of Grass*. Philadelphia, PA: David McKay, 1900.

Index ∾

CC = Clown College; (CC) = attended Clown College; (clown) = on RBB&B Blue Unit, 1977; RBB&B = Ringling Brothers and Barnum and Bailey Circus
boldface = illustrations

Printed by Printforce, United Kingdom